The American Landscape

The American Landscape

Christian Zapatka

edited by Mirko Zardini

PRINCETON ARCHITECTURAL PRESS

PUBLISHED BY

Princeton Architectural Press

37 East 7th Street

New York, NY 10003

First published in Italian by Electa

Lotus Documents 21

ISBN 1-56898-093-0

Printed in Italy

EDITING: Maria Chiara Tronconi

Gail Swerling

DESIGN: Susan Dufour

PRODUCTION: Gianni Manenti

For a catalog of other books from Princeton Architectural Press, call toll free:

1.800.722.6657

Contents

6 The Architecture of the American Landscape
 Pierluigi Nicolini

8 Foreword
 Christian Zapatka

13 The Sublime in the Wilderness

27 Pastoral Reserves in the Nineteenth-Century City

79 The Private Realm: Residential Parks, Private Estates and the
 Private School

101 National Parks and the First Cross Country Parkway

121 Landscapes of the New Deal Era: Suburban and National Parkways,
 Greenbelt, Maryland; Jones Beach, New York

167 Contemporary Landscape Architects and a Sculptor

The Architecture of the American Landscape

Following an apparently accidental route, the journey through the American landscape proposed by Christian Zapatka links together, like beads on a necklace, examples and situations drawn from over a century of history. As far as I am aware no other attempt has ever been made to present an overall picture of the architecture of the American landscape which examines the crucial points of a history that in many ways has no parallel, and that involves, among others, painters, photographers, architects, landscapists, politicians, entrepreneurs, and writers, in a breadth of contributions that is simply staggering. For these reasons, the edition that we are presenting should be of particular interest to the English-speaking public as well as to Italian readers.

Rather than relating the whole story in a chronological and conventional sense, Zapatka takes an approach in which he chooses circumstances, personages, and examples and leaves us free to reconstruct "our" history, although it should be noted that he makes no attempt to conceal his own point of view when indicating the main lines of development of this experience.

Right from the very first images in the book, the European eye is struck by the way that the incredible immensity of the resources of the American territory looms large in the background, so that the European scene by comparison looks all too domestic.

In addition, skimming through these pages, we are introduced into the realms of the sublime, as if we were faced with the spectacle of nature as it appeared to the early pioneers and to the first great landscape artists, and all this at the same time as we are shown the first signs of a brutal process of colonization that was to transform the beauties of nature into objects of mass consumption.

In the United States the myth of the uncontaminated land, of a new Eden, supported by romantic interpretations of the native cultures, came into collision, as we all know, with a process of colonization rooted in the ideas of the Age of Enlightenment, symbolized by the imposition of Jefferson's grid on the American territory. This polarization between rationality of colonization and worship of nature has been accompanied, in American civilization, by another strong contrast: the one between the "high" and "low" levels of culture, in other words between "culture" *per se* (often elitist in character) and what is known as mass culture.

The debates, the interactions, and the evolution of the relations among these four aspects is the substance of a living story, in which American culture still feels totally involved.

In his examination of these questions, Zapatka identifies Olmsted and Moses as the great figures who produced a synthesis in the American culture of the landscape. "The extension of Olmsted's basic ideal," he states in the introduction, "the exploitation of nature at the whim of the people, is evident in some of the works carried out under Franklin Roosevelt's administration and Robert Moses's monopoly.

The projects launched by these public figures, leaving aside their questionable economic and social implications, set out to clean up, regulate, and beautify, at least to a certain degree, the desolate zones on the edges of cities. Although these efforts were certainly not dictated by new ideas (Olmsted's work was chiefly connected with problems of sanitation), they nevertheless produced satellite parks, to be used for living and/or leisure, accessible to that part of the population that owned an automobile... The roads that led to these places—the "parkways"—introduced the visitor into the realm of planning on a regional scale." With the entry into the landscape of the modern world, the space of nature (like that of history or ethnography) defined by the Western imagination has surrendered to a sort of promiscuity that puts artificial and aestheticizing forms of purification to a harsh test. To the gloomy conclusions of those who are unable to see the transformation of nature parks into theme parks as a result of the pressure exerted by mass tourism in anything but negative terms, Zapatka opposes a more complex view. Refusing to carry on with the search for a promised land and rejecting any concession to the revival of a genuine tradition that would imply questionable acts of purification, the book frankly presents all the hybridizations to which the American landscape has been subjected: urban parks as a scheme for the reclamation of decayed environments, road-parks as a simulation of the automobile trip through nature, the commonplaces of the landscape as captured in the snapshot.

Although it refuses to censure manifestations that are usually ignored by more academic treatments, the book does not underestimate the destructive and standardizing effects of the unrestricted exploitation of such resources, with the intrusiveness of modern products and of the means of mass communication and power, going so far as to identify "recycling" as the chief theme of new researches into the landscape.

It is against this complex background that we can set, at the end of the story, the most interesting experiences of contemporary landscapists: from Daniel Urban Kiley to Peter Walker, George Hargreaves, Ron Wigginton, and Mary Miss.

Pierluigi Nicolin

Foreword

Peter Walker, Concord
Performing Arts Center,
Concord, California, 1975.

Frederick Law Olmsted,
Castle Island Park, Boston,
preliminary study, 1890s.

This book is a selective survey of some significant moments in the history of American landscape painting, planning and design. While it covers a number of examples of each, there is a clear emphasis on the planning of large city parks in the late nineteenth century and the public works projects of the early twentieth century, particularly those on the east coast. Perhaps more than any other kind of urban development, parks have imbued the American city with a character indigenous to the American landscape at large — open space. Today, the morphology of the late twentieth-century city relies on greenery planted a century ago to provide literal and meta-

phorical oases in otherwise parched conglomerations of building mass. Of course any investigation of the origins and progress of the American park is largely a study of the work of Frederick Law Olmsted and the legacy of his firm, Olmsted Brothers, Landscape Architects. Well over half of the examples of landscape design presented here are taken from his oeuvre, some well known, others less seen or no longer evident as places of bucolic refuge.

The extension of the essential Olmsted ideal, the harnessing of nature for the enjoyment of the public, can be seen in some of the work achieved under the administration of Franklin Roosevelt and the "reign" of Robert Moses.

Aside from their debatable economic and sociological ramifications, the projects initiated by these public figures attempted, at least on one level, to clean, regularize and beautify wastelands outside of cities.

While not a new concept (Olmsted's work had typically been concerned with sanitation) these efforts made satellite parks, for living and/or recreation, available to an automobile owning population. Greenbelt towns and state parks and beaches were intended as idyllic alternatives to impossible city conditions and the "artificiality"

of places like Coney Island. The roads that led to these places — parkways — brought them into the realm of regional planning.

A look at the tree-lined roads that were built specifically for reaching parks, whether in or outside of the city, is an essential part of any study of American landscape design. Generically known as "parkways," landscaped highways with a continuous right-of-way, can be traced back to Olmsted's Eastern "Park-Way" of 1868 leading to Prospect Park in Brooklyn. An idea pioneered within a city context, it was taken to its logical extension in the form of commuter expressways and national parkways under the aegis of Roosevelt and Moses. These roads have become "ribbon parks" to be glimpsed from an automobile in pursuit of a suburban retreat or an encounter with the great outdoors.

Other parts of this survey examine experimentation with the landscape in the private realm, both at the turn-of-the-century and in the present. The contemporary landscape projects that seem most compatible with the principles of Olmstedian design are those that recognize and work with the richness of the land rather than those which just sprinkle the earth's surface with decorative objects. The landscape architect, Dan Kiley,

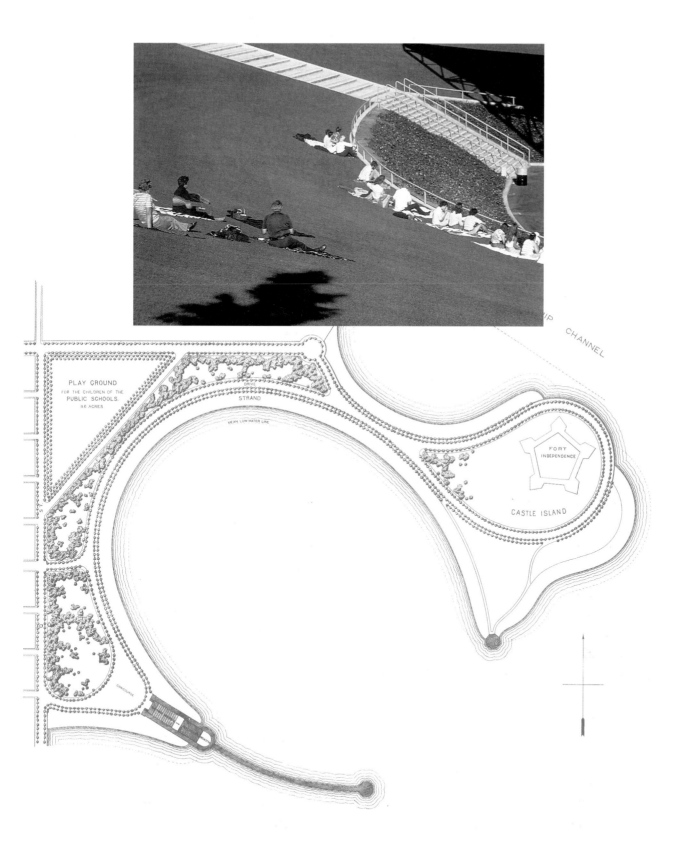

and the artist, Mary Miss, among others, demonstrate an understanding of the force and power of the land in its raw condition.

There is no beginning and no end to this book. It is organized in roughly chronological sequence but can be read at any point. It is meant to provoke a few ideas in the reader's mind, not to provide a comprehensive history of American landscape design. Rather than answering questions, it proffers examples which the author wishes to share with designers and historians as well as with lay readers.

The writing of this *Lotus Document* is the result of an interest in American landscape design that grew out of research for my 1988 article, "The American Parkways" (*Lotus International* no. 56). In the essay, I presented the idea of the landscaped street, road and highway as a phenomenon with possible European precedent but which was peculiar, in its maturity, to American cities, suburbs and national parks. While investigating the parkway question, it became clear to me that many, many gestures in American urban and suburban planning have sought to expose existing natural reserves within or near cities or to make previously inaccessible pastoral settings enticing to nonrural populations. Many of these

9

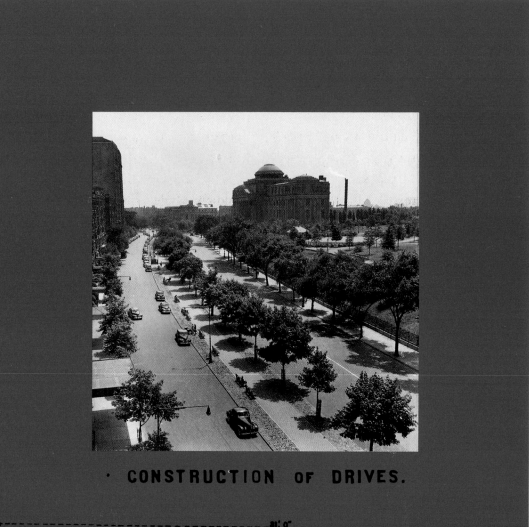

· CONSTRUCTION OF DRIVES.

Main Drain

Tile Drain

Frederick Law Olmsted,
Eastern Parkway, Brooklyn,
1868

efforts were initiated as sanitation projects in which swamps and polluted bodies of waters were cleaned and, only afterwards, turned into parks. This fundamental response to available natural resources is what has intrigued me about the history of American landscape design.

Having grown up in the national capital, I had the occasion to observe, firsthand, some of the best known examples of urban park planning in this country—the National Mall, the tree-lined diagonal avenues crossing the regular grid of the city, the planted circles and squares resolving the more prominent intersections of this plan and Rock Creek Park and Massachusetts Avenue. In contrast to the straight line of most of the city's parks, Rock Creek Park is a valley forest of irregular outline that splits the city into two parts. During the summer, when this park is dense with dark foliage, it is a cool, if humid gulf in contrast to the shimmering heat of the city's hard surfaces above. The belvederes of early twentieth-century apartment towers that loom above the trees are testimony to the effectiveness of a park that could provide natural air-conditioning for those fortunate enough to live on its boundaries. The roads that wind through the park, well below the grade of the city pavement, offer sylvan shortcuts between points within the city, admittedly more comprehensible to natives than visitors.

Massachusetts Avenue, one of the principal East-West axes running through the city, is carried over Rock Creek Park on a massive, multi-arched limestone bridge. It appears to take with it part of the forest, stretching it into a linear park as it climbs into the residential northwest quadrant of the city. My earliest memories of this street are hopelessly crossed with distant impressions of some broad boulevard in Southern France that I cannot separate from the sweeping gesture of Massachusetts Avenue's final ascent towards the Maryland suburbs. More than any other street in Washington, it is indicative of the character of a city set within a park. As it proceeds from downtown to uptown, its parameters of closely-packed buildings eventually give way to walls of trees, behind which can be detected a sequence of embassy residences, occasional stretches of forest, apartment buildings and private houses. In the summer, it forms a veritable tunnel of green in which to drive through the city.

While I had started to write about American architecture and urbanism in the history department at Georgetown University, encouraged by Dorothy Brown and Richard Duncan, my work on the American landscape started in earnest as a graduate student in architecture at Princeton. A course in urbanism with Georges Teyssot led me to question the origins of parkway design and the writing of "The American Parkways" mentioned above. Moreover, the writing of this book would not have happened without his solicitation and encouragement. A seminar in architectural theory with Anthony Vidler, also at Princeton, kindled my interest in the Hudson River School of painting. Additionally, an internship with Diana Agrest and Mario Gandelsonas and an apprenticeship with Michael Graves developed my understanding of architecture and its relation to the land as well as the place of nature in the city.

I have worked on this book in a number of places—Princeton, Washington, Rome, Florence, Chicago—and would like to acknowledge here the institutions which have allowed me the time, resources and equipment to produce it: The computer center at Princeton University, The Garden Library of Dumbarton Oaks in Washington, The American Academy in Rome, Syracuse University in Florence and the Chicago Institute for Architecture and Urbanism. In particular, my year as a Rome Prize Fellow in architecture gave me the opportunity to let my ideas gestate, even as I was studying Italian villas and palaces. At the Academy I was able to question my thoughts on the American landscape in fruitful moments of discussion with scholars and artists in other fields. I wish also to thank my family for their support and guidance in my endeavor, especially my father, Francis E. Zapatka of the American University in Washington, for his astute and invaluable editorial advice and my brother, Mark Zapatka of Dumbarton Oaks, for his help in locating and sending me essential source material.

Christian Zapatka
Chicago, September 1992
Ann Arbor, May 1995

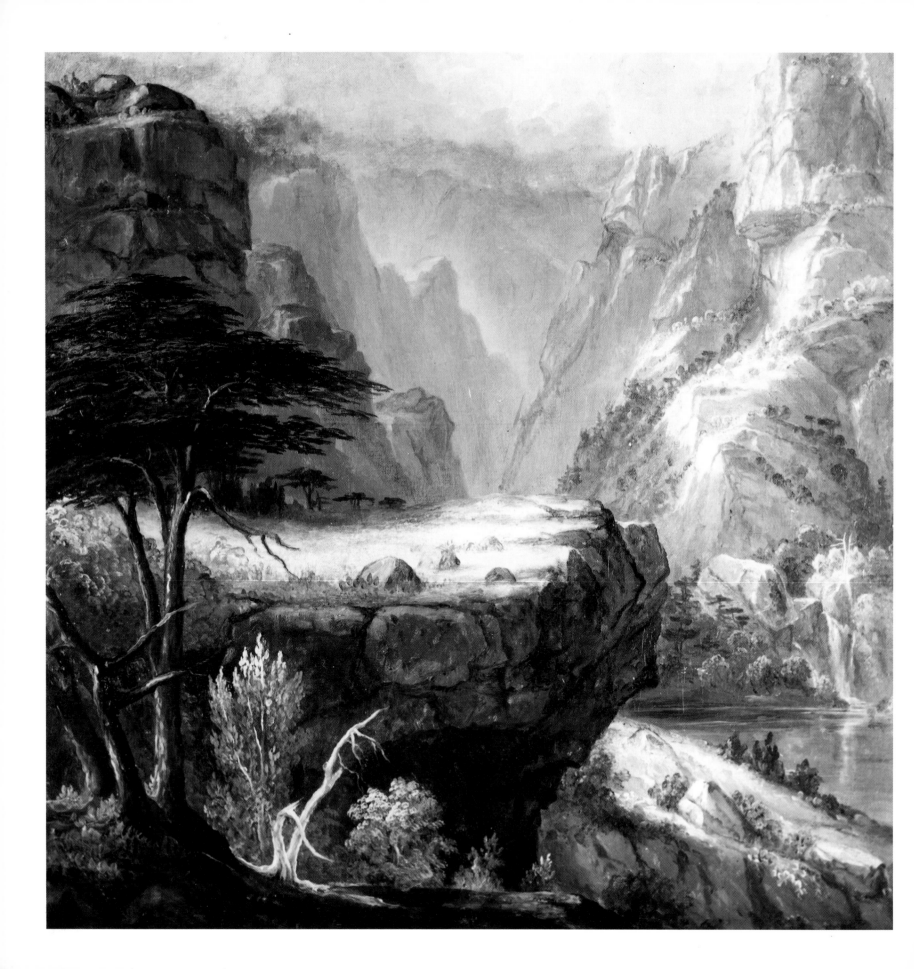

The Sublime
in the Wilderness

The Hudson River School of Painting; The Spectacle and Tourism of Niagara Falls; Thomas Cole and Frederic Church

"...I was filled with awe. The beauty and the wild sublimity of what I beheld almost seemed to crush my facilities... I felt as though I had been carried into the immediate presence of God..."
(Impression of a traveller in the Catskill Mountains in 1832)[1]

The group of mid-nineteenth century landscape painters known as the "Hudson River School" first made visible to an urban population, in both America and Europe, the extraordinary character of the American wilderness just north of New York City in the Hudson Valley. Within the space of two decades they had successfully established an image of the overwhelming force and potential of this new country's land.

Thomas Cole, "Mountain Scenery," oil on canvas, date unknown.

Thomas Cole: Voyages into the Sublime

The recording of the vast, wild landscapes of New York State by Thomas Cole and the Hudson River School seemed particularly appropriate to the young Republic. It provided an opportunity not only for the development of an American school of painting quite distinct from that of the Continental standard, but also a means of establishing a national image based on the celebration of natural phenomena indigenous to the country. This alternative to a controlled European sensibility in landscape painting manifested itself in the form of violent portrayals of nature, in which the infinite, the untamed and the uncharted were meant to be not only observed, but actually experienced. It also provided a catalyst upon which Americans could draw some sense of national pride and even a sense of cultural pride when they were feeling rather green by comparison to the Old World. Searching for the sublime, in the images of the American wilderness had, in fact, become a question of national pride. The enthusiasm with which this work was received in European salons can perhaps be seen as the first official outside recognition of what this young country possessed in natural resources.[2]

Cole had been inspired to portray fictional epic voyages, in which lessons of human progress and mortality were the subject and nature, the appropriate setting. He often chose a real landscape, but altered its natural light from painting to painting, as the backdrop for various series of allegorical paintings, upon which he created a fictional narrative. The subjects of these allegories seem completely at odds with what we might think appropriate subject material for an American painter of the early nineteenth century. The settings are often blurry, mock medieval environments with castles and draped figures lurking in shadows. It is as if images had come to Cole in mirage form as he contemplated the uninhabited but dramatic landscape. *The Departure and Return*, 1837, for example, depicts an anonymous

13

knight's fictional voyage to and from battle. The following passage is Cole's own description of this pair of paintings: "In the first picture, Morning, which I call The Departure, a dark and lofty castle stands on an eminence, embosomed in woods. The distance beyond is composed of cloud-capt mountains and cultivated lands, sloping down to the sea. In the foreground is a sculptured Madonna, by which passes a road, winding beneath ancient trees, and, crossing a stream by a Gothic bridge, conducting to the gate of the castle. From this gate has issued a troop of knights and soldiers in glittering armour: they are dashing down across the bridge and beneath the lofty trees, in the foreground; and the principal figure, who may be considered the Lord of the Castle, reins in his charger, and turns a look of pride and exultation at the castle of his fathers and his gallant retinue. He waves his sword, as though saluting some fair lady, who from battlement or window watches her lord's departure to the wars. The time is supposed to be early summer.

The second picture—The Return—is in early autumn. The spectator has his back to the castle. The sun is low: its yellow beams gild the pinnacles of an abbey, standing in a shadowy wood. The Madonna stands a short distance from the foreground, and identifies the scene. Near it, moving towards the castle, is a mournful procession; the lord is borne on a litter, dead or dying—his charger led behind—a single knight, and one or two attendants—all that war has spared of that goodly company."[3]

When Cole painted his celebrated allegorical series, *The Voyage of Life: Childhood, Youth, Manhood and Old Age* in 1840, it drew such an overwhelming degree of public admiration that the Reverend Gorham D. Abbott, director of the Spingler Institute in New York, which published a catalogue describing the paintings in conjunction with their exhibition, was moved to proclaim in lofty tones that: "The happy influence they were found to exert, by their silent, yet constant teaching, in exercising the imag-

ination, in cultivating and refining the taste, in moulding the sensibilities, and inspiring the soul with exalted and noble purposes of life, suggested the desireableness of extending their influence, especially among the youth of our country... The whole work, in its conception and execution, is strikingly characteristic of the American mind... The great charm and crowning glory of the series, are found in their pure moral tone and Christian sentiment..."[4]

In this series, Cole portrayed the life of a man from childhood to old age in a boat upon a background of different natural phenomena, suggestive of each stage of human development. Childhood is depicted as a journey on a protected stream; youth on a widening river; manhood on a tumultuous river and old age on a darkened lake. The prow of the boat that Man has taken on his voyage of life is shown in the last stage being drawn into a cave. Cole showed in this series that Man's early stage of wonder and discovery are only too quickly supplanted by the knowledge of reality and fear, and ultimately, resignation to mortality.

Perhaps the best known work of Thomas Cole is his allegory, *The Course of Empire*. In this series, he expanded upon the theme of an individual voyage through life, in which mortality is recognized through the discovery of the untameable forces of nature. In this case, he attempted to trace the whole course of civilization. The first painting, *The Savage, or Arcadian State*, is a wild landscape shown in the early light of dawn, with images of primitive huts, savage dances around fires and hunt scenes. The second painting, *The Arcadian, or Pastoral State*, includes vignettes of children learning to draw (upon newly-formed footbridges), an old man teaching himself the principles of geometry by drawing in the sand with a stick, and a primitive, yet monumental temple in the background. The time of day is late morning.

The third painting, which is the middle and largest

Thomas Cole, "The Departure," oil on canvas, 1837.

Thomas Cole, "The Return," oil on canvas, 1837.

in the series, is *The Consummation of Empire*. A fully-developed, perhaps overly-developed, imperial city has suddenly blossomed in full splendor upon the very shores that once cradled a blissful arcadia. Complete with a multitude of architectural styles, masses of people and foreboding signs predicting destruction (such as little boys sinking each other's toy boats in a pool upon a terrace in the foreground), this painting represents the precarious climax of a civilization that has grown too wealthy too quickly. The fourth and fifth paintings, *Destruction* and *Desolation*, show the fall of empire in gruesome detail during a late afternoon storm and, finally, the ruins of the destroyed empire overtaken by nature, subdued in a gloomy moonlight. Here, Cole showed that even the greatest empire, resplendent with the greatest fortifications, is still no match for the constant and infinite forces of nature that continue to reign even after civilization has managed to destroy itself.

While the paintings of the Hudson River School can be acknowledged as the first visually powerful representations of the American landscape,[5] it must be understood that they were only visible to a limited number of people in certain salons of New York and various European capitals, still shockingly new. It was in print that the intellectual notion of a huge wilderness began to be made a little more widespread, but even then, only available or intriguing to a relatively small and literate segment of the population concentrated in urban centers.

Writers such as Andrew Jackson Downing (1815–1852) and Frederick Law Olmsted (1822–1903) called for a national awareness of the resources and potential of the American landscape and recommended methods for appreciating and utilizing the land's resources. Andrew Jackson Downing's *Treatise on The Theory and Practice of Landscape Gardening Adapted to North America*, 1841, a veritable guidebook to the wilds of the Hudson River Valley, had inspired a number of wealthy New Yorkers to

Thomas Cole, "The Consummation of Empire," third in series, "The Course of Empire," oil on canvas, 1833–34.

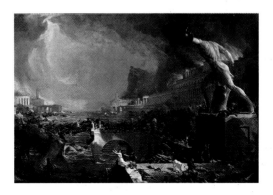

Thomas Cole, "Destruction," fourth in series, "The Course of Empire," oil on canvas, 1833–34.

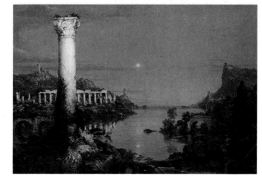

Thomas Cole, "Desolation," fifth in series, "The Course of Empire," oil on canvas, 1833–34.

consider inhabiting this land, during certain periods of the year, simply for the sake of pleasure.[6] Frederick Law Olmsted's addresses to organizations such as the American Social Science Association emphasized the healthful benefits that public parks could provide in urban centers.[7] Eventually, as master park builder for the city of New York, Olmsted would be able to carry out his goals of improving urban life by cleaning and reutilizing tracts of land that had been lying fallow within the boundaries of the city.

While the projects of Olmsted and Downing cannot be classified as attempts to make evident the sublime in American nature, they at least created conditions within which Americans accustomed to living in cities or on farms, could start to enjoy the benefits of nature without hazarding dangerous voyages into the actual wilderness. They made possible the use of a middle ground, between city and nature that was either within the confines of the city or in a position safely outside of the real wilderness.

But well before these oases of natural preserves were developed in the cities and along the tamer shores of the Hudson, there were already mass visitations to the furious waters at the head of the Hudson River. The American public could not be prevented from risking danger in order to see, for themselves, the glories of Niagara Falls that had been depicted so stirringly by Frederick Church's famous *Niagara* and a multitude of other paintings since the eighteenth century.

The Spectacle and Tourism of Niagara Falls

Frederick Church's painting of Niagara Falls, perhaps the prototypical image on canvas of the Hudson River School, can be credited with having been a strong inducement for visiting the Falls in the second half of the nineteenth century.

Accessibility by steamboat ferry to Niagara Falls generated an entire industry of tourism based solely on the viewing of one of the great spectacles of na-

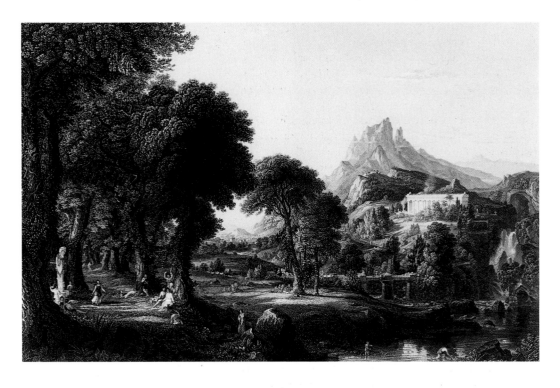

"Dream of Arcadia,"
engraved by James Smillie
after Thomas Cole, 1850.

ture. The well-established steamboat routes up the Hudson River from the port of New York terminated at one of a number of huge wooden frame hotels built precariously close to the edge of the Falls. Viewing platforms, strategically located along the perimeters of the Falls, provided a series of destinations for the visitors' daily itinerary. A sense of potential danger permeated the experience of the tourist on every level of such an excursion, from the possibility of fire on the crowded steamboat, to the potential shakiness of the viewing platforms. If such danger were not evident enough, the viewing of regularly-scheduled performances of tight-rope walkers across the Falls provided the possibility of a more directly understood danger.

A multitude of trinkets, postcards and stereoscopic photographs, all bearing the indelible print of the Falls in one fashion or another, could be bought as keepsakes to attest to one's reckless voyage to the Falls, a trophy to take home to the calmer regions of the rest of the East Coast. The image of the Falls, in their capacity to automatically conjure up notions of danger and triumph at once, also became the setting for monuments to bravery. A "Heroes' Memorial" in honor of the Union Army and Navy is recorded in a contemporary lithograph. A massive obelisk, poised before the Falls, it is surrounded by a low fence and framed by a rainbow. Tiny figures stand before it in wonder.[8]

Perhaps even more extraordinary than the scenes of the Falls in all of their great rushing force, were the scenes of the Falls frozen into outlandish formations of ice. Early photographs of the Falls and their attendant streams cloaked in white blankets rendered the landscape prehistoric. If the Americans of the early Republic were at a loss to give evidence of their country's culture to the rest of the world, they were at least able to adequately convey the magnitude of its natural features in paintings and photographs.

National pride in the American landscape, while tinged by sensationalism in the viewing of Niagara Falls, would appear again after the Civil War as a quest for conserving the purity of the Western landscape. The Rocky Mountain School of Painting, which recorded aspects of the land that would eventually be devoted to National Parks, restored the clarity of an American art form that gave cultural credence to the new nation.

[1] R. J. O'Brien, *The American Sublime, Landscape and Scenery of the Lower Hudson Valley*, Columbia University Press, New York, New York, 1981, pp. 175–177. I wish to thank Anthony Vidler for inspiring me to do research on the work of the Hudson River School of painting and the question of the sublime, in general. Much of this chapter is based on a paper I wrote under his guidance on Thomas Cole in 1987.

[2] Ibid., pp. 175–177. "The landscape itself provided an opportunity to induce emotion and sentiment for national political and cultural esteem... sublime landscape–whether painted or written was the most sought-after phenomenon: through its varied appeals to patriotism, a sense of fear and melancholy, and emotional and oral involvement, it became the preferred manner in which mountain and highland landforms were viewed."

[3] L. L. Noble, *The Life and Works of Thomas Cole*, edited by E. S. Vesell, Belknap Press of Harvard University Press, Cambridge, Mass., 1964, p. 182.

[4] The Reverend G. D. Abbott, *The Voyage of Life*, catalog published by the Spingler Institute, 7 Union Square, New York, New York, 1856, pp. 3–4.

[5] For a good review of American landscape painting before 1830 see the catalog by E. J. Nygren with B. Robertson, *Views and Visions, American Landscape Before 1830*, The Corcoran Gallery of Art, Washington, D.C., 1986. (contributions by A. R. W. Myers, T. O'Malley, E. C. Perry III, J. R. Stilgoe). An excellent source for the period from 1825–75 is Barbara Novak's *Nature and Culture*, Oxford University Press, New York and Toronto 1980.

[6] J. Ackerman, *The Villa*, Thames and Hudson, London, 1990, pp. 230–245.

[7] F. L. Olmsted, *Public Parks*, papers read before the American Social Science Center in 1870 and 1880, Brookline, Mass., 1902.

[8] Catalog entry 175, ("The Heroes' Memorial," lithograph, Buffalo and Erie County Historical Society, Buffalo, New York); J. E. Adamson, *Niagara, Two Centuries of Changing Attitudes, 1697–1901*, The Corcoran Gallery of Art, Washington, D.C., 1985. (essays by E. McKinsey, A. Runte, J. F. Sears).

Hudson River School

Arguably the first *American* painters, this group of mid-nineteenth-century artists working primarily out of New York City, along the Hudson River, attempted to represent the magnitude and beauty of the American wilderness. A Piranesian exaggeration of scale and shocking color schemes, which can be understood as devices for attempting to represent the sublime, characterize their work. Thomas Cole and Frederic Church are the two most celebrated of the school. Their canvases can also be seen as early promotional pieces for visiting the open landscapes of America.

"Up the Hudson on a Steamboat," photograph showing the New Jersey Palisades in the distance, circa 1900.

"The Palisades," steel engravings from Nathaniel P. Willis, "American Scenery," Volume One, circa 1840, designed by William Henry Bartlett.

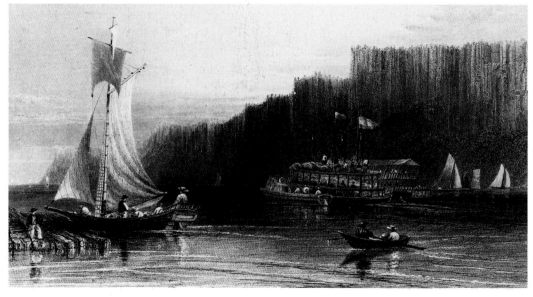

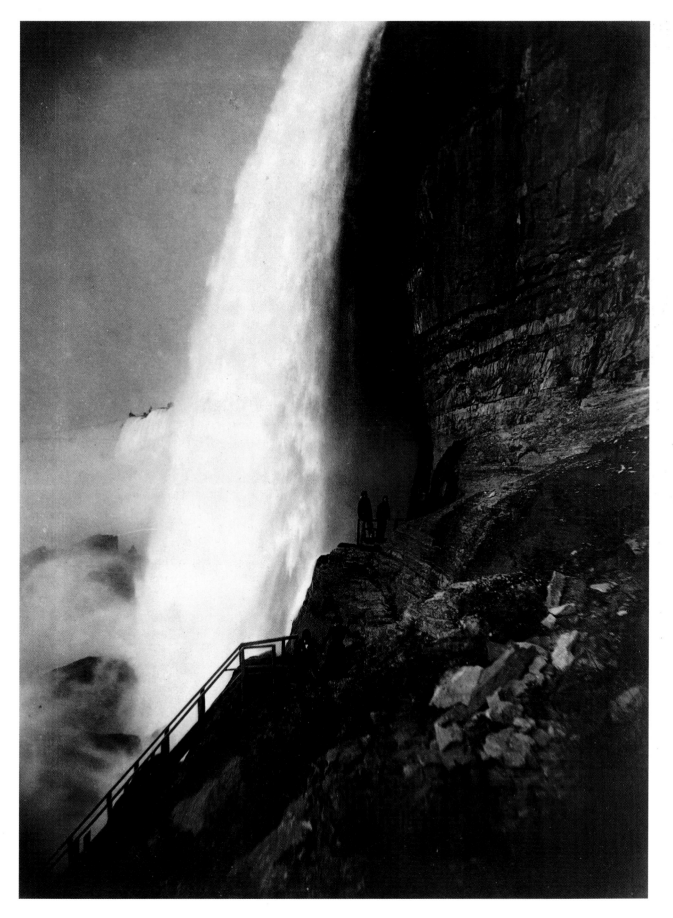

Niagara Falls

The most frequently painted and inspirational of subjects for the Hudson River School of painters, Niagara had become an exceptionally popular destination for tourists by the end of the nineteenth century. Visitors were drawn to the site not only by its breathtaking beauty but to witness the potential danger that could be wrought by the force of nature. Here were to be seen a multitude of circus-like spectacles of daring and bravery. The depiction of the Falls quickly became commercial with the advent of photography and provided the area with a cottage industry of souvenir production.

"Cave of the Winds. Niagara Falls," 1888.

Frederic Church, "Niagara Falls," oil on canvas, 1857.

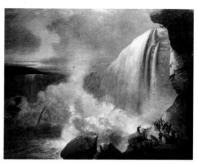

"Blondin Crossing Niagara Falls on a Tightrope," unidentified artist, oil on canvas, circa 1859–60.

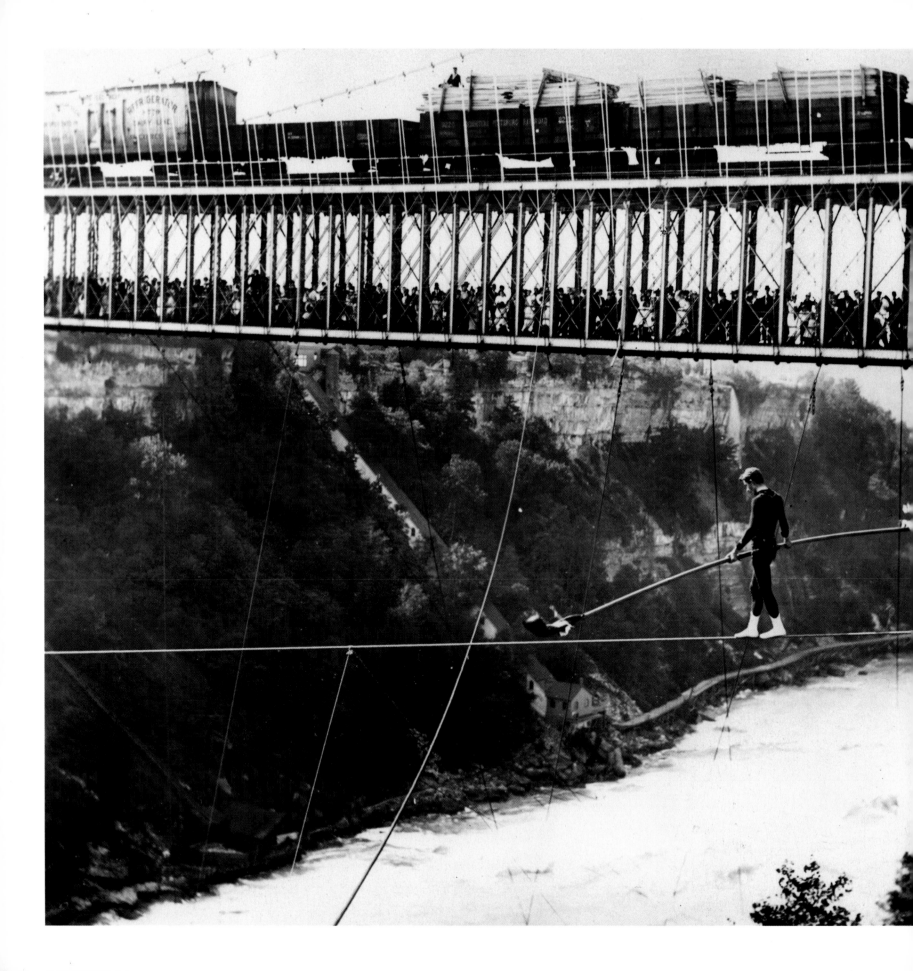

"Clifford Calverly Tightrope
Walking Over Niagara
Falls," July 4, 1893.

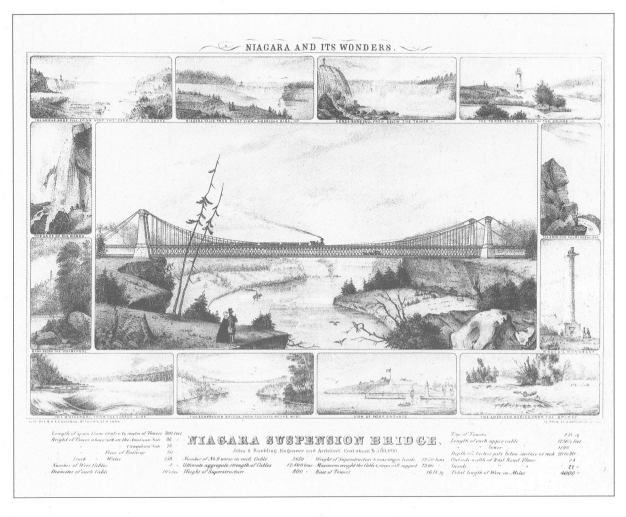

"Niagara Suspension Bridge,
John A. Roebling, Engineer
and Architect. Cost: about
$ 500,000," lithograph
by E. B. and E. C. Kellogg,
published by D.M. Dewey,
circa 1900.

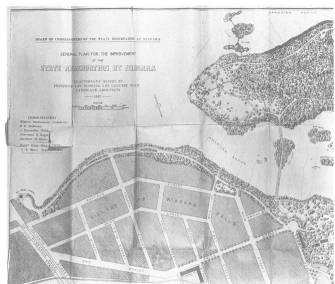

General Plan for the
Improvement of the State
Reservation at Niagara,
Frederick Law Olmsted
and Calvert Vaux, 1887.

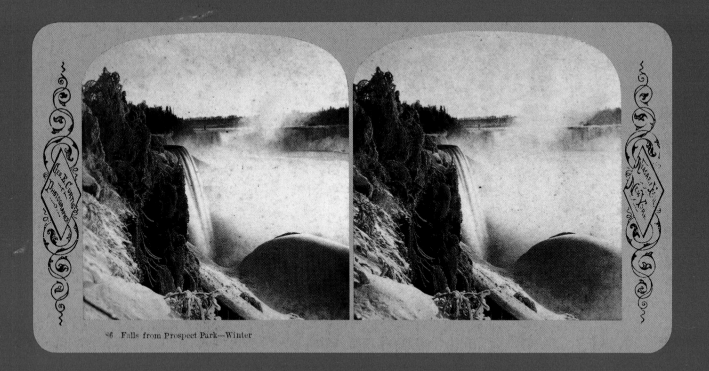

6 Falls from Prospect Park—Winter

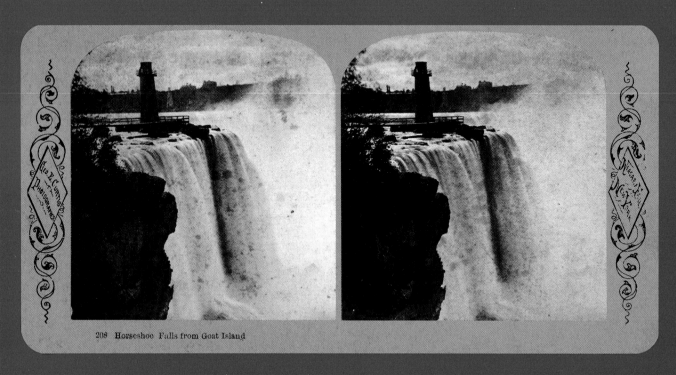

208 Horseshoe Falls from Goat Island

Stereoscopic photographs of Niagara
Falls, circa 1890.

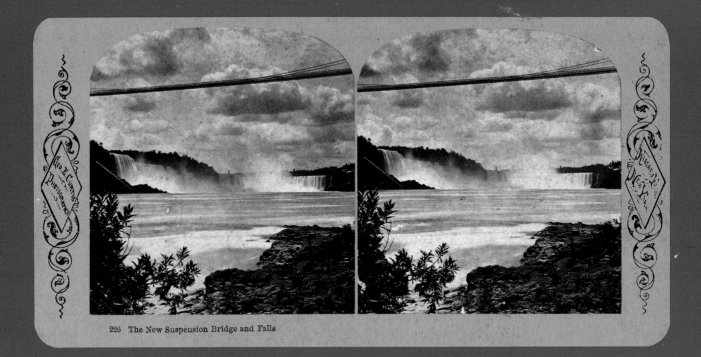

226 The New Suspension Bridge and Falls

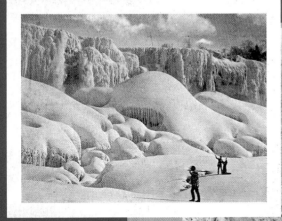

Niagara Falls
in Winter,
postcard,
circa 1910.

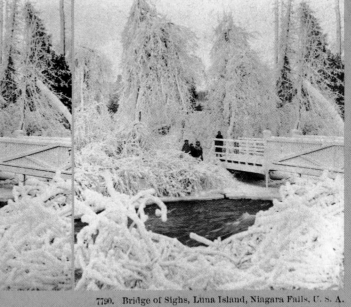

7790. Bridge of Sighs, Luna Island, Niagara Falls, U. S. A.

Copyright 1898, by B. W. Kilburn.

PHOTOGRAPHIC STEREOSCOPIC
VIEWS OF THE FALLS.

Niagara Falls, showing a
kiosk for photographing
stereoscopic views of the
Falls, circa 1890.

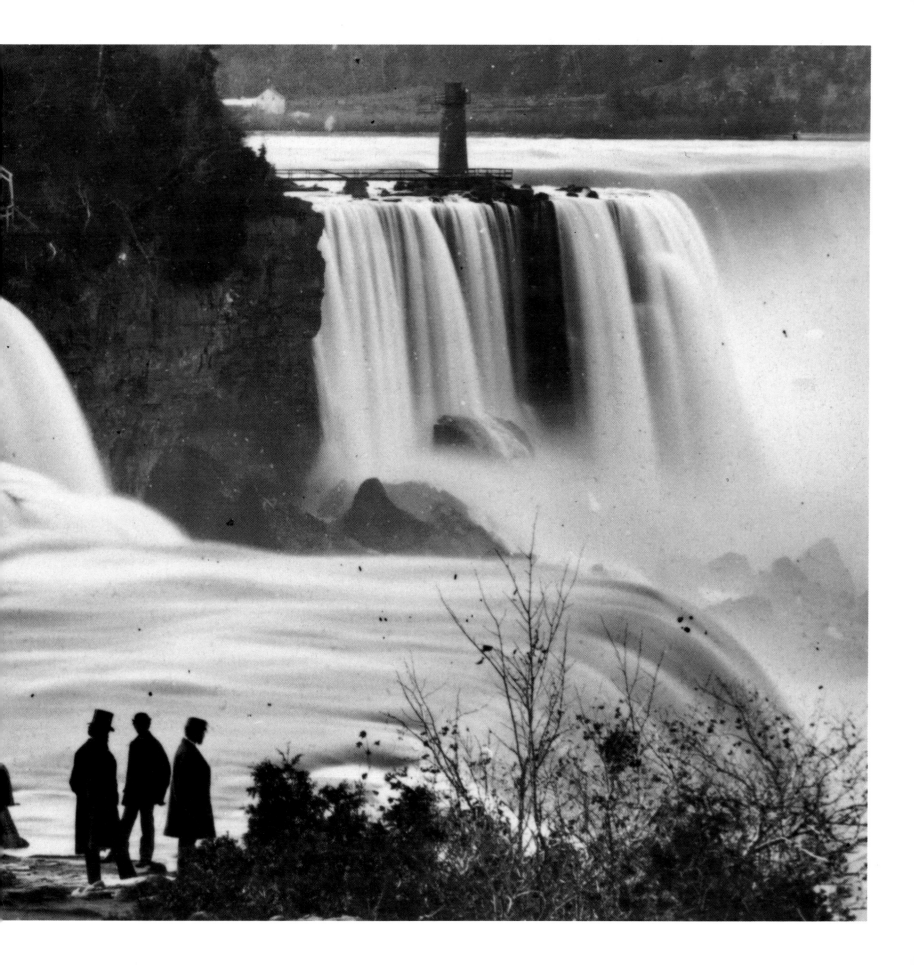

Andrew Haswell Green's
New York City Plan of 1868.

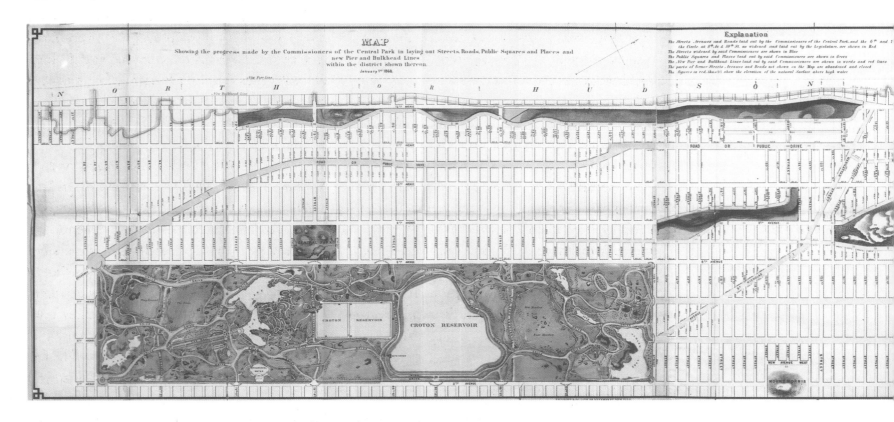

Pastoral Reserves of the Nineteenth-Century City
Frederick Law Olmsted,
Calvert Vaux, Charles Eliot
and Daniel Burnham

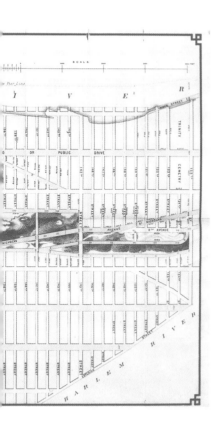

The great urban parks of the nineteenth century, as planned by Frederick Law Olmsted, Calvert Vaux and Charles Eliot, were designed first and foremost to benefit the moral and physical health of the population.[1] With the transformation of wastelands, which formerly isolated one part of the city from another, into public parks, city dwellers were given the opportunity to take fresh air and exercise on a regular basis. The tangential development of paved, tree-lined streets with separate lanes for pedestrians and vehicles, known as "Park-Ways," would make the walk to the parks safe and agreeable.[2]

The new parks and parkways became settings in which it was possible for individuals and families to spend an entire day, engaging in such activities as strolling, bicycling, horseback riding, picnicking and boating. Field houses served as indoor retreats in which to rest and organize park events. These daytime shelters became localized centers of an emerging culture of pleasure seekers reliant upon the resources of urban parks.

In the midwest, cities such as Detroit and Chicago also received great public parks in the second half of the nineteenth century. There, too, much of the initial motivation for such work was grounded in the conviction that it was essential to the well-being of the inhabitants of industrialized cities to have ready access to the benefits of public parks. In Chicago, the lingering repercussions of the World's Columbian Exposition of 1893 formed the groundwork for elaborate city-wide plans to restore the character of the city to a state consistent with its motto, "Urbs in Horto," a "City Set in a Garden."[3] Aside from the obvious advantages that large parks provided the residents of cities at this time, it is also evident, from examining the documentation of such work, in the form of drawings, photographs and written accounts, that these projects contributed to a successful urbanization of the American city.[4]

Along with the subsequent founding of residential parks built on the fringes of cities, also frequently on the sites of former wastelands, the activity of late nineteenth century park building induced the form of the American city into the form of the American metropolis at the turn-of-the-century.

Central Park, New York

The immense park that was completed for New York by Frederick Law Olmsted and Calvert Vaux in 1868 was not at the center of the city.[5] It was north of the urbanized sector of the early metropolis. Contemporary aerial perspective drawings show the geography of the park in relation to the rest of the city quite clearly. To the north, east and west of the park there were no orderly rows of houses forming city blocks. There were only random rustic structures, the remains of former farms, and a few lone urban buildings. The genius of Olmsted and Vaux's plan was in its vastness and its foresight to have anticipated the future growth of the city into the northern regions. This was what would make the plan manifest itself as the "world's first great

27

public park."[6] Already planned as an iron grid in regional maps by the middle of the century, the city of New York followed its expected course of growth and, within a matter of decades, rows of buildings had engulfed the grid.

Once demarcated, the boundaries of the park were inviolable. Its size assured, forever, a natural oasis in a city destined to grow to enormous proportions. Olmsted and Vaux's plan, submitted in the competition for the park in 1858, had been anonymously signed, "Greensward."[7] Given the essential character of the park as a giant lawn set down in the middle of the city, it seems a fitting title.

Olmsted and Vaux approached the problem of creating the park in almost exclusively pragmatic terms. Although the design of the park conforms to the expected precepts of Romantic landscape design prevalent at the time,[8] its realization as a natural preserve in the middle of the city relied more on practical aspects of earth moving, land gradation and drainage than design manipulations more typically found within the realm of drawing. It took ten years, with the labor of thousands of men,[9] to make what had once been unusable marshland into a near fictional scene of rolling meadows and clear bodies of water, the potential pastoral retreat for millions of city-dwellers. Along with an impressive array of day-time park structures such as refectories, boathouses and belvederes, the park's natural benefits drew thousands of New Yorkers to its acres on a daily basis through the rest of the nineteenth century and well into the twentieth.[10]

Despite being faced with the presence of natural obstacles in the planning of the park, such as two large receiving reservoirs,[11] Olmsted and Vaux managed to take advantage of some existing topographical conditions in order to create local features within the park, some of which eventually appeared as microcosms of the whole. The "Ramble," for instance, a small forest planted around remnants of Manhattan schist, the remains of an ancient mountain range, featured a set of belvederes on the outcroppings of rock. This miniature forest and its attendant belvederes referred, at a reduced scale, to the extensive acreage of the whole park in relation to its principal Belvedere on Vista Rock, the highest point of the park.

While the small belvederes in the Ramble were designed of wood in a rustic manner, the large Belvedere, commanding sweeping views of the park, was designed by Calvert Vaux in rough stone as a mock medieval castle, a folly reminiscent of English Romantic garden design. For the Ramble, Olmsted introduced horticultural variety with the planting of exotic trees and shrubbery. None of the original plantings survive, but the intended picturesque quality is preserved with the density of the forest.[12]

In contrast to the informal character of the Ramble, the Bethesda Fountain and Terrace and the Mall, all approximately at the center of the park, are formal architectural elements imposed on the land.[13] The Bethesda Fountain and Terrace appear in contemporary aerial views as the nucleus of the man-made environment of the park. Designed by Calvert Vaux, the surfaces of its Romanesque-style walls and parapets are laden with elaborate details carved into sandstone panels. Dominating the Terrace on one side is a bronze sculpture called *The Angel of the Waters*. Cast by Emma Stebbins, an American sculptor living in Rome at the time, the statue gives the fountain and terrace its name. The statue refers to a story in John's Gospel about the healing power of a body of water in Jerusalem made miraculous by an angel's visit. Four putti representing Temperance, Purity, Health and Peace are positioned below the angel.[14]

The Mall, one thousand, two hundred and twelve feet long and bordered by three hundred American Elm trees, is the one formal element in the park that can be compared to the design of any number of smaller American parks of the period. Since the eighteenth century, American towns and cities fea-

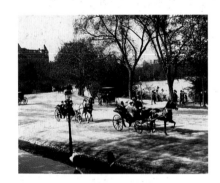

Driving in Central Park, circa 1900–05.

Regions of dismal, unhealthful swamps and impenetrable bogs had to be drained by the Park's architects, 1860.

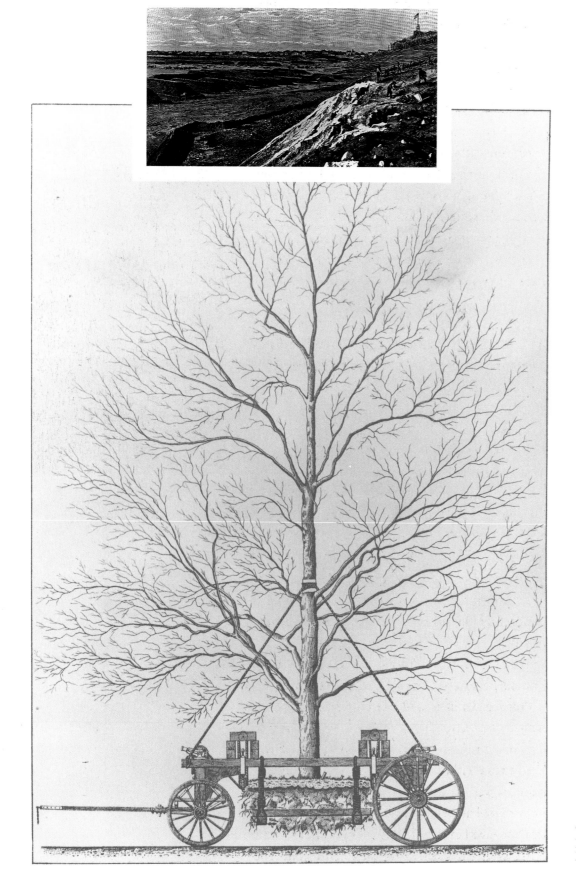

Construction of Prospect
Park, Brooklyn, 1868.

Tree moving machine,
Prospect Park, Brooklyn,
lithograph, circa 1870.

tured central "Greens" that were frequently lined with trees in this manner. This Mall was the most extreme version of such a "vernacular" design. It is also a version of a "Park-Way," the design idea that Olmsted and Vaux would develop afterwards as a means of linking city parks to city neighborhoods. The Mall was connected to the Bethesda Fountain and Terrace by an underground arcade and from the Terrace it was possible to hire a small boat in which to explore the lake. These three formal elements of the park could thus be experienced in conjunction with one another, a zone in which park visitors could avail themselves of a predetermined route for strolling, the by-ways of which also provided the chance encounter with other strollers.

In addition to the pedestrian promenades of the Mall and Bethesda Terrace, there were planned drives such as Cherry Hill Concourse for horses and horse-drawn carriages. Many of these original drives were access roads across the park, unimpeded by cross traffic, which was carried overhead on bridges. One of the first instances of the use of such a device for controlling traffic routes, such overpasses would later become instrumental in Olmsted's suburban parkway planning.

The entire effect of the park is one of providing a seemingly endless natural setting. Its pedestrian and vehicular courses are continuously manipulated by subtle changes in land formation, screens of foliage and abrupt turns in paths. Thus the wanderer is led on a journey that seems longer than it actually is due to a continuously changing panorama of individual vistas provided by such conceits. In its great size and multitude of shifts in topography, the park can be perceived as a series of landscape scenes simply to be viewed, as well as a park in which to enter and enjoy the natural forms found there.

Prospect Park, Brooklyn

The planning of Prospect Park, primarily by Calvert Vaux, but with some consultation from Olmsted,

who had been in California at the time, was based quite simply on the provision of three elements— "turf, wood and water."[15] Unlike Central Park in Manhattan, Brooklyn's Prospect Park did not have a regular shape carved out of a wasteland and bounded by the outlines of a projected iron grid. It was formed from land lying within a network of existing, non-orthogonal streets, initially bisected by Flatbush Avenue. An early plan shows this first condition while a subsequent one shows the avenue subsumed within the park as an alley of trees. The final plan is one of a park with meandering boundaries, free of any constraints that might have been imposed by pre-existing streets.

Of the five hundred and twenty-six acres of which the park is composed, Vaux and Olmsted determined, in their plan of 1866, that it should be divided into three distinct areas, one an extensive meadow, one an area of hills and one, the precinct of a large lake.[16] Often acknowleged as the masterpiece of Olmsted and Vaux's work, the design of Prospect Park was perhaps most successful in its judicious use of "berms," mounds of earth that form natural borders between the city's hard edges and the park's natural terrain.[17] This device was used to fully encircle the park and thereby make of it a preserve within the city. It is a good example of one of Olmsted and Vaux's pragmatic measures enhancing and making permanent, at the level of topographic section, an otherwise disarmingly simple park plan.

The overpasses first introduced in Central Park to separate pedestrians from vehicular traffic are used in Prospect Park, as well. Here, the clever manipulation of topography to separate types of traffic also creates tunnels which serve as portals to different districts within the park. Endale Arch, for example, serves as an overpass to separate conflicting paths as well as an entry into the Long Meadow, an area perceived of as brilliantly-lit by contrast to the darkness of the tunnel that the Arch forms. The

Pruning ladder, Prospect Park, lithograph, circa 1870.

31

plan of the Long Meadow is in the form of a crescent whose end cannot be perceived upon entering the Meadow from Endale Arch. It is a solution which makes the Meadow's seventy-five acres, contrived out of a swampy low-lying portion of land, appear bigger than they actually are.[18]

The Ravine is the middle zone of the park. It preserves the natural contours of the hilly site which is the remnant of a glacier. As with the Ramble in Central Park, this wooded area, well-insulated from the city, was replete with simple structures atop its various ridges. In characteristic Olmsted fashion, any necessary infrastructure was disguised in the form of existing rocks and boulders. The parapets of a bridge in the Ravine, for example, are simply a series of small boulders which appear to be the continuation of a rock-lined path. Another overpass in the park, which carried carriage traffic overhead while serving as a portal to another part of the park, is the triple Nethermead Arch designed by Calvert Vaux. A three-arched bridge, spanning a bridle path, a brook and a pedestrian path, it separated the Ravine from the Lake.[19] The Concert Grove, like the Bethesda Fountain and Terrace in Central Park, is the single formal element of architecture in Prospect Park. Composed of an amphitheater, a terrace for listeners and a concourse for those who wanted to attend concerts without alighting from their carriages, the Grove served as a point of assembly in a park that was otherwise more conducive to individual forays into pastoral settings.[20]

The Lake in Prospect Park, covering sixty acres, was deliberately planned by Olmsted and Vaux to be four times the size of the lake in Central Park as ice-skating had proved to become a very popular winter sport at this time. Its irregular profile, following the outlines of a swampy region that had been flooded and levelled by the edge of the Wisconsin Glacier, was deemed by Olmsted and Vaux as particularly ideal for the intended bucolic character of Prospect Park.[21]

Eastern "Park-Way," Brooklyn

In 1868, Olmsted and Vaux, in their capacity as landscape architects and superintendents for Prospect Park, issued a report to the President of the Park's Board of Commissioners.[22] In it, they called attention to the fact that, while the presence of Prospect Park was increasingly being recognized as a distinct advantage to the citizens of Brooklyn, there was an embarrassing lack of a corresponding system of roads leading to it. They saw the park as a magnificent natural reserve, but with no clear boundaries or approaches to distinguish its presence among the narrow city streets. In their recommendation for an appropriate "scheme of routes of approach to and extension from the Park..."[23] Olmsted and Vaux admitted that they were proposing a large project, but a necessary one for the growth of the city. In assessing the state of the American city, they observed that: "The present street arrangements of every large town will, at no very distant day, require not to be set aside, but to be supplemented by a series of ways designed with express reference to the pleasure with which they may be used for walking, riding and the driving of carriages..."[24]

For the immediate need to provide pedestrian and vehicular access to Prospect Park, Olmsted and Vaux proposed their seminal plan for the "Eastern Park-Way." They cited models such as the Avenue de l'Impératrice in Paris, which "connects a palace and a pleasure ground within the town" and Unter den Linden in Berlin, which "leads likewise from a palace and palace grounds, to a great rural park on the opposite side of town,"[25] and then called for a plan which would: "Provide for each of the several requirements which we have thus far examined, giving access for the purposes of ordinary traffic to all the houses that front upon it, offering a special road for driving and riding without turning commercial vehicles from the right of way, and furnishing ample public walks, with room for seats, and with borders of turf in which trees may grow of the most stately

character."[26] Olmsted and Vaux maintained that by running a thin extension of Prospect Park through the residential neighborhoods immediately preceding the park, substantial benefit could be provided to the health of the citizens of Brooklyn. They even envisioned the possibility of "detached villas, each set in the middle of a small, private garden" fronting the parkway as an alternative to the "unwholesome fashion of packing dwelling-houses closely in blocks."[27]

The Eastern Park-Way thrived as an urban park promenade through the end of the nineteenth century and eventually adapted itself to the twentieth century by offering access to the subway system at points along the pedestrian walkways.

Riverside Park, New York

In 1873, Olmsted was asked by the Park Commissioners to resolve a problem that had beset them concerning the appropriate treatment of a linear area of green along the Hudson River between 72nd Street and 123rd Street and the winding boulevard that bordered it, Riverside Avenue. Designated by them as a park in 1865, before anything had been built alongside it in the extension of the iron grid plan of Manhattan, the Commissioners were concerned that this outpost of the city should eventually become a desirable residential neighborhood.[28] Olmsted, after assessing the situation, swiftly and decisively proposed that the thin strip of land and its adjacent Avenue should simply be combined into one entity.[29] As obvious a solution as this may seem today, it must be remembered that at the time, the concept of making a city street serve as a park was quite novel. It had only just been developed as an idea in Brooklyn a few years earlier in the form of the Eastern Parkway. Olmsted, well-armed with the recent success of the Eastern Park-Way, managed to design a convincing and valuable linear park for Upper Manhattan.

The segment of green available was a deviant in shape by comparison to the iron grid plan that it bordered. Its advantage, however, was its salubrious location high above the Hudson River and the references that could be drawn between any new townhouses built along its borders and the previous villas that used to occupy the area. Riverside Park and Drive, once fully graded and planted, became yet another credit to Olmsted as a designer of city parks and parkways. Even the new curvilinear apartment houses built adjacent to the townhouses were able to incorporate in their form the grace and elegance of the sinuous tree-lined Avenue they were built upon. The subsequent building of the monumental tomb to General Grant at the head of the Park in 1892, while serving as a striking landmark, annoyed Olmsted in the association made between the dead and the pastoral park. He remarked at the time: "It is a very fine site for a public monument. But it will be extremely unfortunate if... the remains of the dead are brought into close association with the gaiety of the Promenade at this culminating point."[30]

Morningside Park, New York

At the same time that Olmsted had been approached by the Park Commissioners of New York about the Riverside Park Proposal, he was asked to create a park out of the barest, rockiest spot on the island of Manhattan, the ledge between Morningside Heights and the Harlem Plain known as the Manhattan Ridge. Too impenetrable to be overlaid with street patterns of the iron grid, the site was deemed suitable only for a park. Working with Jacob Wrey Mould, the architect who assisted Calvert Vaux with the construction of buildings in Central Park, Olmsted graded the site into three terraces while Mould provided a massive buttressing system to suspend Morningside Drive along the edge of the new park.[31]

Olmsted had decided to make this a park of views into the distance.[32] There are no sequential series of

natural guidelines that carry the visitor into the depths of a sylvan wonderland. Here, the barren character of the outpost is maintained. The only concessions to park design are a series of ponderous stone ramparts that support lookout platforms. There is but a meager degree of pastoral sanctuary provided by this rocky cliff, poised between the heights of the Upper West Side and the urban plains stretching to the East River. Rather than suggesting to the visitor a communion with nature, its character more aptly allows for the indulgence of a melancholic stroll along a lonely precipice at the edge of the city.

The Emerald Necklace, Boston, Massachusetts

One of the grandest schemes for a comprehensive urban park and parkway system was realized when the Olmsted firm joined efforts with those of the Boston landscape architect, Charles Eliot at the end of the nineteenth century. Between 1894 and 1902, the firms of Olmsted and Eliot produced the phenomenon known as "The Emerald Necklace," which encircled the city of Boston with an unbroken chain of parks and parkways.[33] Starting from the old Common, a path of green was extended into the newly formed Back Bay, ran along the dual axis of Commonwealth Avenue and the Charles River bank, entered the Back Bay fens and finally emptied into the natural reserve of Franklin Park.

The narrow links connecting the major parks, which were not quite parks in and of themselves, but not just streets, either, became known as "ribbon parks" and were given names such as "Arborway," "Jamaicaway," "Riverway," "Fenway."[34]

Olmsted's and Eliot's vision resulted in a system which opened up the new parts of the city and tied them back to the old, forming a continuous pedestrian and vehicular park promenade, largely over areas that had once been nothing but swamps and muddy river banks.

Park benches and drinking fountain, Franklin Park, Boston circa 1900.

Franklin Park, Boston, Massachusetts

If New York's Central and Prospect Parks were extraordinary achievements in harnessing unused or fallow land in the city for the purpose of the enjoyment of New Yorkers, the intent of Franklin Park was to provide not just an urban park for the citizens of Boston but unspoiled, farm-like scenery at the edge of the city.[35] The principal attraction of Franklin Park, the one square mile terminus of the Emerald Necklace, was its preserve of natural land insulated from the normal accretions of man-made elements that are typically found in urban parks. After having planned most of the parks of New York, Olmsted was well aware of the inevitable accumulation of objects that begin to fill a city park.[36]

In his plan for Franklin Park, Olmsted's crucial gesture was to set aside an entire part of the land solely for the purpose of containing the standard non-pastoral aspects of an urban park, such as statuary, concession stands, exotic plants, a zoo and a formal promenade. This part of the park was named "The Ante Park." The remainder of the land, separated from the Ante Park by a dense screen of shrubs and trees, as well as a sunken road, was dubbed the "Country Park."[37] Hence, it was made possible, within the boundaries of the city of Boston, to experience a natural reserve completely unmarked by signs of urban life.

Olmsted argued in his proposal, "Notes on the Plan of Franklin Park" that city life was harmful to the spirit as well as the health of the population. He wrote: "A man's eyes cannot be as much occupied as they are in large cities by artificial things, or by natural things seen under obviously artificial conditions, without a harmful effect, first on his mental and nervous system and ultimately, on his entire constitutional organization."[38]

Contemporary photographs of Franklin Park show a pastoral setting that appears to be very far from the city. Olmsted's requirements for the scenery were stated in the following decree: "Open views will be had between simple bodies of forest... from wherever these larger prospects open, the middle distances will be quiet, slightly hollowed surfaces of turf or buskets, bracken, sweet-fern, or mosses, the backgrounds formed by woodsides of a soft, even, subdued tone, with long graceful, undulating sky-lines, which, according to the point of view of the observers of the Park, will be from one to five miles away."[39]

The only landscape work done in this area was the removal of field rock and low-lying brush in forested areas. Paths were discretely blended into the topography of the land.[40]

Olmsted, impressed with the aspect of the land in West Roxbury, called for it to be preserved as a "country park" in his initial assessment of available land for parks in Boston in the 1880s. In an 1881 report, he remarked on the suitability of the site: "lovely dales gently winding between low wooded slopes... broad expanses of unbroken turf, lost in the distance under scattered trees."[41] He believed that this site would be particularly appropriate as the terminal reservoir for the Emerald Necklace park system. Its name, Franklin Park, was given in honor of its distant benefactor, Benjamin Franklin, who had bequeathed funds to the city of Boston for civic purposes.[42]

The plans having been officially approved in 1886, the park was opened in the 1890s. The park typically drew crowds of 11,000 on a Sunday.[43] They came to picnic, participate in field games and enjoy the rural scenery. Any organized activities that required indoor shelters were conducted in the Ante Park in order to leave the scenery of the Country Park untarnished.

A series of photographs taken in 1903 are testament to the success of the concept of a rural park unintruded upon by man-made objects. One shows a bench made of narrow wooden planks supported by a set of small boulders hugging the edge of a hillock. The other shows a pile of small boulders in

which there is an opening. Upon close inspection, it is evident that the formation is in fact a water fountain. Both photographs show situations in which the necessities of urban parks are blended into the setting in such a naturalistic manner that they appear to be a part of the landscape. Another pair of photographs from the same era show two park structures. One, a large neoclassical structure with an upper level loggia, built on a flat expanse of pavement, is identified as a refectory. It seems likely that such a building was to be found in the Ante Park. The other, possibly a superintendent's house, shows a structure resembling a prairie house. It is built amid sizable boulders and lies low to the ground, its eaves stretching over the rocks. This surely must have been intended for the Country Park. A photograph of a library, also a vaguely neoclassical edifice built on a slope among trees, is appropriately located in the Ante Park. Finally, a photograph of scores of lawn tennis courts shows one type of park activity permissable in the Country Park. Perhaps the one feature of the Country Park of Franklin Park that was the most telling of a rural setting was the dairy farm. It was an actual working farm that was to provide, as Olmsted pointed out, "the necessities of picnic parties... to supply to all a few simple refreshments such as are to be recommended for children and invalids... fresh dairy products of the best quality."[44]

If the merit of Franklin Park can be measured in terms of its frequent usage, its position as the repository of the Emerald Necklace points to an even greater impact that the overall park and parkway system had on the people of Boston. In Boston, the connections between the parks were of equal importance as the actual park reserves and in some cases, more desirable, as they were more accessible to more people, given their linear expanses. So successful were Olmsted and Eliot in promoting the desirability of parkways that problems arose in city legislation when it appeared that one part of the city was benefitting from the existence of a parkway system built with metropolitan funds while another area was suffering due to the lack of such a system. In his book, *Landscape Architect*, Eliot demonstrated a concern for the equitable distribution of forest reserves for the construction of parkways. Describing what he termed, "the parkway problem complex"[45] in Boston, Eliot made it clear that: "The south side of the metropolitan district has already provided itself with numerous, modern, broad highways and parkways, while the north side of the district has as yet provided itself with none. The result is that expenditures made in the southern section of the district naturally produce more striking results than can be hoped for in the northern section... expenditures already made by the commission on the south side of the city are justifiable on the ground that they do secure the greatest good of the greatest number, the expenditures for north-side parkways are by no means as clearly equitable..."[46]

In response to this problem, the boulevard act of 1894 was enacted in order to control parkway building in Boston and provide for the monitoring of such by a metropolitan park commission.[47]

In a note of concern for the recreation of the urban working classes, Eliot also called for the connection of the city center to outlying forest reserves with electric car lines that would "afford rapid and pleasant transit to the reservations for the masses," and that would be fully as important as the pleasure driveways."[48]

Belle Isle, Detroit, Michigan

Detroit's legendary park, Belle Isle, was at one time considered one of the most spectacular American parks at the end of the nineteenth century. Since the early nineteenth century the island had been visited by the citizens of Detroit seeking a respite from the city in nature. It was given its name on the occasion of an outing in 1845 in honor of the many young ladies who made the trip by boat to the island.[49] By the

1870s, the landscape design firm of Frederick Law Olmsted had been commissioned to improve the island so as to make it officially part of the city of Detroit's public park system. Olmsted's plans provided not only for a system of woodland drives, artificial canals, lakes and formal boulevards, but a series of structures that gave the whole island a character of being a permanent, occupiable appendage to the city.[50]

One of the most striking aspects of Belle Isle was its approach from Detroit by a grand and ceremonial bridge. Initially, a timber and steel truss bridge was built in 1889 to connect Belle Isle to the city of Detroit. Before this, picknickers were transported to the island by boat. The timber planking was largely destroyed in 1915 by a fire, which also resulted in the collapse of the steel superstructure.[51] In 1918, a proposal was made by the Belle Isle Bridge Division of Engineering and Construction for a much larger and more decorative bridge to be built as an essential link in the overall park system of Detroit.

Built of solid concrete piers holding up a bridge floor of reinforced concrete, it extended outwards across the lake from East Grand Boulevard at the edge of a fashionable residential district.[52] This point was highly visible from the city of Detroit as well as the Canadian border and was lined on both sides by large houses with well-kept gardens. The width of the bridge was fifty-nine feet in the center for two lanes of automobile traffic in each direction. There were also two twelve foot wide pedestrian lanes at the outer edges. The access to the bridge started eight hundred feet in from the Detroit side with a vehicular underpass that carried automobile traffic under the cross traffic of Jefferson Avenue before reaching the actual bridge.[53]

A guidebook to the park published in the 1890s contains descriptions of its topography and special features that makes it clear that it was considered one of the great urban parks of the period. As an island, its rustic character must have been well protected from many urban encroachments. Topographic and design plans prepared by the Olmsted firm, as well as contemporary photographic views of the island depict an idyllic and remote retreat composed of highly planned yet very natural elements suitable to the requirements of a park used for daytime excursions. Woodland drives for cyclists and pedestrians alike, canals for rowboats, and formal boulevards planted with endless flower beds must indeed have been the locus for many a city dweller seeking another worldly haven.

The park also contained a well-established system for temporarily housing, regulating and surveying a multitudinous and daily rotating population of pleasure-seekers. The 1890s guidebook describes not only the supply of water available to the visitor for amusement, but the bathhouses and boathouses that served as station points from which to properly take advantage of such a situation: "There is water everywhere—water for drinking, bathing, rowing, sailing and wading—all free. The bath houses contain scores of bath rooms, with hundreds of bathing suits for both men and women, with lockers for clothing and plenty of clean towels. The water in the canals and lakes is only from one and one-half to two and one-half feet deep, so there is little danger. The two boat-houses have an almost unlimited supply of fine new boats to let."[54]

Other structures in the park included a refectory for indoor picnics, a bicycle pavilion, a skating pavilion, a planetarium, an aquarium and a police station. All of these attractions and signs of civilization in the woods contributed to a park environment that can no longer be experienced in the same way in the late twentieth century. The atmosphere of Belle Isle in its heyday was characterized by a moderate and controlled approach to enjoying nature. The park was within the confines of the city, yet outside of it, seemingly in the wilderness yet subject to the mores of a localized infrastructure of control. It seems worthwhile here to invoke the distant memory of

this rural/urban park at the end of the nineteenth century on the shores of Lake Saint Clair as a potent example of a "heterotopia," Michel Foucault's term for describing a region outside the bounds of normal civilization yet controlled by its own system of governance, whether actual or merely implied.[55]

The Chicago Waterfront, Chicago, Illinois
In 1908, the Commercial Club of Chicago commissioned the architects Daniel Burnham and Edward Bennett to prepare a comprehensive scheme for the city of Chicago.[56] The program was to unite the open spaces of green with the waterfront in a sweeping gesture that would rival the impact of the World's Columbian Exposition of 1893. In the publication documenting this endeavor, *Plan of Chicago*, the authors conceded that their plan could be directly traced to the World's Columbian Exposition. They wrote of the Fair of 1893 with a respectful admiration that fully credited its place in the history of American urbanism: "The World's Fair of 1893 was the beginning, in our day and in this country, of the orderly arrangement of extensive public grounds and buildings. The result came about quite naturally. Chicago had become a commercial community wherein men were accustomed to get together to plan for the general good. Moreover, those at the head of affairs were, many of them, the same individuals who had taken part in every movement since the city had emerged from the condition of a mere village. They were so accustomed to results even beyond their most sanguine predictions, that it was easy for them to believe that their Fair might surpass all fairs that had preceded it."[57]

Acknowledging that the American city is characterized by industry, Burnham and Bennett noted the importance of providing adequate parkland to its citizens. After the transitory city of the World's Columbian Exposition in Jackson Park was taken down, they proposed that this park, initially designed by Frederick Law Olmsted in the 1870s, be made once more usable, a waterfront amenity for the citizens of the industrialized city.

The South Park Commissioners had proposed that the entire lakefront along the South Shore of Lake Michigan be improved in the form of a vast waterfront park that would link Jackson Park with Grant Park.[58] This proposal was part of a greater comprehensive plan for a metropolitan park system in Chicago that would include an outer belt of parks and parkways, as well. Burnham and Bennett acknowledged the usefulness of the South Park Commission's proposals in defining their own project for Chicago. They stated their objectives as threefold: "First, to make the careful study of the physical conditions of Chicago as they now exist; second, to discover how those conditions may be improved; third, to record such conclusions in the shape of drawings and texts which shall become a guide for the future development of Chicago."[59] They phrased their projected view of the improvement of the city in terms relevant to the health and well-being of the city and its citizens: "...In establishing a complete park and parkway system, the life of the wage-earner and of his family is made healthier and pleasanter; while the greater attractiveness thus produced keeps at home the people of means and taste, and acts as a magnet to draw those who seek to live amid pleasing surroundings..."[60]

The watercolor renderings produced by Jules Geurin for this project recall the ambition of the goals of the *Plan of Chicago*. Dramatic nighttime panoramas and sweeping aerial views show a staggering view of a fictional wonderland of urbane prosperity and divertisement. These renderings, combined with the intricately rendered diagrams of the existing and proposed park system, make up a report for a park plan that goes beyond questions of landscape design. It is a plan for the improvement of an entire city which has the character of a park in and of itself. The efforts to secure as much park space as possible in the city was a part of Chicago legislation since

Water parade, Belle Isle
Park, Detroit, 1905.

1839. The city's motto is "Urbs in Horto," a "City Set in a Garden," so this had always been a preoccupation with the city's founders, yet in 1839, the only available park space was a half-square on Michigan Avenue where the Public Library was built at the turn of the century.[61]

By 1864, however, after a number of urban park squares had been established by individual citizens, the Common Council appropriated space for a larger park to be named after Abraham Lincoln. By 1869, there was interest in making a connection between existing parks and boulevards, with the aim of reestablishing the ideal of a city set within parks to replace that of a city with parks in it.[62]

In 1908, Burnham and Bennett noted that while the extent of the city park system was second only to that of Philadelphia's in 1870, by 1900, the ratio of park space to persons living in the city was only one acre to five hundred and ninety people. They insisted that "for health and good order," the ratio should be one acre of park per one hundred people.[63] A whole number of new parks were acquired in the form of ten-acre plots within individual districts of the city, the money for them raised by bond issues. On the South Side alone, seventeen new parks, with a total area of six hundred and seventy-one acres, were established within a few years at the beginning of the twentieth century.[64] Burnham and Bennett reported on this improvement with optimism: "A feature of these small parks is the neighborhood-center building, provided with baths, gymnasia, refectory service, club rooms, and reading rooms for the district served. These 'clubhouses for the people,' as they are called, are in service both summer and winter. The outdoor swimming-pools and athletic fields are in [the] charge of expert directors furnished by the authorities. The aim of the commissioners is to improve the health and morals of the people, and to stimulate local pride and patriotism; and the work has attracted international attention."[65]

The aims of Burnham's and Bennett's *Plan of Chicago* called for an intersection, as much as possible, between any addition to these new smaller parks and nearby boulevards in the form of round-points, which could then be treated as parks in and of themselves.

In insisting on the need for more park space for the well-being of the city and of the population, they called attention to the well-developed and extensive park systems of London and Paris as models for imitation. They also cited the examples of Boston and Washington as American cities that managed to provide the same. But, ultimately, they pointed to the shoreline of Lake Michigan as the most extraordinary setting for a city park.

The Mall, Washington, D.C.

In 1791, Pierre Charles L'Enfant, Major in the French Army and Civil Engineer, was commissioned by George Washington, first President of the American Republic, to plan a national capital over the tracts of Tidewater land along the Potomac river donated by the former colonies of Maryland and Virginia. L'Enfant proposed a Baroque scheme that was partially reminiscent of his native Versailles. It was composed of a system of radial avenues set over a regular grid of streets and linked, at their diagonal intersections, by circles or squares. Grand as this plan was for the new nation, the course of history through the nineteenth century did little to translate the impact of the two-dimensional composition of the plan into an adequate three-dimensional representation of its initial concept. The history of the plan of Washington can, in some ways, be seen as a history of the attempts at its realization.

From the outset, there were local obstacles that hindered the smooth implementation of the plan and perhaps showed the extravagance of such a plan in a region that was still largely devoted to parochial concerns. L'Enfant, for example, ordered the re-

moval of a manor house being built by a Maryland landowner in the middle of one of L'Enfant's projected squares. Ensuing disputes among the members of the planning commission, coupled with L'Enfant's seeming arrogance and stubbornness on the point, finally led George Washington to replace L'Enfant with the surveyor, Andrew Ellicott, whose name would be associated with the plan hereafter.[66] Building activity in the Federal City's first hundred years, however, never seemed to meet the possibilities suggested by the strong model of the L'Enfant/Ellicott plan. Rows of "Federal" (modified Georgian) townhouses built in the first part of the century and numerous private mansions, of eclectic style built in the second part of the century dotted the broad avenues in sporadic fashion or else sat isolated in ill-defined parks. These erratic patterns of construction did nothing to define the parameters of the striking lines of the city plan, some of which were not yet even in place.

Towards the end of the century, when rows of small-scale Victorian townhouses were actually beginning to invade the boundaries of some of the radial avenues, the Highway Act of 1898[67] was passed as a means of reclaiming those avenues that were being encroached upon by new construction, as well as for establishing a future system of roads to accommodate the expected expansion of the city beyond the area originally charted by L'Enfant and Ellicott.

By the turn-of-the-century, "on the occasion of the centennial of the removal of the seat of government from Philadelphia to Washington,"[68] planners and politicians alike were increasingly intent on imbuing the Federal City with a grandeur that it had not yet achieved in its first century. The annual meeting of the American Institute of Architects in 1900 addressed this problem as a principal topic. It led, in 1901, to the formation of the McMillan Plan,[69] the scheme that would give the plan of Washington its impetus for the next century.

Implemented by Senator James McMillan of Michigan, chairman of the Committee on the District of Columbia, the McMillan Plan was produced by the architects, Daniel Burnham and Charles McKim; the landscape architect, Frederick Law Olmsted, Jr.; and the sculptor, Augustus Saint-Gaudens, all of whom had previously worked together on the World's Columbian Exposition of 1893 in Chicago. This well-practiced team proposed an enormous plan that was designed to shake the Federal City out of a torpor that had allowed rambling paths, haphazard groupings of small scale buildings, and even train tracks, to blur the outlines of avenues and formal parks prescribed by the L'Enfant plan. The team made models of the Mall and its surrounds in both the existing and projected states in order to show how their plan would bring order and harmony to the Capital Mall.

The primary gesture of the McMillan Plan, which seemed to out-classicize even the L'Enfant plan, was a massive strengthening of the axial relationship between the Capitol Building, the Washington Monument and the future site of the Lincoln Memorial, on one bank of the Potomac River. The proposed axis was presented in the form of a broad and clear Mall planted with multiple rows of trees lining an enormous central expanse of grass, modeled after the "Tapis Vert" at Versailles. The overall length of the mall was broken into blocks by cross streets and included an elaborate system of terracing at the base of the Washington Monument.

An integral part of this monumental park scheme was the allocation of building sites for future public buildings on prominently-positioned city blocks bordering the Mall. The three areas designated for this purpose were the blocks surrounding the Capitol, those surrounding the White House and those within a large, wedge-shaped tract of land between the Mall and Pennsylvania Avenue, bounded at one end by the White House Grounds and at the other,

41

The cascade in Meridian Hill
Park, Washington, D.C.,
mid-twentieth century.

by the Capitol Grounds. Despite the efforts of the group associated with the McMillan Plan, the physical improvement proposals remained largely at the level of speculation for the first quarter of the century. While some of the landscaping elements were realized at this time, the building projects that were to strengthen the lines of the Mall's plan would take another several decades to complete.

[1] F. L. Olmsted, *Public Parks*, papers read before the American Social Science Center in 1870 and 1880, Brookline, Mass., 1902.

[2] For a discussion of the emergence of the American parkway phenomenon see C. Zapatka, "The American Parkways," *Lotus International,* no. 56, Electa, Milan, 1988. Portions of that article appear in this *Lotus Document*.

[3] D. Burnham and E. Bennett, *Plan of Chicago*, Commercial Club of Chicago, 1908, p. 43. This is a limited edition volume containing the proposal by Burnham and Bennett for a master plan for renewing Chicago's park system in the wake of the World's Columbian Exposition of 1893. (My appreciation to the library of the American Academy in Rome for the use of one of their two copies).

[4] A great majority of my sources are from the Library of Congress, the National Archives, the Garden Library of Dumbarton Oaks, the Frances Loeb Library of the Harvard University Graduate School of Design, the Frederick Law Olmsted National Historic Site, The Washington Historical Society and the Library of the American Academy in Rome.

[5] Much of the documentation relied upon for a description of the New York parks is from Jeffrey Simpson, *Art of the Olmsted Landscape: His Works in New York City*, edited by M. E. W.

Hern, New York City Landmarks Preservation Commission and The Arts Publisher, Inc., 1981. (Publication made possible by the Arthur Ross Foundation and the National Endowment for the Humanities)

[6] J. Simpson, "Central Park," p. 5.

[7] P. Deitz, "Central Park's Bethesda Terrace and its Restoration," in *Antiques*, April 1988, p. 890. This article provides a close view of the intricate architectural decoration of the fountain and terrace.

[8] A. J. Downing's mid-nineteenth century plan for the Mall in Washington, D.C. is a good example of the influence of the picturesque style that took hold in America at this time.

[9] J. Simpson, "Central Park," p. 5.

[10] For a few remarks on the decline in use of Central Park, see B. Kelly's Introduction to Simpson, *Art of the Olmsted Landscape*. Kelly notes, for example, that Robert Moses's "improvements" for the park were ultimately destructive to its bucolic character.

[11] J. Simpson, "Central Park," p. 7.

[12] J. Simpson, "Central Park," p. 7.

[13] J. Simpson, "Central Park," pp. 11–12.

[14] P. Deitz, p. 891.

[15] J. Simpson, "Prospect Park," p. 23.

[16] J. Simpson, p. 23.

[17] J. Simpson, p. 23.

[18] J. Simpson, p. 24.

[19] J. Simpson, pp. 26–28.

[20] J. Simpson, p. 30.

[21] J. Simpson, p. 31.

[22] Eighth Annual Report of the Commissioners of Prospect Park, Brooklyn, January 1868, p. 173. (This account of the Eastern Parkway is taken from Zapatka, "The American Parkways," *Lotus International*, no. 56, Electa, Milan, 1988.)

[23] Ibid., p. 175.

[24] Ibid., p. 192.

[25] Ibid., p. 196.

[26] Ibid., p. 197.

[27] Ibid., pp. 199–200. At this point in their report, Olmsted and Vaux recalled the wisdom of the Romans who never permitted their city dwellings to be attached to each other. Even for slave houses, there was a minimum of five feet required between existing exterior walls.

[28] J. Simpson, "Riverside Park and Morningside Park," p. 17.

[29] J. Simpson, p. 17.

[30] J. Simpson, p. 17.

[31] J. Simpson, p. 20.

[32] J. Simpson, p. 20.

[33] Much of this description of Franklin Park is derived from the *Revised General Plan of Franklin Park*, City of Boston Parks and Recreation Department, prepared by V. M. Weinmayer Associates, Landscape Architects, 1980.

[34] Ibid., p. 6.

[35] Ibid., pp. 6–7.

[36] Ibid., p. 11.

[37] Ibid., p. 12.

[38] Ibid., p. 12.

[39] Ibid., p. 10.

[40] Ibid., p. 10.

[41] Ibid., p. 11.

[42] Ibid., p. 12.

[43] Ibid.

[44] Ibid.

[45] C. Eliot, *Landscape Architect*, Houghton, Mifflin, Boston and New York, 1902, p. 597.

[46] Ibid., p. 597.

[47] See C. Eliot, *Landscape Architect*.

[48] Ibid., p. 463.

[49] From an 1890s guidebook, *Belle Isle Illustrated*. (My appreciation to the Frances Loeb Library, Harvard University Graduate School of Design.)

[50] Ibid.

[51] Belle Isle Bridge Division of Engineering and Construction, *Report on the Proposed Belle Isle Bridge*, Department of Public Works, City of Detroit, 1918, p. 11.

[52] Ibid., p. 15.

[53] Ibid., p. 19.

[54] *Belle Isle Illustrated*, 1890s.

[55] M. Foucault, "Heteropias," *Lotus International*, no. 48/49, Electa, Milan, pp. 8–17.

[56] D. Burnham and E. Bennett, *Plan of Chicago* Commercial Club of Chicago, 1908, p. 1.

[57] Ibid., p. 4.

[58] Ibid., p. 6.

[59] Ibid., p. 8.

[60] Ibid., p. 8.

[61] Ibid., p. 43.

[62] Ibid., p. 44.

[63] Ibid., p. 44.

[64] Ibid., p. 44.

[65] Ibid., p. 44.

[66] K. R. Bowling, *Creating the Federal City, 1774–1800: Potomac Fever*, Octagon Research Series, The American Institute of Architect's Press, Washington, D.C., 1988, pp. 98–100. This book contains a good discussion on the credibility of the myth that Washington was built on a swamp and other topographical questions relating to the formation of the District of Columbia.

[67] H. P. Caemmerer, *Washington, The National Capital*, United States Government Printing Office, Washington, D.C., 1932, p. 66.

[68] *Eleventh Report: 1926–1929, The National Commission of Fine Arts*, United States Goverment Printing Office, Washington, D.C., 1930, p. 17.

[69] H. P. Caemmerer, op. cit., p. 73.

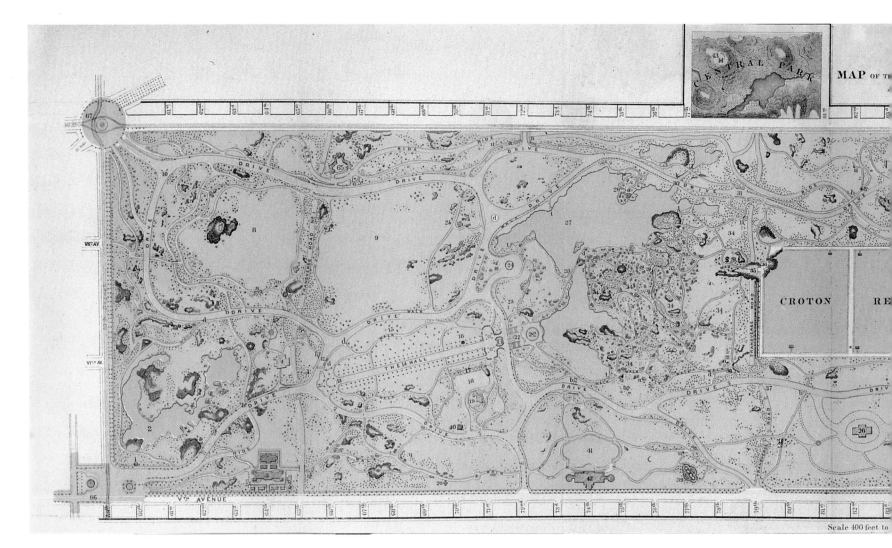

Central Park
New York, New York

Perhaps the greatest urban park of all time, this contained wilderness has an elusive size and constantly surprising range of characteristics. It is two and a half miles long and contains a reservoir, a zoo, lakes and meadows as well as scores of park buildings. Completed in 1868 by Frederick Law Olmsted and Calvert Vaux simply as a reserve within the anticipated growth of the city's grid system of streets and avenues, the plan ingeniously and aggressively preserved the natural within the manmade. The buildings of the city can be seen as fortress walls protecting a green precinct. While the European city typically grew up around either side of a *river* with open landscape surrounding the whole, New York grew up around either side of *an open landscape* with rivers surrounding the whole.

"Plan of Central Park," color lithograph included in the Report of the Park Commissioners of New York, 1871.

Map of Central Park showing improvements up to June, 1865. Published by Prang and Co., 1870

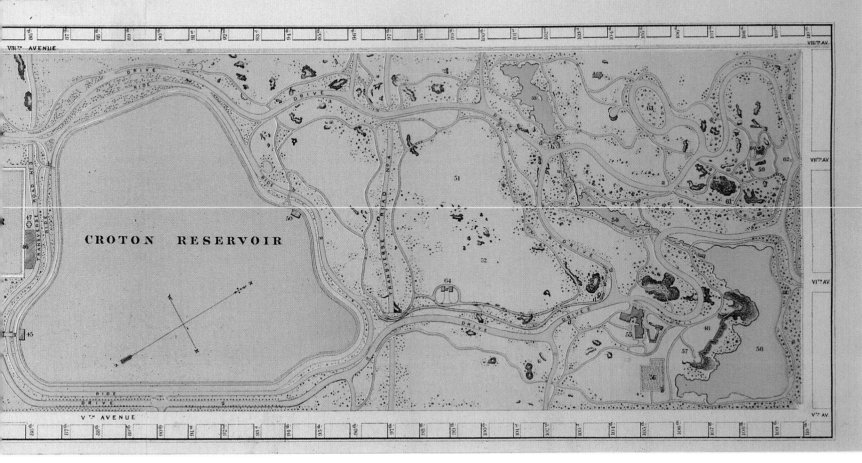

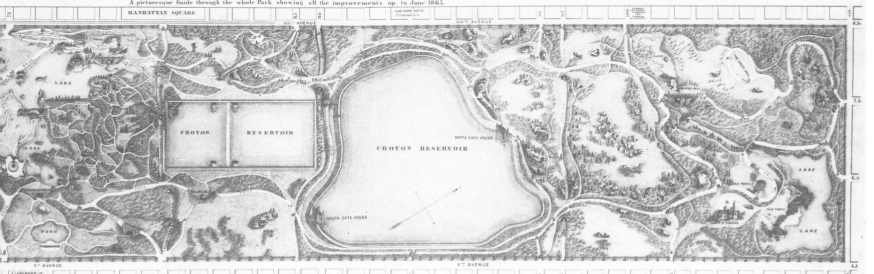

CENTRAL PARK, NEW YORK.
A picturesque Guide through the whole Park showing all the improvements up to June 1865.

Published by L. Prang & Cᵒ. 159 Washington Sᵗ Boston. Mass. & 639 Broadway New York (Branch Office)

45

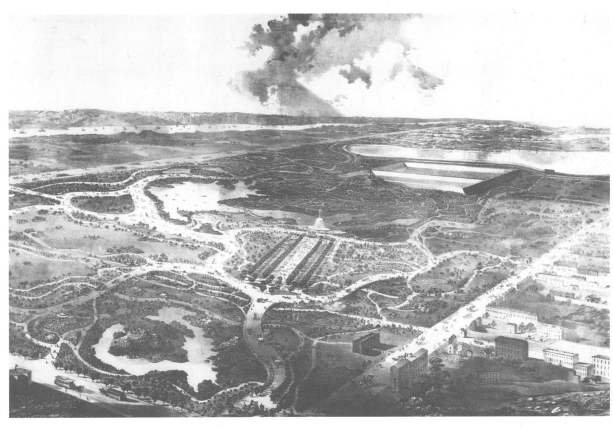

Martel's bird's-eye view
of Central Park from south
of 59th Street, lithograph,
1868.

Aerial view of Central Park,
1933.

48

May party in Central Park,
hand-tinted color postcard,
1898.

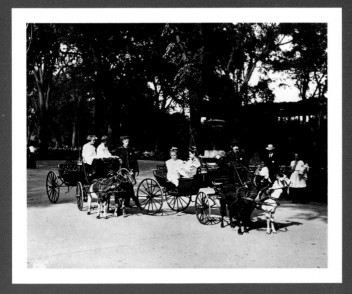

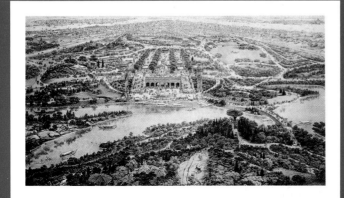

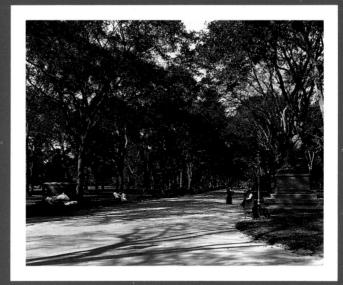

Goat-drawn carriages for children in Central Park, circa 1900–05.

Bethesda terrace in Central Park, lithograph by John Bachman, 1868.

Lake and bridge in Central Park with the Dakota apartment building in background, circa 1900–05.

The Central Park Mall, circa 1900–05.

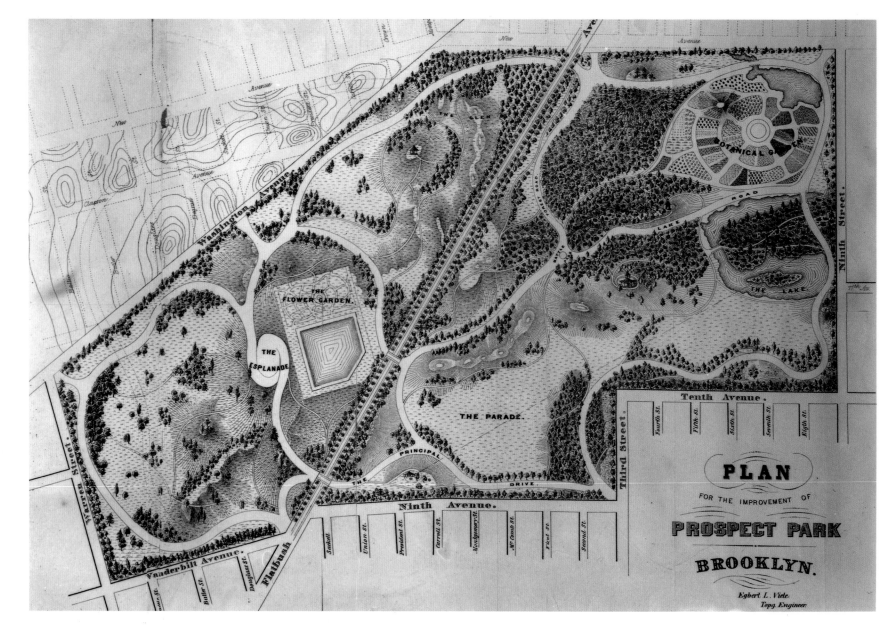

Prospect Park
Brooklyn, New York

If Central Park is the perfect rectangle of nature within a concrete forest, then Prospect Park in Brooklyn, with its meandering boundaries, can be appreciated as a more pastoral setting in the city. Designed by Frederick Law Olmsted and Calvert Vaux simultaneously with Central Park, Prospect's borders are lined with berms of earth that make a more physical separation from the surrounding city than Central Park's low walls do.

Once in and over these mounds, one has the distinct impression of being in the country. This five hundred acre park has a principal figurative entry that creates a ceremonial point of access, unlike Central Park which can be entered in many discrete and unmarked points.

Plan for the improvement of Prospect Park, Brooklyn, 1859.

50

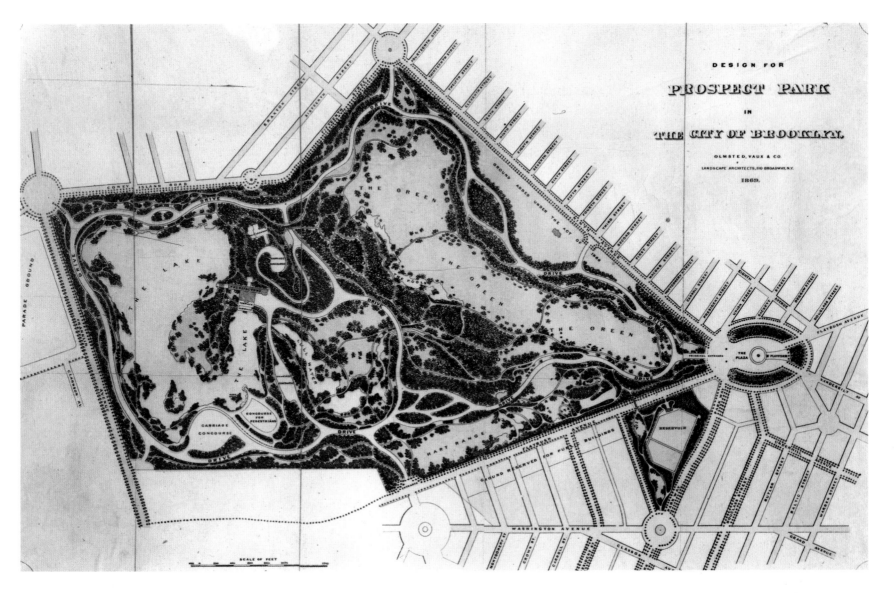

DESIGN FOR
PROSPECT PARK
IN
THE CITY OF BROOKLYN.

OLMSTED, VAUX & CO.
LANDSCAPE ARCHITECTS, 110 BROADWAY, N.Y.
1869.

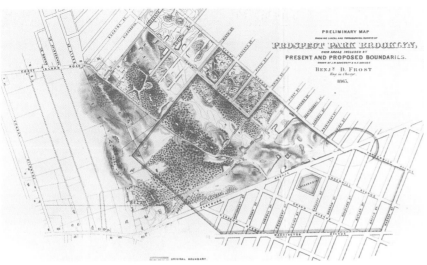

Topographical surveys
of Prospect Park, Brooklyn
over areas included by
present and proposed
boundaries, 1865.

Design for Prospect Park
in the City of Brooklyn,
Olmsted, Vaux & Co.,
1869.

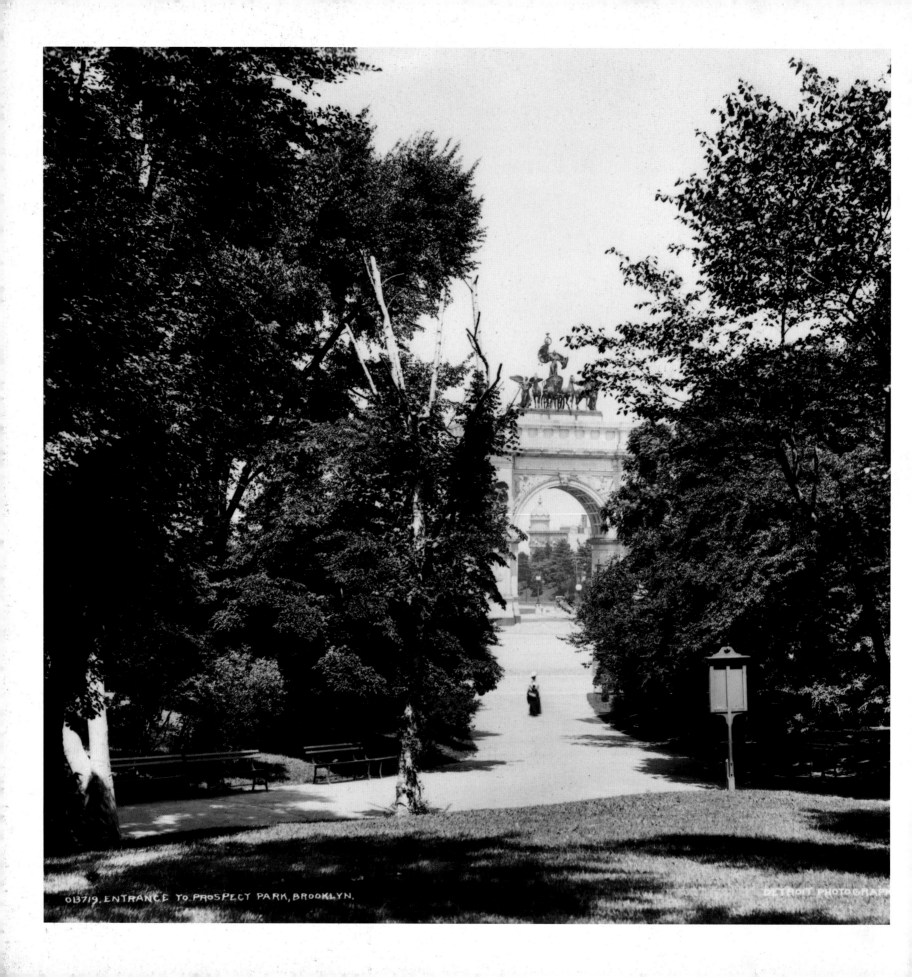

013719. ENTRANCE TO PROSPECT PARK, BROOKLYN.

DETROIT PHOTOGRAPH

Entrance to Prospect Park, Brooklyn, circa 1900–05.

View of entry to Prospect Park, Brooklyn, circa 1900–05.

Prospect Park, the lake from Redout Hill, lithograph, circa 1870.

Design for the pavilion to be erected in the Concert Grove, Olmsted, Vaux & Co., 1873.

DESIGN FOR - THE PAVILION - TO BE ERECTED IN - THE CONCERT GROVE

OLMSTED VAUX & CO. LANDSCAPE ARCHITECTS

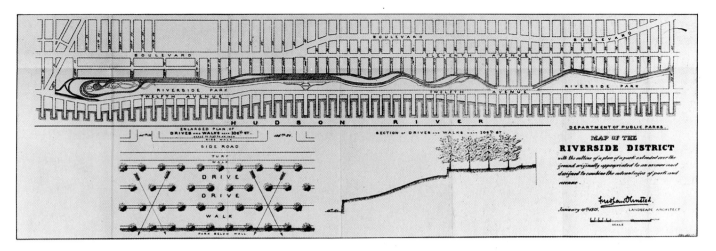

Map of the Riverside
District, New York, 1875.

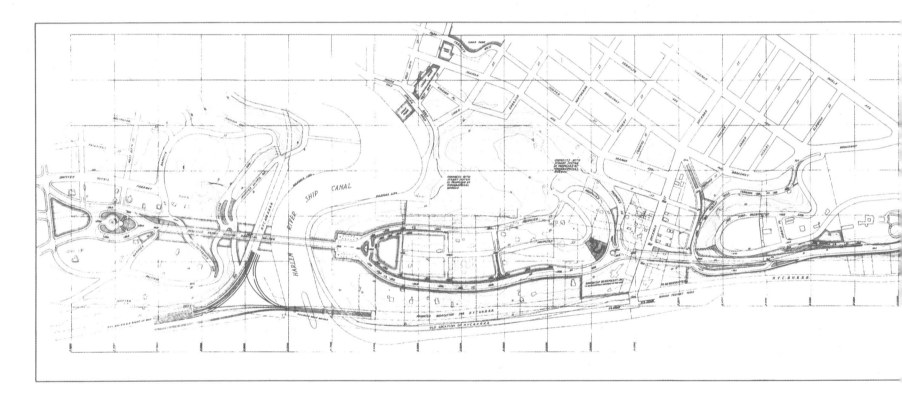

View of Riverside Drive,
photograph, circa 1900–05.

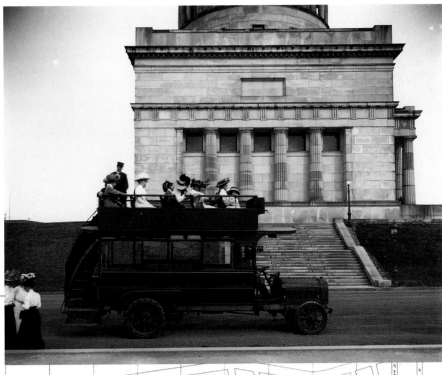

Bus in front of Grant's Tomb in Riverside Park, 1915.

Plan for the extension of Riverside Drive from 155th Street to the Harlem River, Arnold W. Brunner and Frederick Law Olmsted, 1913.

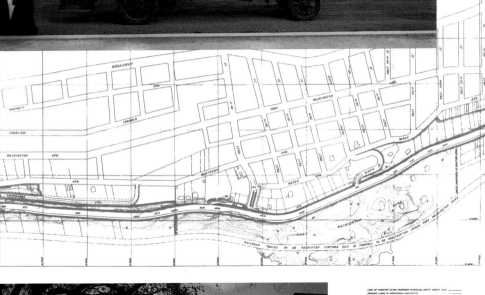

CITY OF NEW YORK – BOROUGH OF MANHATTAN

PLAN FOR THE
EXTENSION OF RIVERSIDE DRIVE
FROM 155TH STREET TO THE HARLEM RIVER
TO ACCOMPANY REPORT DATED MAY 1913
SUBMITTED TO HON. GEORGE MC. ANENY
BY ARNOLD W. BRUNNER AND FREDERICK LAW OLMSTED

SCALE OF FEET

100·0 500 1000 1500 2000

EXHIBIT-A

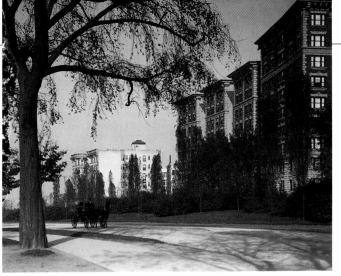

Riverside Park
New York, New York

An early example of a linear park/parkway, Riverside is an unexpected green edge along the otherwise abrupt riverfrontage of the island of Manhattan. Grand houses, opulent apartment buildings and memorial monuments in white marble, combined with groves of trees and sloping lawns made this remote western outpost in the city a picturesque refuge from the relentless grid of the city. Its form provides a glimpse of the stretched quality of New York without being a straight line. Initially planned by Olmsted in the late nineteenth century, it experienced a second phase of development in the 1930s under the aegis of Robert Moses.

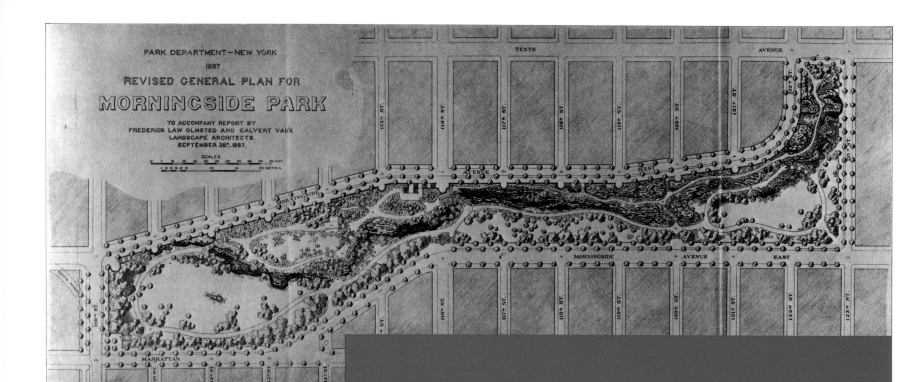

Morningside Park
New York, New York

A strangely melancholic place, this lofty park was worked into the rocky cliffs of the heights of upper Manhattan at the end of the nineteenth century by Olmsted. Providing views eastward into the city, the park is laid out as a series of rough platforms. With its sinuous outline, it is the one case of a Manhattan park that breaks the clamp of the grid from within.

Revised general plan for Morningside Park, Frederick Law Olmsted and Calvert Vaux, 1887.

Lookout platform, Morningside Park, 1935.

Morningside Park playground in front of block houses from West 116th Street to West 119th Street, 1956.

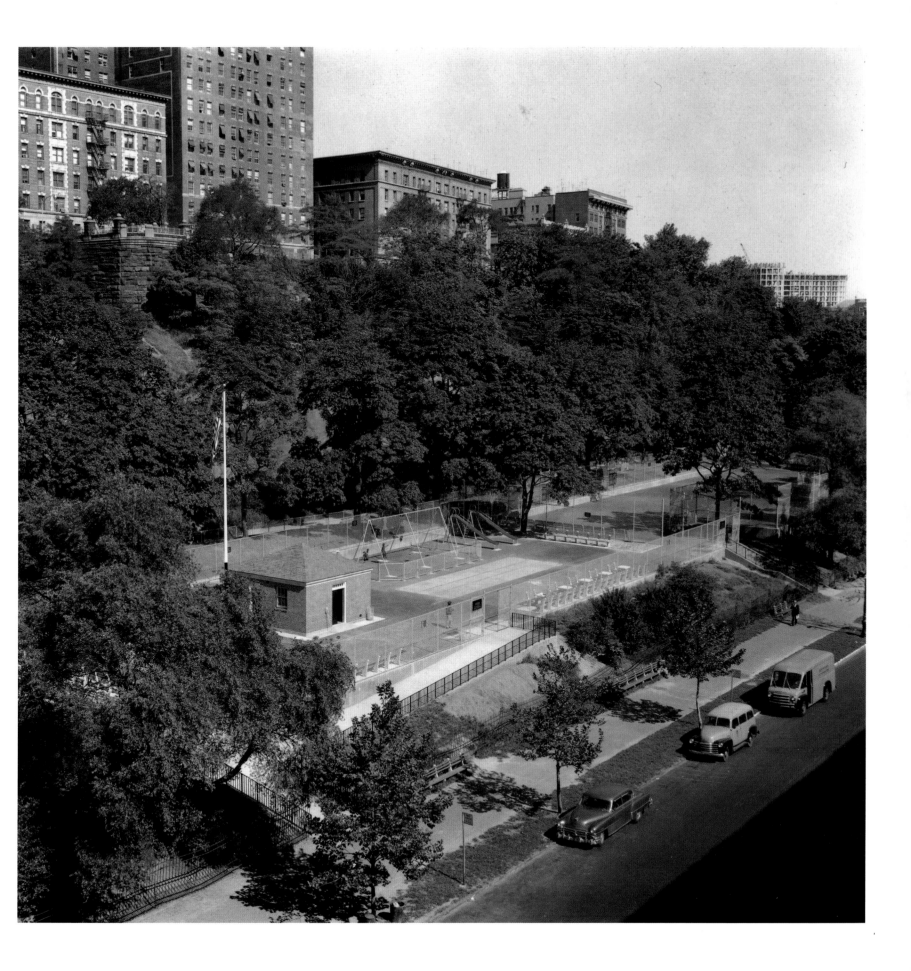

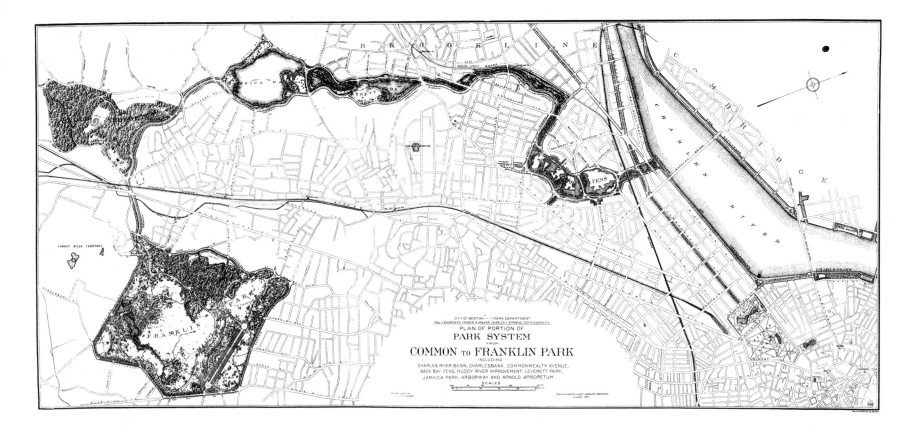

The Emerald Necklace
Boston, Massachusetts

The joint efforts of Olmsted and Charles Eliot, this continuous string of "emeralds" commencing in the Boston gardens and culminating in the giant "pendant" of Franklin Park offered this northern city a series of green respites from its urban density. Neither in the center of the city nor at its edges, the necklace of parks and parkways formed a prominent figure about the city. Completed between 1894 and 1902, the necklace is one of the most comprehensive urban park plans in America.

Plan of portion of park system from Common to Franklin Park (The "Emerald Necklace"), Olmsted Brothers' Office. Copy loaned to D. H. Burnham in 1904.

The Boston Common, circa 1910.

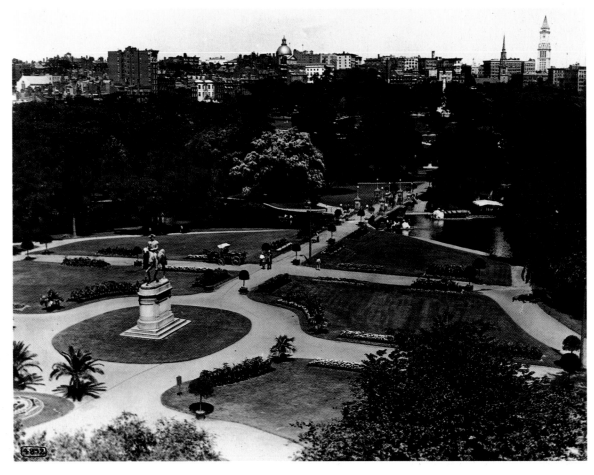

58

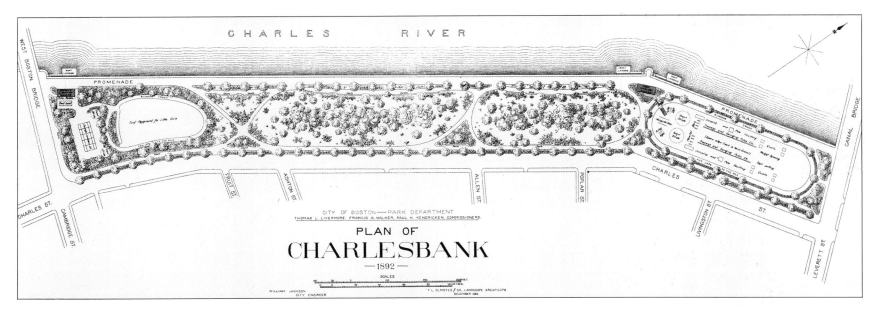

Plan of Charlesbank, Boston, Frederick Law Olmsted, 1892.

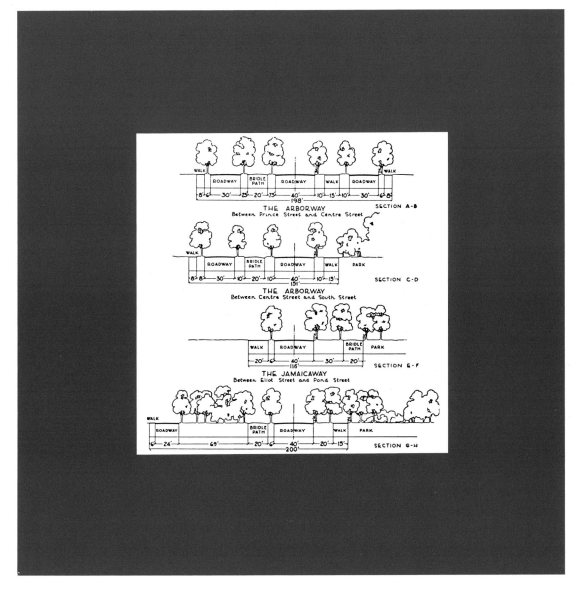

Charles Bank
Boston, Massachussets

A riverfront promenade designed by Olmsted in 1892, this linear park featured one of the first examples of gymnasia in a park, one for women and one for men. Stretching for one half mile along the Charles River, it was intended to offer moments of fresh air and repose to the office workers of Boston.

Cross Sections, Boston Parkways, illustration in J. Nolen and H. Hubbard, "Parkways and Land Values, Harvard City Planning Studies XI," Oxford and Harvard, 1937.

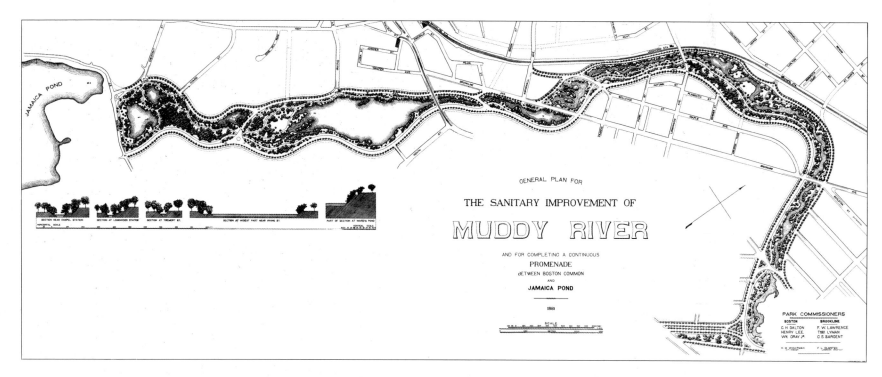

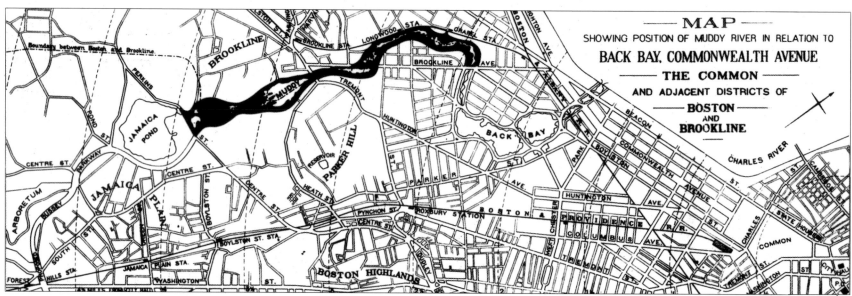

Muddy River
Boston, Massachusetts

A representative example of
Olmsted's practice of cleaning and
draining undesirable swampland and
then, secondarily, making a park of
the resultant landfill. Composed of a
series of ponds and wooded glens,
the route of the sequence was to be
from the Common to Jamaica Pond.

60

General plan for the sanitary
improvement of Muddy
River and for completing
a continuous promenade
between Boston Common
and Jamaica Pond, Frederick
Law Olmsted, 1881.

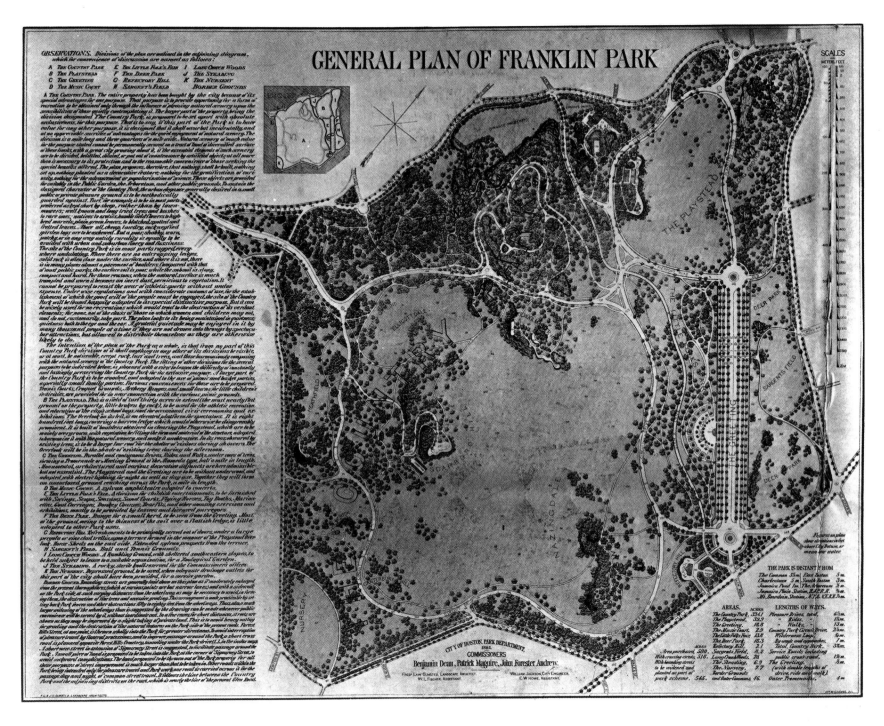

General plan of Franklin
Park, Frederick Law
Olmsted, 1885.

Franklin Park

Boston, Massachusetts

Boston's largest park, Franklin is the
equivalent in size and conception of
Brooklyn's Prospect Park. Designed
at the turn of the century by the
Olmsted Brothers, the park offered
a truly bucolic setting at the end
of the city. Blurring the distinction
between park and city, a number
of buildings occupied prominent
positions on the grounds: there was
a library, a refectory, park
superintendent's houses, children's
shelters and a dairy.

61

The refectory, the library
and superintendent's house,
Franklin Park, circa 1900.

Lawn tennis courts, Franklin
Park, 1900 ca.

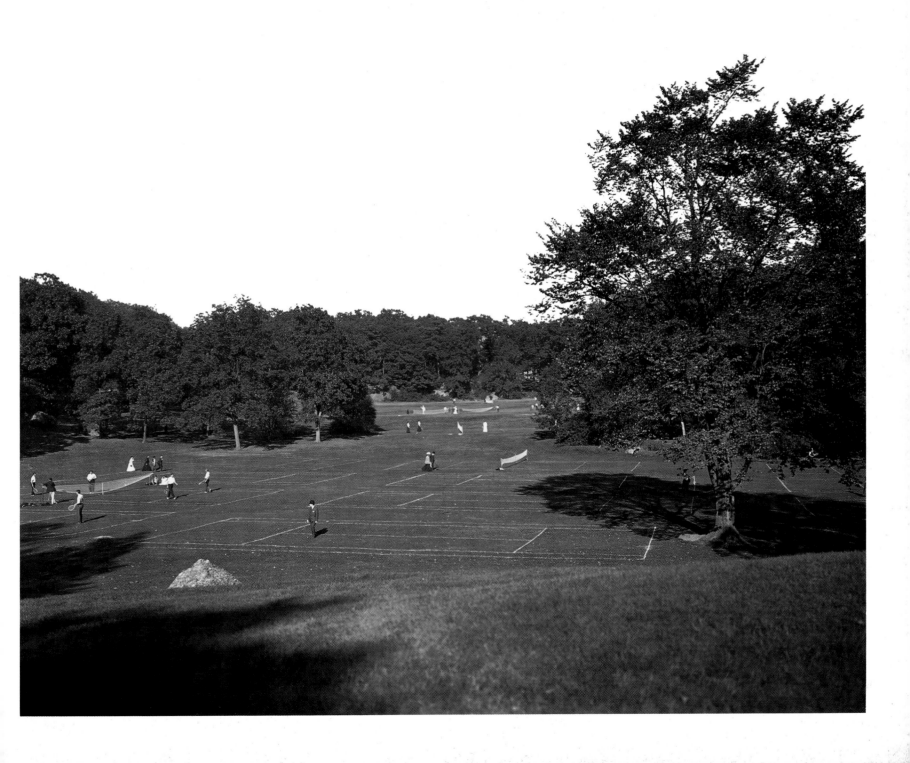

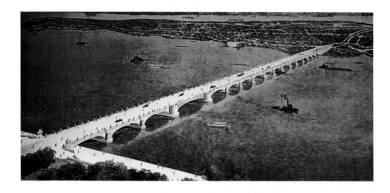

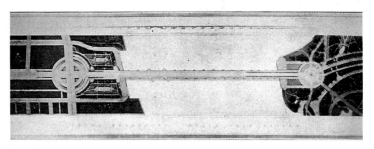

Perspective view and plan for
a new bridge for Belle Isle,
Detroit, Cass Gilbert, 1883.

Topographical map of Belle
Isle Park, Detroit, Frederick
Law Olmsted, 1883.

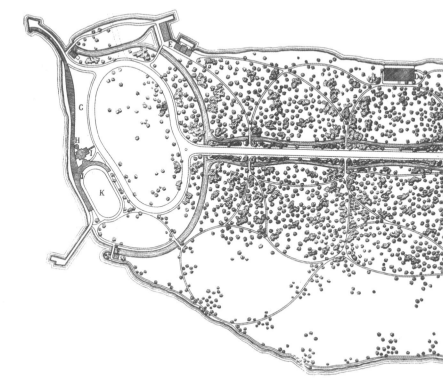

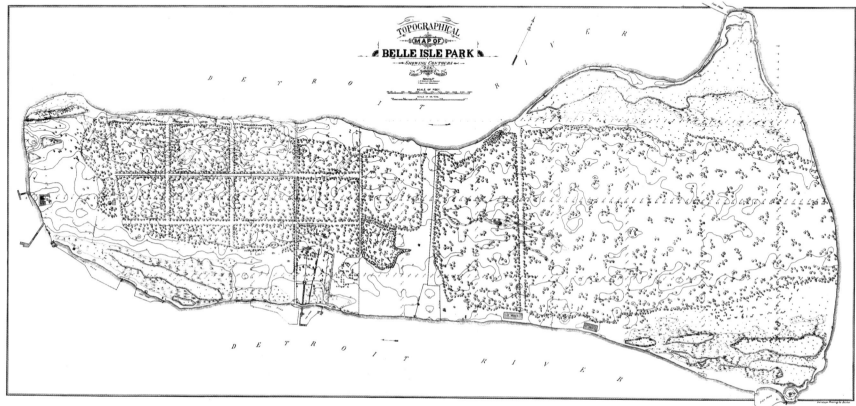

64

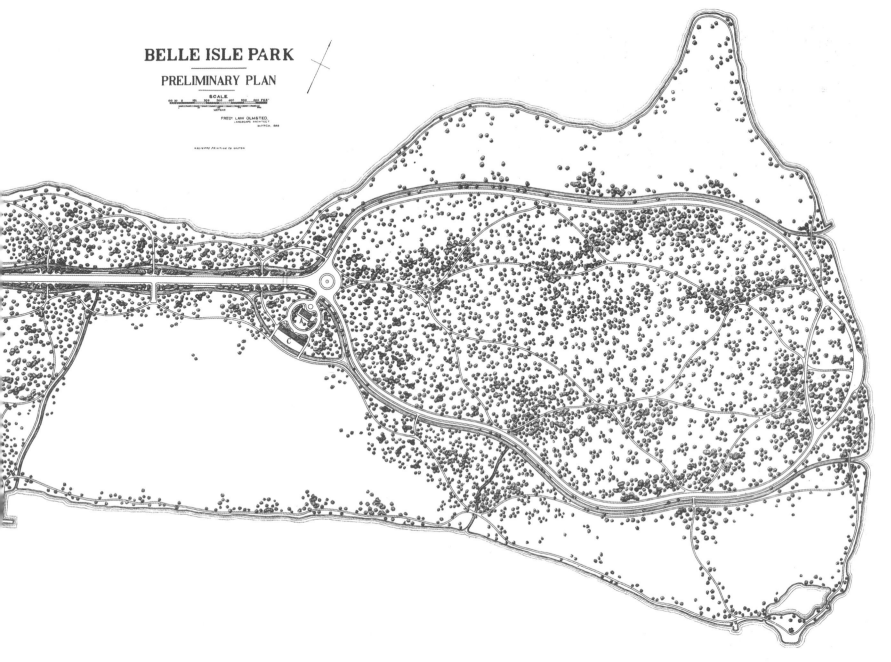

BELLE ISLE PARK

PRELIMINARY PLAN

SCALE

FRED* LAW OLMSTED,
LANDSCAPE ARCHITECT
MARCH, 1883

Belle Isle
Detroit, Michigan

Designed by Olmsted in the 1870s, the park was brought to completion by others in Detroit. This was an island park with a program: there was a boat club, an aquarium, a refectory, a conservatory, a bicycle pavilion, an ice skating pavilion, designated promenades and organized events. Connected to Detroit by a concrete bridge, the island was the acknowledged weekend recreation site for the city.

Preliminary plan of Belle Isle Park, Detroit, Frederick Law Olmsted, 1883.

65

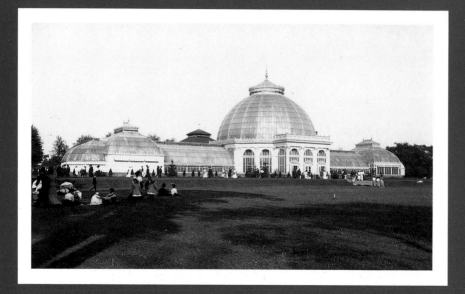

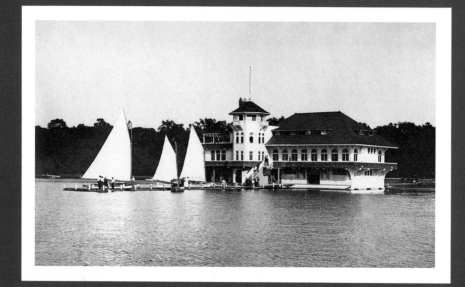

Conservatory, Detroit Yacht
Club and refectory, Belle Isle
Park, 1905.

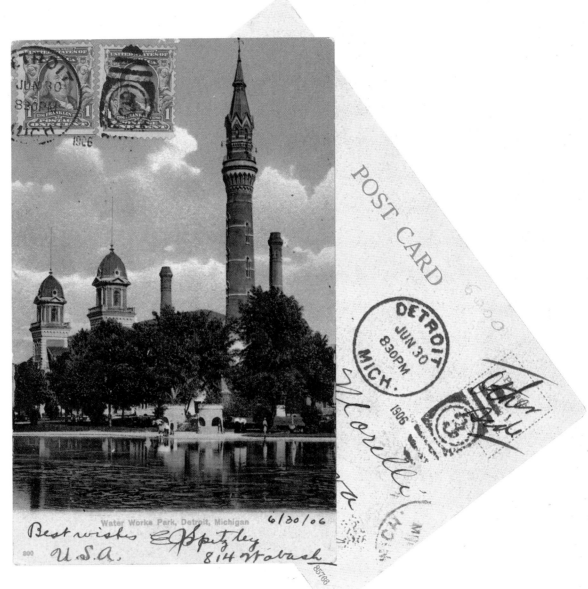

Detroit Water Works park,
postcard, 1906.

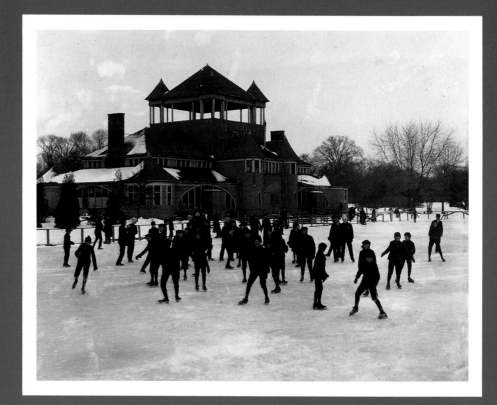

Forest Drive, ice skating pavilion and Central Avenue, Belle Isle Park, 1905.

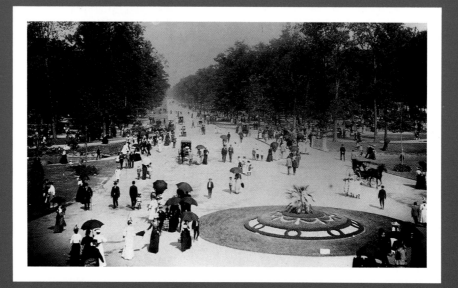

Chicago Waterfront
Chicago, Illinois

The central object of The Chicago Plan of 1908, Grant Park on the Chicago Waterfront can be seen as a door to the city. It is perhaps one of the grandest schemes in the world for an urban waterfront park. A radiating set of avenues and parkways were to stem from this central point out into the far reaches of the city and into the surrounding countryside thus making it one of the first city plans on a metropolitan scale.

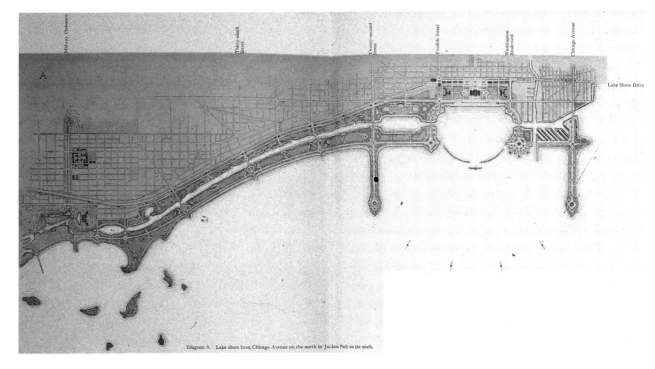

Diagram A. Lake shore from Chicago Avenue on the north to Jackson Park on the south.

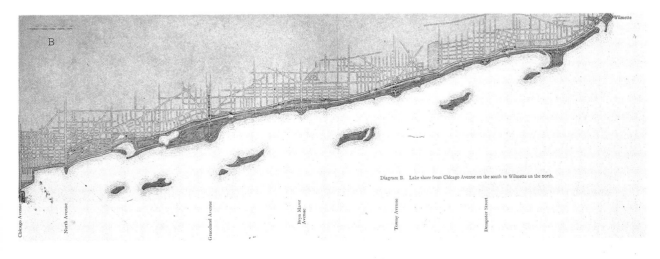

Diagram B. Lake shore from Chicago Avenue on the south to Wilmette on the north.

Three views of Chicago, Plan of Chicago, Commercial Club of Chicago, 1908.

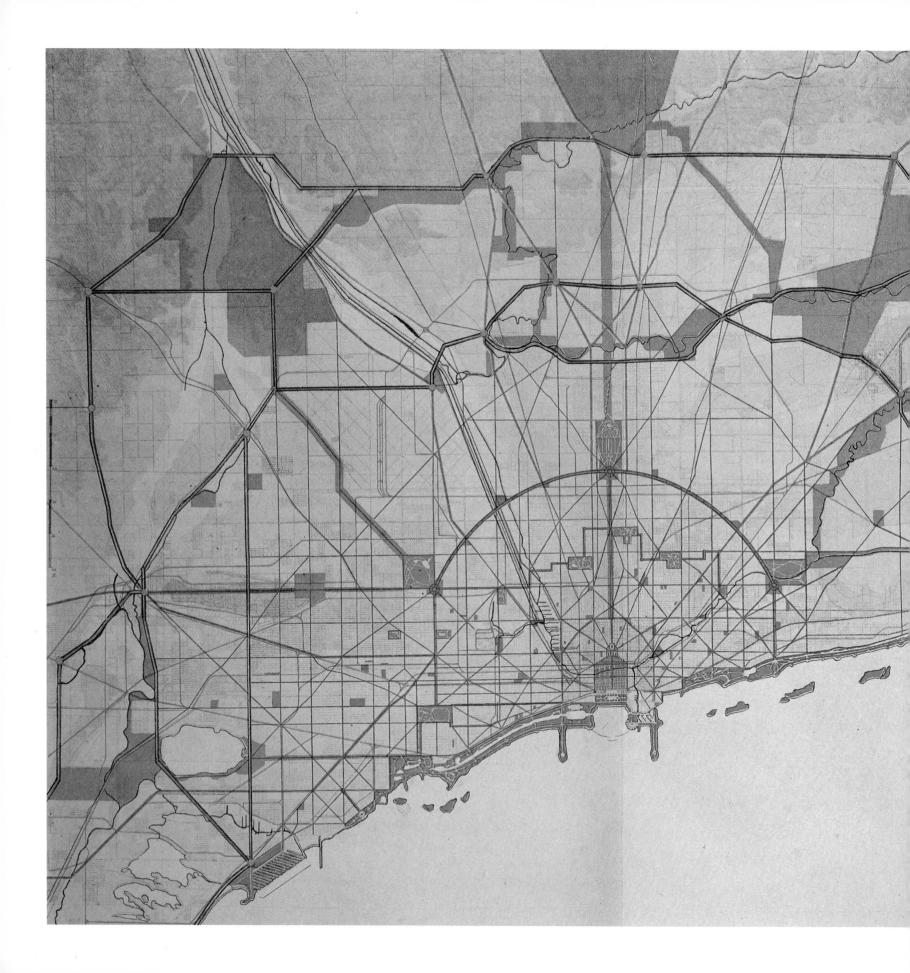

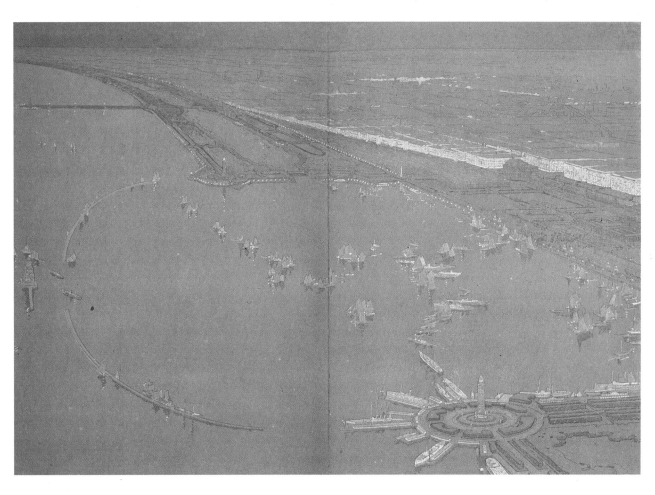

Bird's-eye view at night
of Grant Park, the facade
of the city, the proposed
harbor and the lagoons of
the Proposed Park on the
South Shore, Plan of
Chicago, 1908.

General map showing
topography, waterways and
complete system of streets,
boulevards, parkways and
parks, Plan of Chicago,
Commercial Club of
Chicago, 1908.

Plan of the Mall at
Washington, from the
official map of 1792.

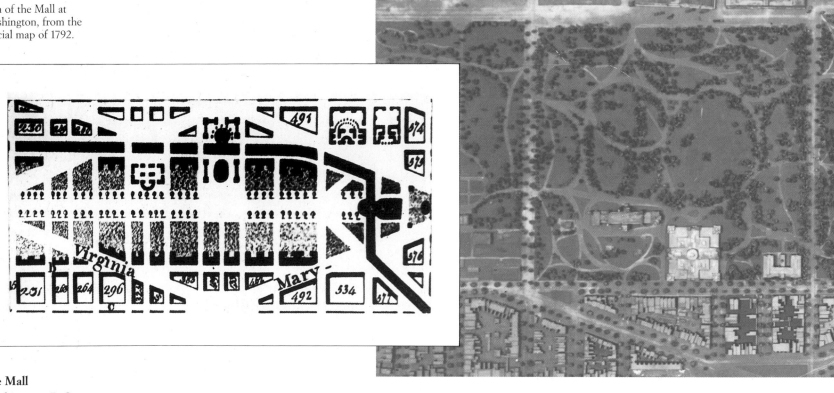

The Mall
Washington, D.C.

The McMillan Plan of 1901 was what
brought the lines of L'Enfant's 1791
plan into sharp focus after a century
of natural and manmade growth had
blurred the boundaries of the
design. A great *tapis vert* running
between the Capitol and the
Potomac River establishes the axial
composition of the original plan
while marble monuments and
museums hold the outer parameters.

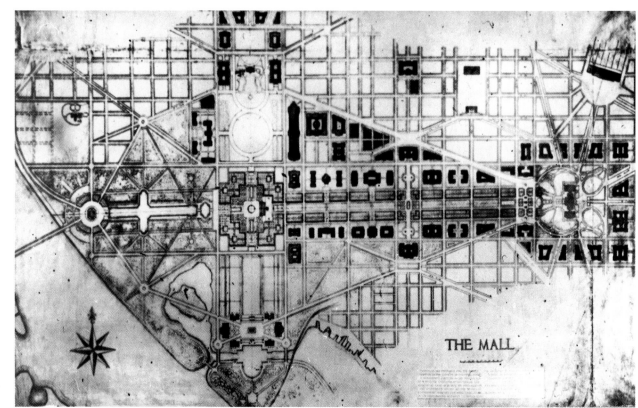

THE MALL

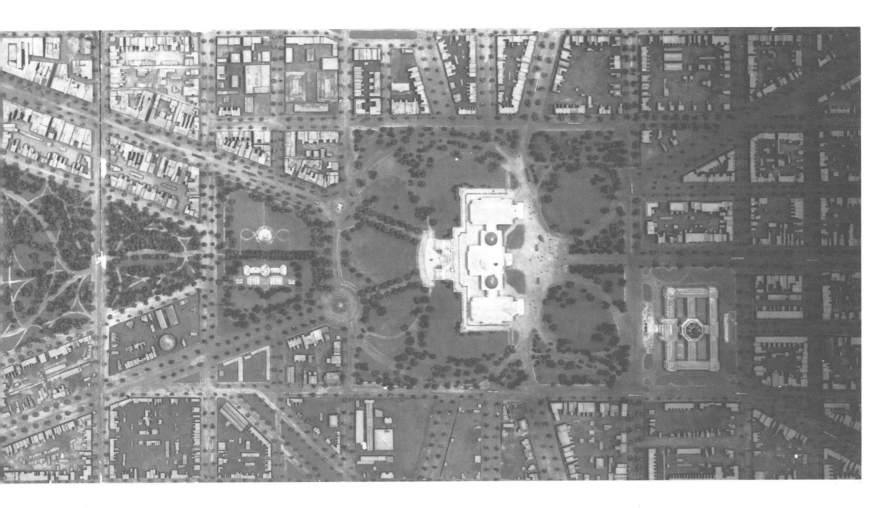

Relief model of the Mall
at Washington, 1900.

The McMillan Plan:
The Mall, 1901.

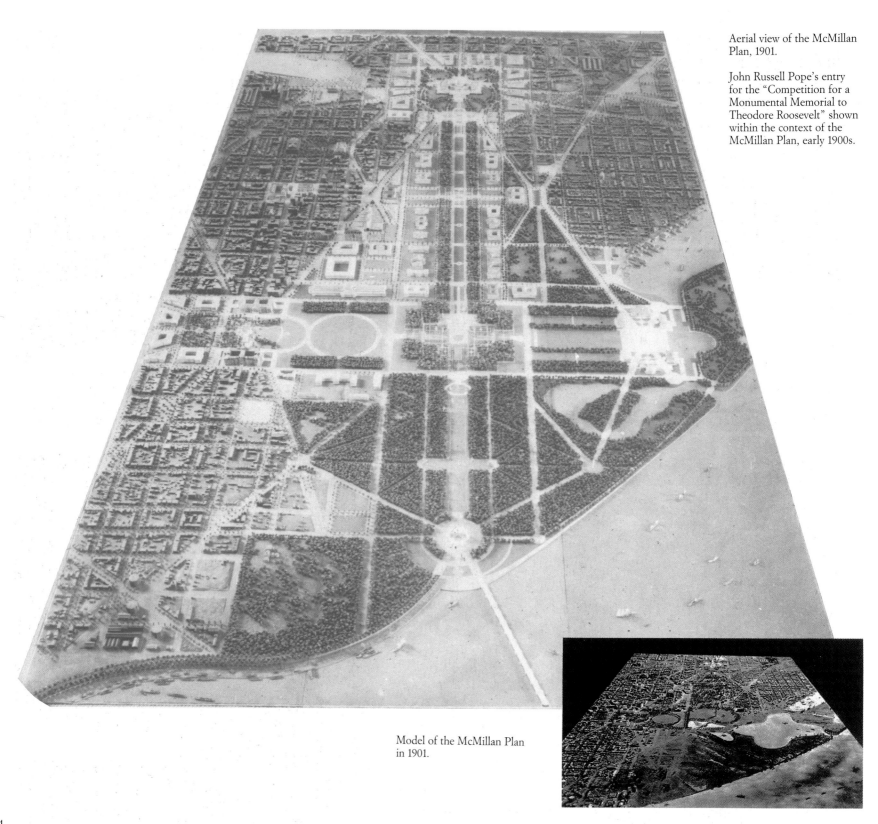

Aerial view of the McMillan Plan, 1901.

John Russell Pope's entry for the "Competition for a Monumental Memorial to Theodore Roosevelt" shown within the context of the McMillan Plan, early 1900s.

Model of the McMillan Plan in 1901.

Model of the existing Mall in 1901.

74

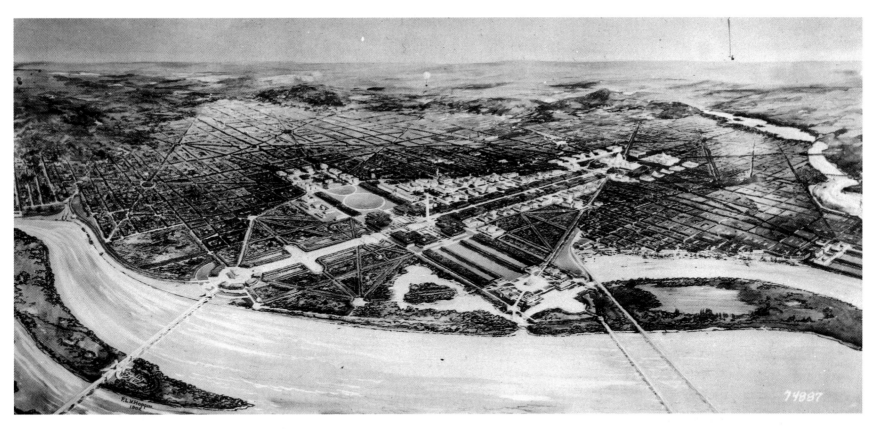

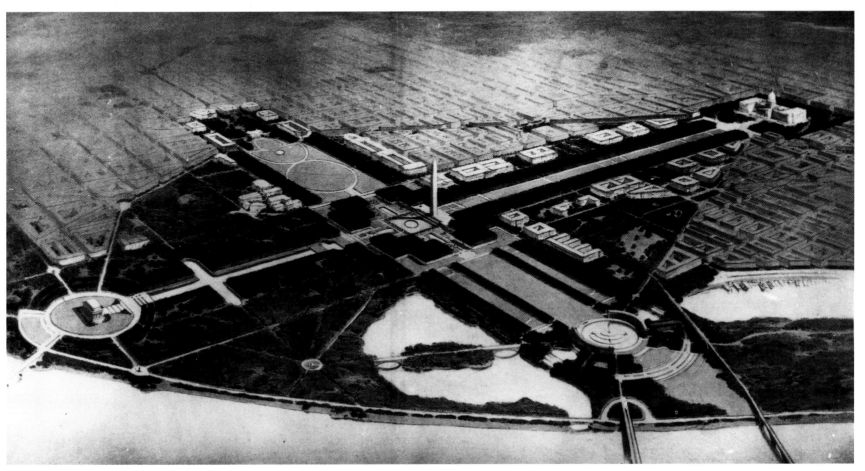

75

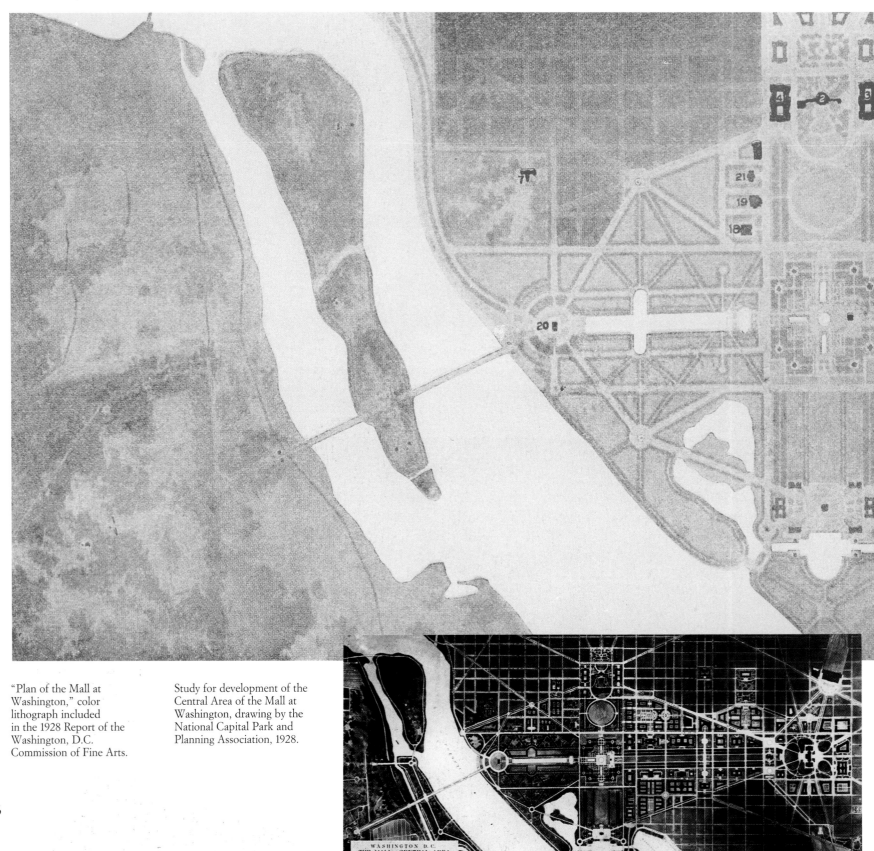

"Plan of the Mall at Washington," color lithograph included in the 1928 Report of the Washington, D.C. Commission of Fine Arts.

Study for development of the Central Area of the Mall at Washington, drawing by the National Capital Park and Planning Association, 1928.

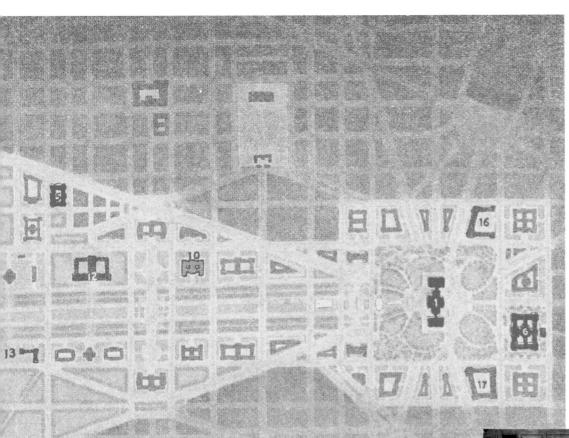

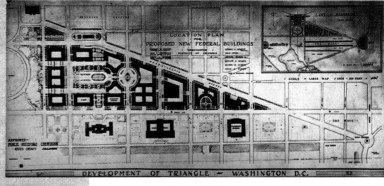

Development of the Federal Triangle, Washington, D.C., 1928.

Approved projects for the Mall at Washington and model of the Federal Triangle, photograph included in the 1928 Report of the Washington, D.C. Commission of Fine Arts.

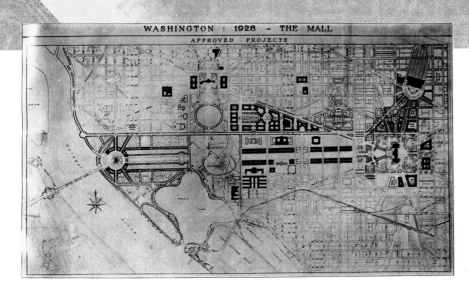

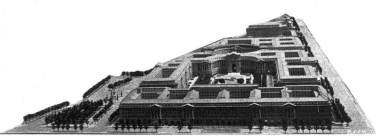

77

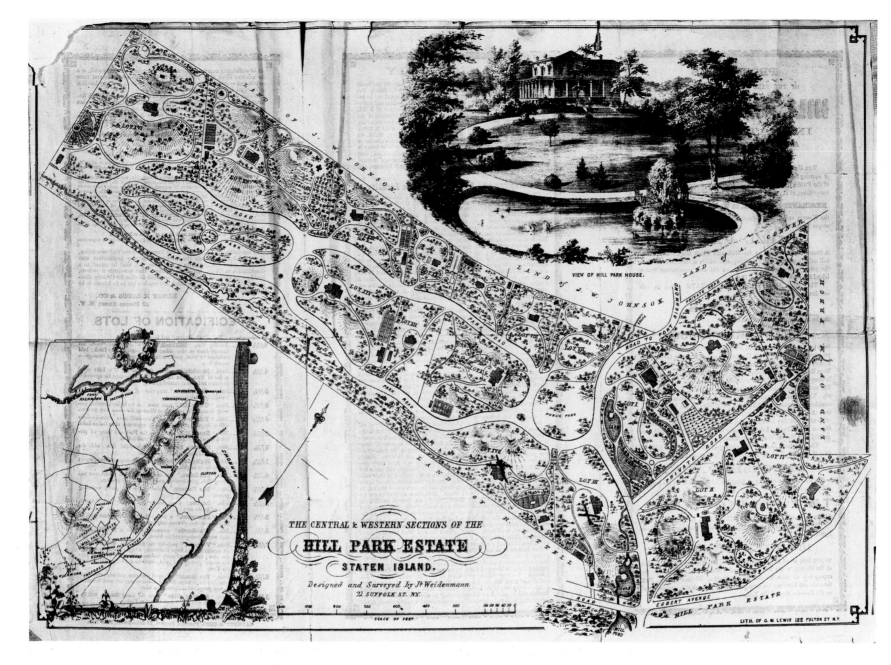

THE CENTRAL & WESTERN SECTIONS OF THE

HILL PARK ESTATE

STATEN ISLAND.

Designed and Surveyed by Jᵒ Weidenmann
21 SUFFOLK ST. N.Y.

VIEW OF HILL PARK HOUSE.

Hill Park Estate, Staten
Island, New York, Jacob
Weidenmann, late
nineteenth century.

The Private Realm

Residential Parks, Private Estates and the Private School: Alexander Jackson Davis, Andrew Jackson Downing and Frederick Law Olmsted

The next logical step in the idealized use of nature established by the plans of the park builders of the nineteenth century was to suggest permanent housing in a park setting. In 1859, the architect, Alexander Jackson Davis (1803–1892), along with Calvert Vaux, designed a paradigmatic plan for a park which included houses. It was named Llewelyn Park and built in West Orange, New Jersey.[1] The design, with its curvilinear streets and informal lot shapes, appears to have been influenced by Andrew Jackson Downing's treatises.[2] The formation of such a residential park, within a short distance of New York, launched the possibility of living in an intermediate zone between city and country.

Landscape plans for suburban residential parks used the same models developed for city parks, but included small villas for permanent family shelter. These bucolic dwellings, picturesquely situated in open terrain, outside the confines of an urban grid pattern, might be thought of as a private version of the public fieldhouses and refectories used for day-time activities in the city parks. The efforts of the landscape designers involved in this process contributed to the making of a uniquely American kind of metropolis in which residual land both in and outside of the city was gradually made usable and even habitable.

By the end of the late nineteenth century, with the help of an expanded railroad system, any number of such communities could be realized. Olmsted and Vaux's plan for "Riverside," (1869) commissioned by the Riverside Improvement Company in Chicago, advanced the concept of the habitable park by including a public park and a commercial center. Its easy proximity to Chicago by train made Riverside the model suburban community in the late nineteenth century.

In the mid-to-late-nineteenth century, projects for suburban neighborhoods such as Roland Park in Baltimore and Druid Hills Park in Atlanta proposed curvilinear plans that not only took advantage of the site conditions but introduced less rigid streets. The streets were much less integrated with the houses than in urban cases. Early photographs show individual foot bridges, for example, going from the crown of the road to the sidewalk in front of each house. The suburban streets were more highway-like than urban. These neighborhoods could be seen as residential versions of some of the great city parks. The allure of a country house within the boundaries of the city was one of the forces behind the project.

Roland Park, Baltimore, Maryland

In 1890, a Baltimorian named William Edmunds, the president of a trade publication, *Manufacturers' Record*, decided to develop one hundred acres of his property five miles outside of Baltimore. With the help of a newspaper publisher in Baltimore and a businessman from Kansas City, Edward Bouton, he managed to get the Lands Trust Company of England, through their Kansas City agent, Jarvis and

Conklin, to back his project for a residential park. The park was to be named after an English land-holder of Baltimore County, Roland Thornberry, and by 1891 a Roland Park Company of Baltimore City had been established.[3]

At the time, Roland Park was only accessible from the city via cobblestone roads so the first task was the planning of new roads that could be more easily traversed by carriages. In addition to the building of new roads, electric and telephone lines were extended to the site. Eight local artesian wells were tapped for a water supply and two water towers assured constant water pressure.

The beliefs of the Roland Park Company were that a congenial community did not have to be made up strictly of wealthy inhabitants; thus there were provisions made for elevator apartment buildings and semi-detached houses as well as single family dwellings on a grander scale.[4]

The company also incorporated land-use restrictions into the deeds of each property in order to prevent any undesirable future building activity. This was the first instance in the United States of such a clause. The restrictions also prohibited individual outbuildings and stables on each property lot. At first a community stable was provided and after the widespread use of the automobile, individual garages were permitted for each property lot. The former stable became a community garage for the apartment buildings. New houses were to be built by architects, the plans of which had to be approved by a committee of architects and the company. A further stipulation was that residents would pay an annual fee for street cleaning and garbage collection, which were provided by the company.[5]

Residential lots in Roland Park went on sale in 1892. The lots were advertised in a three page advertisement in the *Baltimore Sun* and free carriage rides to the park were offered by the Roland Park Company from their offices on North Charles Street. There were very few buyers at first as there were only a few

houses built by the company, very far apart from each other, and the problem of transportation was still a great hindrance. Eventually, the company built the Lake Roland Elevated Railway as a direct connection between the city and the park. In addition, Roland Avenue, which had been a narrow country road was widened into a boulevard with trees planted on a center island.[6] A second plot of land, known as the Guilford District, was added to the park about 1915. It was planned by Frederick Law Olmsted, Jr. As might be expected, Olmsted was careful to follow the contours of the land quite closely in designing house lots and streets so that some houses would, in effect, be quite a distance from the street, while others quite near it, according to the land that they occupied.[7]

Streets in the new Guilford District were planted with trees and shrubbery that were selected so as to provide not only ample foliage but different colors at different times of the year. The concrete sidewalks were not finished in a typical hard and smooth manner but in a way that allowed the color and texture of the gravel particles to be apparent at the surface and thus more pleasing to the foot and the eye.[8]

The street gutters were deliberately made rather shallow so as to give the streets the appearance of a continuous surface and not broken by ditches at the edges. Olmsted also made provision for a number of private parks to be set in the middle of residential blocks for the exclusive use of the residents of the houses immediately surrounding them.[9]

At this time a shopping center was built for the community. The building complex that it occupies was originally planned as an apartment and office building, but it became clear that a shopping center would be crucial so the ground floor was given over to retail ventures. In 1896, one hundred and fifty acres of the park were set aside for an eighteen-hole golf course which became incorporated into the Baltimore Country Club in 1898. The name of the

club intentionally did not include "Roland Park" so as not to sound exclusive. By 1900, a number of protestant churches had been formed in the community as well as some primary and secondary schools. Later, two colleges and a Roman Catholic Seminary, St. Mary's, were built in Roland Park.[10]

In 1903, despite the formation of a well-established community, the English company that had originally backed the project withdrew its funds in order to make more money with the Kimberly Diamond Mines in South Africa.[11] The resounding success of Roland Park, however, is reflected in its being used as a model for later suburban developments such as the famed Country Club District of Kansas City.

Druid Hills, Atlanta, Georgia

The "ideal residential suburb" of Druid Hills, located northeast of the city of Atlanta was, on a financial level, the product of Joel Hurt, an ambitious Atlanta developer, and the Kirkwood Land Company.[12] Conceived of as early as 1890, the preliminary plan for this residential park was designed by Frederick Law Olmsted in 1893, and the final version, by his son and step-son in 1905.[13]

By 1875, Atlanta had become a burgeoning concern for the newly-industrialized world of the Ante-Bellum South. Hurt, a successful banker, developer and amateur botanist who had been living in Atlanta in this period, was effectively a civil engineer, as well. In his projects for urbanizing Atlanta, he made improvements in street and rail systems as well as commissioning architects such as John Wellborn Root to build in the city. Advised by his friend, Daniel Burnham of Chicago, to consider employing Olmsted for the work of laying out a residential suburb, Hurt was presented with the possibility of bringing to the capital city of the New South, the services of a well-established northern civil engineer.[14]

Covering some fourteen hundred acres, Olmsted's plan for subdividing this land into building lots and

View of a house in Roland Park, Baltimore, Maryland, early twentieth century.

roads included provisions for the necessary dams and bridges as well as lakes and a broad curved parkway named Ponce de Leon Avenue.[15] Given the (financial) Panic of 1893, however, the project was not pursued at this time and it was not until 1902 that Hurt was able to resurrect his dream for the "ideal residential suburb."[16]

In 1895, Frederick Law Olmsted had retired from his practice and was otherwise occupied with his last project, the Biltmore Estate. It was Frederick Law Olmsted, Jr., who, in conjunction with his step-brother, John C. Olmsted, furthered Hurt's project for Druid Hills. Preserving the essential concept of their father's plan, the two brothers drew up a final plan in 1905 for only a part of the overall acreage of the Kirkwood Land Company.[17] In it, however, they developed the character of Ponce de Leon Avenue as their father might have envisioned it. It was planned as a double parkway separated by small parks and openings giving way to the vistas provided by intersecting streets curving into the topography of the land where the individual building lots were located.[18] The system of parks achieved in the plan corresponded to Olmsted Senior's stated view of a hierarchy in uses for parks: "medium-sized parks for rural relaxation and picnicking, smaller landscaped areas with ponds for water recreation, and linear parkland for pleasure drives."[19]

Finally, the suburb as built, could reasonably be called a residential park. Primarily built in the neo-Georgian style so popular in the early twentieth century, the houses were nestled in miniature parks created by the judicious planning of the streets. The houses and miniature parks that they occupied were so well integrated that the newspaper *The Atlanta Constitution* reported in 1895 that the houses in Druid Hills supply "the demand for both a city home and a country residence. With its breezes and ozone laden parks, no one would think of leaving such a home for a trip to a summer retreat."[20]

Private Estates

In the private realm of the commissioning of landscape design, a style distinctly derivative of European landscape ideals was evident in the second half of the nineteenth century, an era of unabashedly extravagant estates. All along the East Coast, from Newport, Rhode Island to the gold coast of Northern Long Island to Palm Beach, Florida, there were estates whose landscape designs could just as easily have been found in the Loire Valley as in the United States.

A remarkable exception to this trend was Frederick Law Olmsted, Senior's plan for "Biltmore," George Washington Vanderbilt's estate in Asheville, North Carolina. Beyond the immediate confines of the mock fifteenth-century French chateau designed by Richard Morris Hunt, the rest of the estate's multitudinous acres were given over to the cultivation of a forest. It was just as much a plan of conservation as it was a landscape design. As Olmsted's last major project, it seems a fitting end to a career that started by calling attention to the deplorable plight of ravaged forests in the Ante-Bellum South.[21]

The Biltmore Estate, Asheville, North Carolina

The estate of George Washington Vanderbilt in Asheville, North Carolina was Frederick Law Olmsted's last design project. The plan was conceived of in a way quite different from the expected approach to estate design in the late nineteeth century in America. While the house was designed as a French chateau by Richard Morris Hunt as if it were on the North Shore of Long Island, the landscape work was a sensible, informed response to the natural conditions of the land.[22] It was a project to plant a forest.

Olmsted, in his first site visits to the property, had noticed that the land had been ravaged by an accumulation of forest fires, livestock grazing and the selling of wood, but at one time had probably been quite lush with various kinds of trees.[23] Upon seeing

the property, he immediately suggested that the land not be considered for contrived park scenery, but, in the fashion of some European estates, be made into a forest preserve. He declared to Vanderbilt: "The topography is most unsuitable for anything that can be called park scenery... such land in Europe would be made forest, partly if it belonged to a gentleman of large means, as a preserve for game, mainly with a view to crops of timber. That would be a suitable and dignified business for you to engage in; it would, in the long run, be probably a fair investment of capital and it would be of a great value to the country to have a thoroughly well organized and systematically conducted attempt in forestry made on a large scale."[24]

After conducting a lengthy survey of the property grounds, Olmsted judged from the state of the soil, that the land could best bear a forest of white pine trees. He proposed that these trees would grow well in the soil, especially once the soil was properly laced with lime and manure. He pointed out that the pine trees would provide a good alternative to the dominating oak trees, be green in the winter and be of good economic value in the future.[25]

For Vanderbilt, who had been planning the estate as a winter retreat for his mother and himself, an evergreen forest must have seemed quite appealing. In accounting for the possibility of forest fires, Olmsted included in his forest plan, a number of bisecting paths that could act as fire breaks, as well as the inclusion of sources of water such as streams.[26] Olmsted's phrasing of his plans were set forth in terms of forest management, another indication that this project was more concerned with conservation than design. He suggested to the young Vanderbilt that forest management would be "far more interesting to a man of poetic temperament than any of those (occupations) commonly considered appropriate to a country-seat life."[27] He also made it clear to Vanderbilt that the idea of "gentleman farming" was a "very unsatisfactory amusement."[28]

Olmsted conceded that there could be a formal park of some two hundred and fifty acres upon which the chateau could preside. He envisioned, however, an approach road to the house through the forest that would offer views of the house from a vehicle until the entrance gates were reached.[29] In addition, Olmsted imagined sub-tropical vegetation such as vines and creepers enveloping the trees of the approach road in order to give the appearance to guests arriving from New York in the winter that they were, indeed, closer to the sun here.[30] At the gates, there would be a sudden opening up of the land to expose the house and its immediate park. In the words of Olmsted, the effect of the approach road would be that of "an abrupt transition into the enclosure of the trim, level, open, airy, spacious, thoroughly artificial Court, and the Residence, with its orderly dependencies."[31]

For the two hundred and fifty acre park immediately surrounding the house, Olmsted deferred to the precedent set by Richard Morris Hunt's design for a French Renaissance chateau and accordingly referred to sixteenth-century models for chateau gardens. Specifically, he followed the example of Andre Le Notre's garden for the chateau of Vaux-le-Vicomte, also built for a young man, Louis XIV.[32] He planned a visual axis that would begin at the vestibule of the house and terminate at a temple of Diana placed on the east side of the house. All the formal gardens were then planted around this axis on the east side. Using English, French and Italian models, Olmsted created a series of walled gardens with complementary parterres, pools and wisteria-covered pergolas. He reserved the land on the west side of the house for an informal deer park and protected ramble for winter walks. As a transition between the formal park grounds of the chateau and the forest beyond, Olmsted designed a shrub garden with curving and sloping paths. This was a method he had employed many times previously in public park design.[33]

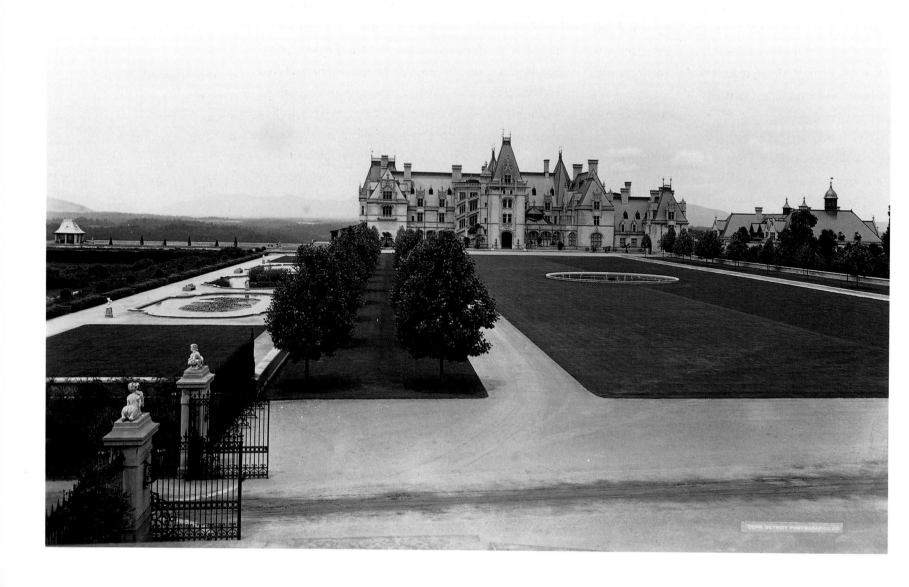

It is apparent from the correspondence between Olmsted and Vanderbilt that Olmsted was particularly interested in the planting of trees for the estate. He was convinced, for example, that this was a place to plant an arboretum, a "museum of living trees."[34] He believed that by thinning out an area of existing woods and then planting a number of trees of different specimens and in positions suitable for promoting their best characteristics, the results could be quite informative. He insisted that such an arboretum would be "by far finer and more instructive than any other in the world, an arboretum to which naturalists would report from all over the world."[35] He also advised Vanderbilt that it would be very cost efficient to establish a nursery on the grounds of the estate in which to grow plants from seedlings rather than importing fully-grown plants. He told Vanderbilt that if he put into effect the process of horticulture and forestry that he was advising, the estate would become so extraordinary that he would have "people crossing the Atlantic to see it."[36]

Olmsted's friend, Professor Charles Sargent of Harvard University's famed Arnold Arboretum, however, recommended that Olmsted abandon the notion that the planting of an arboretum could have any scientific merit for there were no scientists to attend to it. He advised that it would be more prudent on Olmsted's part to plant it as an ornamental garden. Sargent's advice offended Olmsted who had been thinking of this project strictly in terms of forestry and horticulture.[37]

Olmsted employed as the forester for the estate, Gifford Pinchot, the first professional forester in America. In 1898, Pinchot prepared an exhibit at the World's Columbian Exposition on the forest of Biltmore. It was the "first attempt in this country to explain and promote scientific forestry to the general public." Ten thousand free copies of the accompanying pamphlet were distributed by the generosity of Vanderbilt.[38] That same year, Pinchot brought to Biltmore, a young German named Carl Alwin Schenck to become the first resident forester of Biltmore. Schenck later established the first school of forestry in America on the grounds of the estate.[39] One of the most crucial factors in the success of the Biltmore estate was the proper engineering required for making the roads in the forest easily traversable and agreeable. For the one hundred miles of road in the forest, Olmsted gave the engineer in charge of this task very specific requirements for minimum road widths and radii for curves in the roads.[40] Any instance in which a road crossed a stream necessitated the building of a rough rock bridge with parapets and banks along the stream at that point. The road building requirements extended to the removal of trees within three feet of the road unless of a very special variety. Olmsted was plagued with the problem of providing a good hard surface for the roads and spent a great deal of time considering various possibilities. By 1896, however, a visitor to the estate was able to remark on the efficacy of the macadamized surface of the roads.[41] This was a sure sign that one of the principal estate planning ideals had been achieved.

The Hunnewell Estate, Wellesley, Massachusetts

"It will be my aim to plant every conifer, native or foreign, that will be found sufficiently hardy to thrive in our cold New England climate."
(from the diary of H. H. Hunnewell).[42]

On a much smaller scale than that of the Biltmore Estate, and a few decades earlier, there was another example of the desire to take advantage of the abundance of evergreen trees on the East Coast. The estate built by Horatio Hollis Hunnewell on the shores of Lake Waban opposite Wellesley College in Wellesley, Massachussetts was not planned by a garden designer. Mr. Hunnewell, a successful financier, was an avid amateur horticulturist and found great satisfaction in designing his own estate. The result was an elaborate and eccentric, all-season

evergreen garden known as the Hunnewell "pinetum." Begun in 1851, it is the oldest topiary garden in America.[43]

Obsessed with a vision of an Italian style garden on the land surrounding his Greek Revival manor house, Hunnewell made every effort to amass as many evergreen trees as he could possibly import to his land from the 1840s to the 1870s. In the process, he developed new varieties such as "hunnewelliana" and "hatfieldii," named after himself and an estate superintendent, respectively. He also named certain varieties of rhododendron, of which he imported thousands from England, after the women in his family.[44]

A five-acre lake front site, containing at least two hundred and fifty varieties of trees, the pinetum's appearance still bears a resemblance to that of contemporary images of it shown in stereoscopic photographs. It is planted on a series of seven terraces on a grade change of seventy-five feet and includes a number of belvederes, terraces and grottoes formed of simple wood and granite construction. At the base of the terraces, bordering the waterfront, is a carriage drive lined with a stone balustrade. Inspired by Italian gardens he had visited, Hunnewell was determined to create an equivalent for himself with the use of evergreens native to New England. Hunnewell even imported a Venetian gondola and gondolier for the lake.[45]

Much diminished in size and splendor today, the estate still maintains a forty-acre arboretum of evergreen trees as well as an extensive rhododendron garden which are visited by students of horticulture and landscape design. Hunnewell had built houses for all of his eight children on the grounds of the estate so the property is still in the family and still being tended today.

The Lawrenceville School, Lawrenceville, New Jersey

The grounds of the Lawrenceville School were planned by the office of Frederick Law Olmsted in Brookline, Massachusetts in the 1880s.[46] The original core of the campus was composed of buildings around a circus of lawn. The simplicity of the plan relied on the planting of trees on its circumference to give it a character beyond that of an open field. The buildings on the circus accommodated both classrooms and dormitories.

The dormitory buildings were conceived of in a very domestic style and built to resemble large rambling houses, all in red brick with green shutters. The classroom buildings, on the other hand, were built of rough stone in the contemporary neo-Romanesque style. These buildings, in shades of browns and reds with smooth stone window and door frames are distinctly institutional in character. In a letter to Dr. J. C. Mackenzie, the headmaster of the school, Olmsted proposed that the placement of the buildings should reflect an arrangement in which every bedroom in the houses would receive sunlight at least one time during the course of a day, while the classroom buildings should be oriented so as to avoid receiving any direct rays from the sun.[47]

As the campus expanded, to include a gymnasium and playing fields, additional land had to be acquired beyond the confines of the initial circus. Correspondence between Olmsted and Dr. Mackenzie indicate that the additional land was essential for the work.[48]

This seems to imply that the territory of the central circus of the campus could not be disturbed. In a letter from Olmsted to Mackenzie, written on stationery of the architectural firm of Peabody and Sterns of Boston, Olmsted responded to Mackenzie's suggestion to Mr. Peabody that the houses be moved from the south front of the campus to the east side adjacent to the playing fields. In the letter, Olmsted noted that the grounds of the school could not be considered in urban terms in which there were front and back sides to buildings with rear alleys, for example. He stated, instead, that the cam-

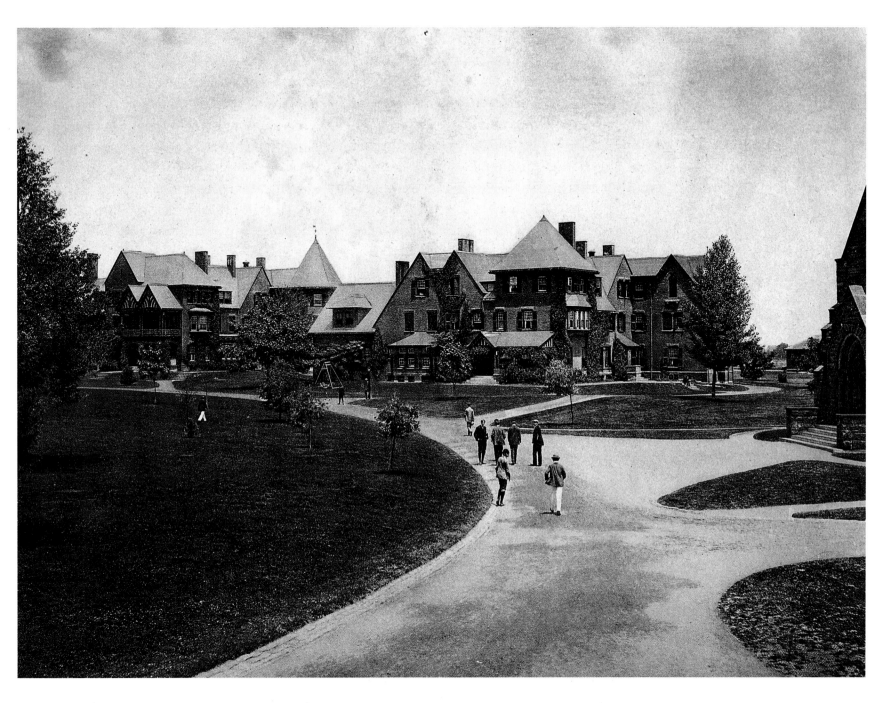

View of the Circus,
Lawrenceville School,
Lawrenceville, New Jersey,
Frederick Law Olmsted,
circa 1900.

pus was designed in such a way so as to make the buildings, standing in the middle of a park, have north and south fronts. Olmsted furthered his point on this issue by reminding Mackenzie that schools he had seen in England and on the Continent had followed such an arrangement as well.[49]

Relative to some apparent frustrations regarding the planning of the playing fields of the Lawrenceville School, Olmsted quoted in a letter to Mackenzie the admonition of a certain Judge Green, presumably a trustee of the school, that "the school should be a place for study—not for play."[50] In the final plan for the overall campus, the playing fields

appear as a distinct campus from that of the front circus. They were designed at a later date, after some delays in acquiring the proper amount of land. As it stands today, the South Circus is very much intact with mature deciduous trees lining its circular drive. The great brick buildings surrounding it are still in good form. It serves as a portal to the overall campus which is now much greater in size. The playing fields surround this original part of the campus and in fact, Dr. Mackenzie's vision of dormitories facing the fields has recently been realized with the construction of new residential structures on that part of the campus.

[1]J. Ackerman, *The Villa*, Thames and Hudson, London, 1990, p. 298.

[2]J. Arnold, *The New Deal in the Suburbs*, Ohio State University Press, 1971, pp. 3–4.

[3]Community Research and Development, Inc., *Reflections on Roland Park*, published by the village of Cross Keys, Maryland, 1964, p. 2.

[4]Ibid., pp. 2–3.

[5]Ibid., pp. 3–4.

[6]Ibid., pp. 4–5.

[7]Ibid., p. 6.

[8]The Roland Park Company, Baltimore, Maryland, *Guilford*, Information for Buyers, Owners and Architects (The Roland Park-Guilford District, 100 acres of restricted land), Pamphlet no. 2, April 1914, p. 9.

[9]Ibid., p. 8.

[10]*Reflections on Roland Park*, pp. 11–13.

[11]Ibid., p. 13.

[12]E. A. Lyon, "Frederick Law Olmsted and Joel Hurt: Planning for Atlanta," in *Olmsted South*, Old South Critic New South Planner, edited by Dana F. White and Victor A. Kramer, Greenwood Press, Westport, Connecticut, 1979.

[13]Ibid., p. 165.

[14]Ibid., pp. 166–167.

[15]Ibid., pp. 171–173.

[16]Ibid., p. 176.

[17]Ibid., p. 177.

[18]Ibid., p. 178.

[19]Ibid., p. 178.

[20]Ibid., p. 179.

[21]For a review of Olmsted's southern experiences see the first volume of *The Papers of Frederick Law Olmsted, The Formative Years, 1822–1852*, edited by C. McLaughlin and C. Beveridge, The Johns Hopkins University Press, 1977.

[22]The following description of Biltmore is based on V. L. Volk's *The Biltmore Estate and its Creators: Richard Morris Hunt, Frederick Law Olmsted and George Washington Vanderbilt*, an Abstract of a Dissertation, Emory University Graduate Institute of the Liberal Arts, 1984.

[23]Ibid., pp. 139–140.

[24]Ibid., p. 138.

[25]Ibid., pp. 140–141.

[26]Ibid., p. 141.

[27]Ibid., p. 142.

[28]Ibid., p. 142.

[29]Ibid., pp. 144–145.

[30]Ibid., p. 161.

[31]Ibid., p. 145.

[32]Ibid., p. 151.

[33]Ibid., pp. 151–152.

[34]Ibid., p. 163.

[35]Ibid., p. 144.

[36]Ibid., p. 145.

[37]Ibid., p. 164.

[38]Ibid., p. 148.

[39]Ibid., p. 165.

[40]Ibid., p. 153.

[41]Ibid., pp. 153–158.

[42]The following description of Hunnewell Gardens is based on on-site observations and an undated article by M. J. Ertman in *Wellesley* (number of issue unknown, the alumnae magazine of Wellesley College, p. 9. (My appreciation to the Wellesley Historical Society for the use of original photographs.)

[43]Ibid., p. 11.

[44]Ibid., p. 9.

[45]Ibid., p. 11.

[46]The description of the Lawrenceville School is based on on-site observations and correspondence between Frederick Law Olmsted and Dr. J. C. Mackenzie, the headmaster of the Lawrenceville School at the time. (My appreciation to the John Dixon Library of the Lawrenceville School for copies of the correpondence and use of original photographs.) While the work of the Olmsted firm took place in the 1880s, the school was actually founded in 1810. The history of its campus design before Olmsted's time is unknown to this author.

[47]In a letter from Olmsted to Mackenzie dated April 28, 1883.

[48]In a letter from Olmsted to Mackenzie dated March 14, 1884.

[49]In a letter from Olmsted to Mackenzie dated October 22, 1883.

[50]In a letter from Olmsted to Mackenzie dated January 25, 1885.

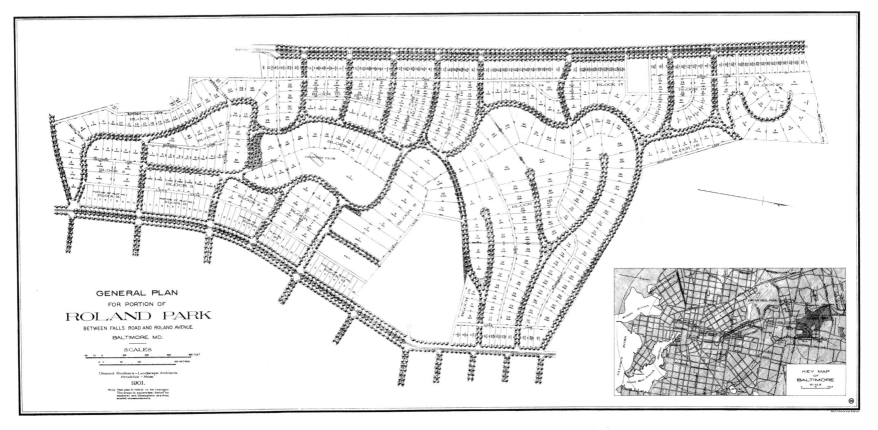

General Plan for Portion of Roland Park, Olmsted Brothers, 1901.

View of a house in Roland Park, Baltimore, Maryland, early twentieth century.

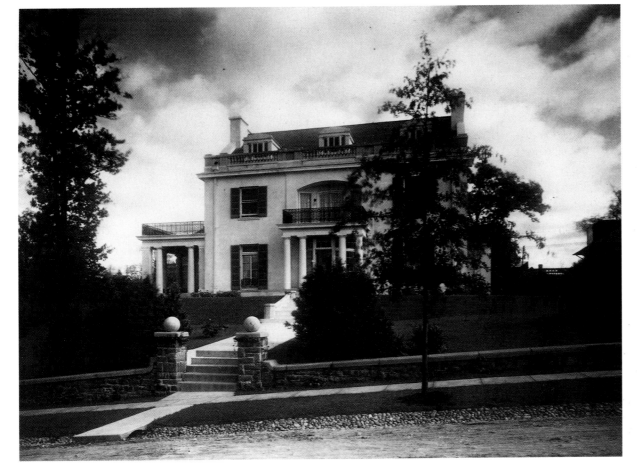

Roland Park
Baltimore, Maryland

Begun in 1890 as the subdivision of a one hundred acre site five miles outside of the city, this was one of the first automobile suburbs. In 1901 Olmsted provided a plan for a portion of the area and then again in 1915, for the neighboring Guilford District. Houses in the park were distinctly separated from the streets and set back quite a distance. Apartment buildings, a shopping center and a country club were added later.

89

Druid Hills

Atlanta, Georgia

Developed between 1890 and 1905
and designed initially by Olmsted,
Sr. and later, by his sons, Druid
Hills was planned as a fourteen
hundred acre park. A double
parkway provided primary access
while secondary streets, merging into
the topography, led to the residential
lots, small parks in and of
themselves, judiciously screened
from the street by landscaping.

General plan for subdivision
of property to be known as
Druid Hills, Atlanta,
Georgia, Olmsted Brothers,
1905.

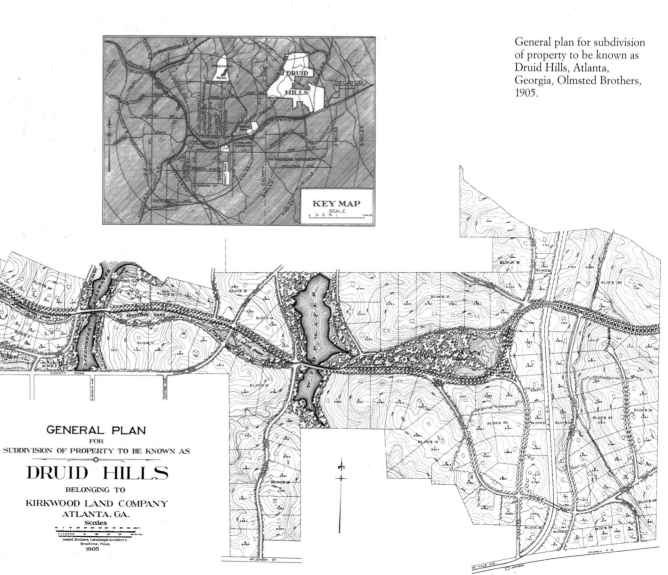

GENERAL PLAN
FOR
SUBDIVISION OF PROPERTY TO BE KNOWN AS

DRUID HILLS
BELONGING TO
KIRKWOOD LAND COMPANY
ATLANTA, GA.
Scales

Olmsted Brothers, Landscape Architects.
Brookline, Mass.
1905

The River Road, Biltmore,
North Carolina, 1902.

Biltmore Estate
Asheville, North Carolina

Frederick Law Olmsted's last landscape project, the Biltmore Estate of 1899, was planned for George Washington Vanderbilt in terms of conservation and forest management rather than design. Leaving two hundred and fifty acres free for parterres surrounding the "chateau" designed by Richard Morris Hunt, Olmsted gave over the rest of the enormous acreage to the planting of white pine trees. One hundred miles of road traversed the forest that Olmsted had persuaded Vanderbilt would be more engaging for him to maintain as a hunting park and arboretum than a farm with livestock.

92

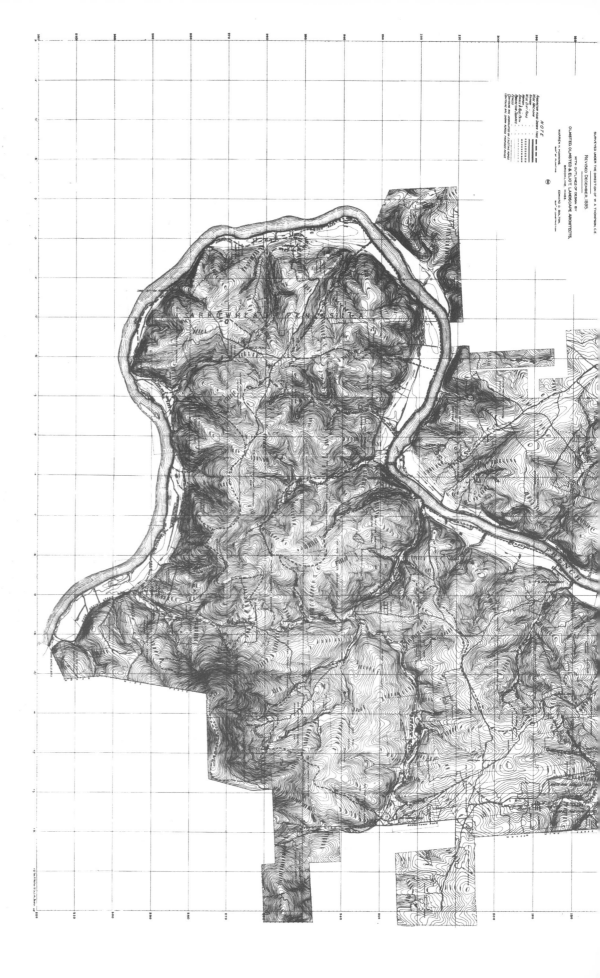

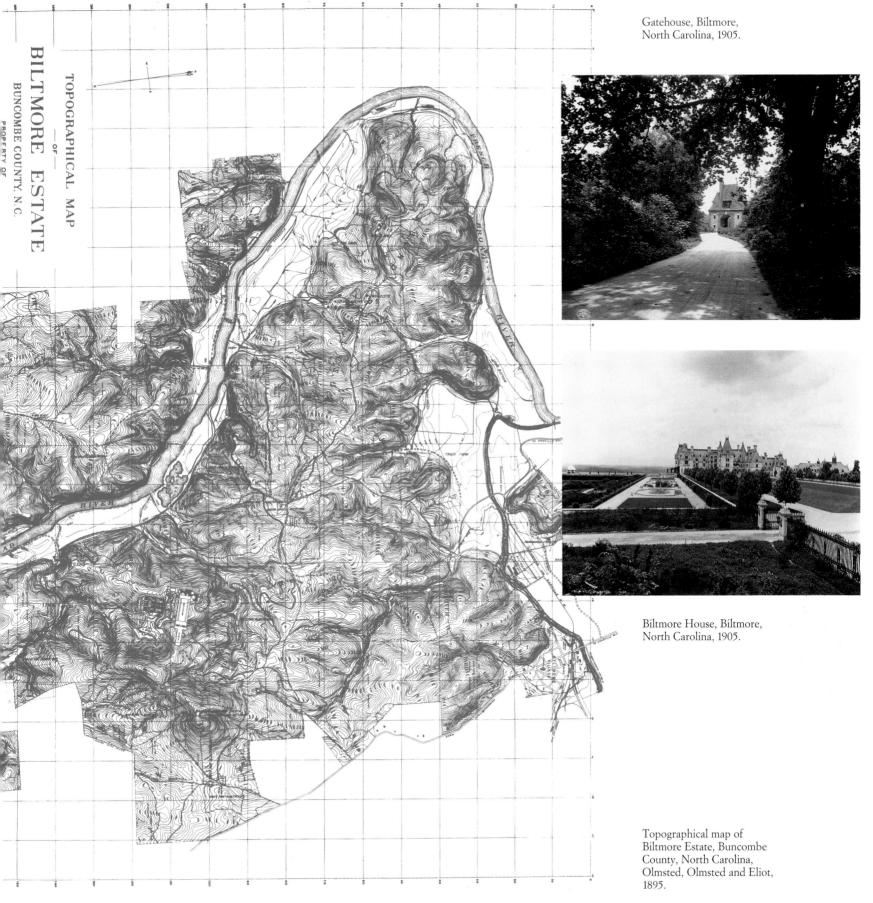

Gatehouse, Biltmore,
North Carolina, 1905.

Biltmore House, Biltmore,
North Carolina, 1905.

Topographical map of
Biltmore Estate, Buncombe
County, North Carolina,
Olmsted, Olmsted and Eliot,
1895.

TOPOGRAPHICAL MAP

— OF —

BILTMORE ESTATE

BUNCOMBE COUNTY, N.C.

PROPERTY OF

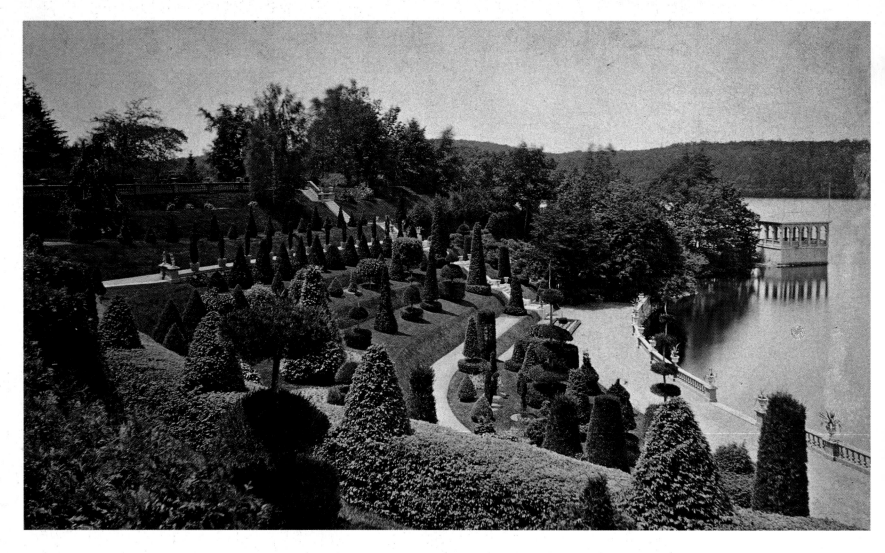

The Hunnewell Estate
Wellesley, Massachusetts

The oldest topiary garden in America, the Hunnewell "Pinetum" on the shores of Lake Woban was begun in 1851 by Horatio Hollis Hunnewell, a successful financier and amateur horticulturist. Two hundred and fifty varieties of evergreens were planted on a series of terraces reminiscent of Italian gardens Hunnewell had visited.

View of the gardens and of the main house, Hunnewell Estate, early twentieth century.

"The Artist's Dream," Hunnewell Gardens, stereoscopic photograph, 1894.

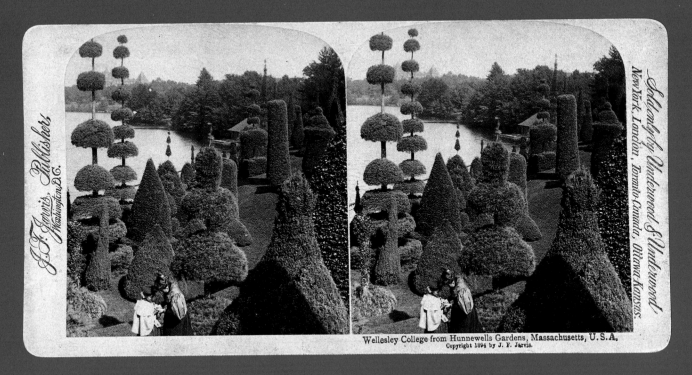

Wellesley College from Hunnewells Gardens, Massachusetts, U.S.A.
Copyright 1894 by J. F. Jarvis.

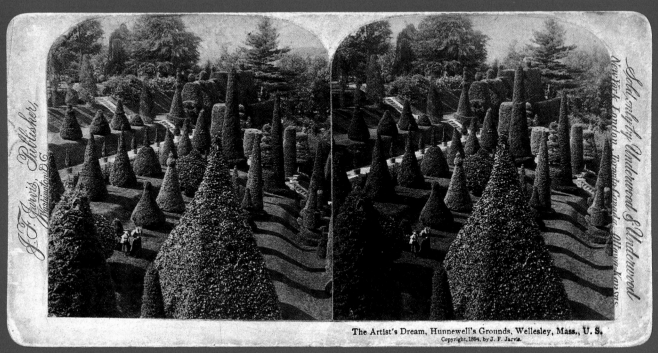

The Artist's Dream, Hunnewell's Grounds, Wellesley, Mass., U. S.
Copyright, 1894, by J. F. Jarvis.

Lawrenceville School
Lawrenceville, New Jersey
Designed in the 1880s by the
Olmsted firm in the manner
of certain English and European
schools, the campus plan is defined
by a central circus around which the
buildings are placed. The buildings
are meant to be understood as
separate entities within a park,
having no "streetfront" or "back."

Views of the Circus,
Lawrenceville, New Jersey,
circa 1900.

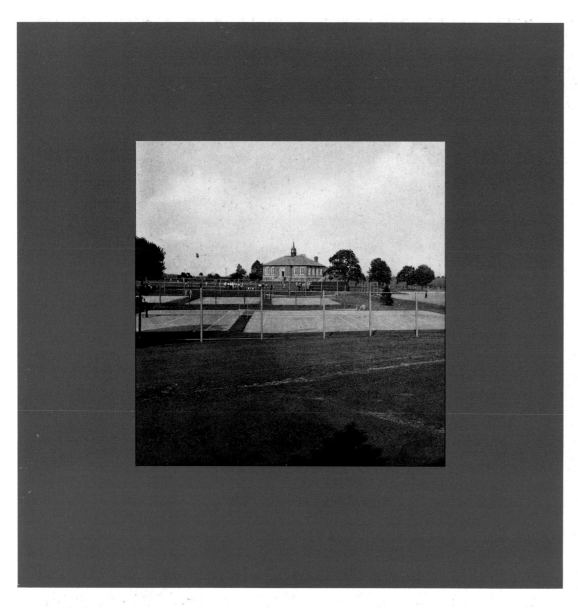

General view of athletic
fields, Lawrenceville School,
circa 1900.

Classroom building, upper
house, residence of senior
class, and bath house, circa
1885.

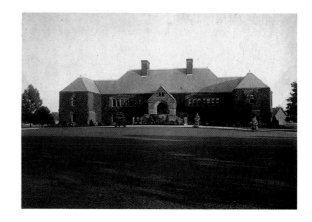

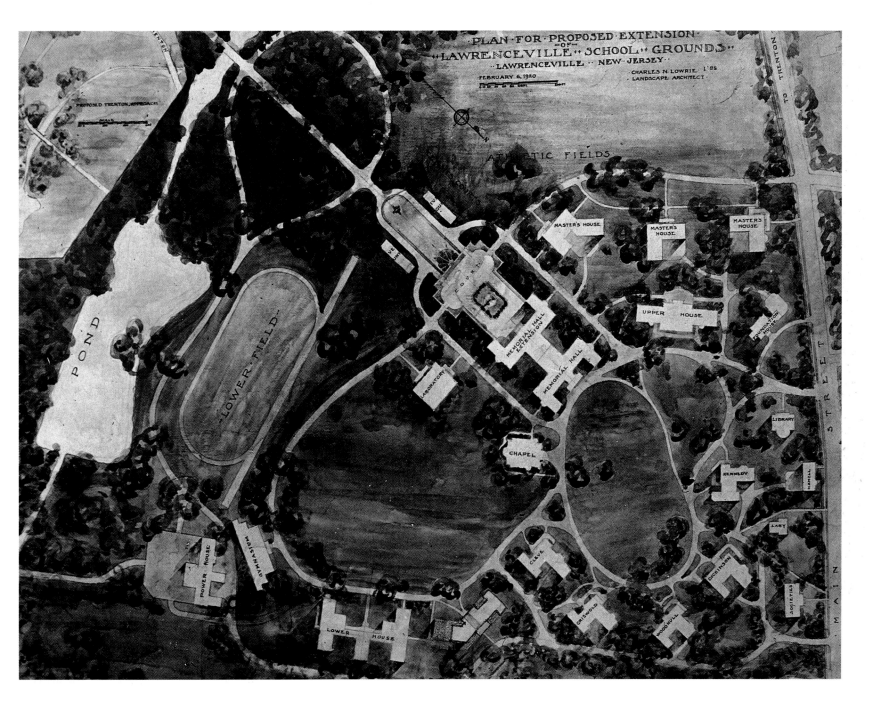

PLAN·FOR·PROPOSED·EXTENSION·
·OF·
··LAWRENCEVILLE··SCHOOL··GROUNDS··
·LAWRENCEVILLE··NEW·JERSEY·

FEBRUARY 6, 1920 CHARLES N. LOWRIE, L'88
LANDSCAPE ARCHITECT

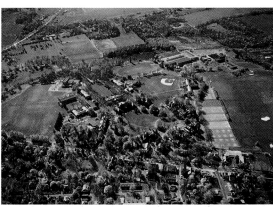

Plan for proposed extension
of Lawrenceville School
Grounds, Charles Lowrie,
1920.

Aerial photograph,
circa 1970.

National Parks and the First Cross Country Highway

Lincoln Highway, Yellowstone, Yosemite, Grand Canyon

While the urban and suburban residential parks of the second half of the nineteenth century brought the benefits of nature to city dwellers and those willing to live on the fringes of the city, the project for establishing National Parks out of great tracts of land in the uncharted West would ultimately make possible the first-hand viewing of the immense American landscape.

If the natural features of New York State such as Niagara Falls were first made known to the public through the medium of painting, the canyons and summits of the West were publicized in articles in daily newspapers. As early as the 1860s, newspapers such as the *New York Tribune* and the *Springfield (Massachusetts) Republican* were carrying numerous pieces on the features of the western landscape.[1] Immediately after the Civil War, Samuel Bowles, the editor and publisher of the *Springfield Republican*, Albert Richardson, a correspondent for the *New York Tribune*, and Schuyler Colfax, the Speaker of the United States House of Representatives,

made a pioneering voyage to the government-sanctioned preserves of the West.[2] Shortly after this trip, Bowles and Richardson published their collected essays on the American landscape. Bowles's *Across the Continent*, 1865, and *Our New West*, 1869, and Richardson's *Beyond the Mississippi*, 1867, became best-selling books among an urban population eager to know what the greater part of their country's landscape looked like.[3] Bowles was one of the first advocates of the preservation movement, which called not only for western land grants, but the protection of sites such as Niagara Falls and the Adirondack Mountains. He phrased his public appeals in a way that would generate national pride in American land and the use of it for public enjoyment.[4]

Bowles and Richardson, however, were not the first writers to exclaim over the grandeur of the American landscape. In the late eighteenth century, national pride in the landscape had already been promulgated by writers such as Thomas Jefferson and Philip Freneau.[5] Jefferson and Freneau both advocated crossing the Atlantic from Europe solely in order to see America's natural phenomena. Jefferson was particularly proud of the Natural Bridge formed out of a giant boulder in Virginia and the rapids of the Potomac River at Harpers Ferry, West Virginia.

Even with appealing prose on the wonders of the West by writers such as Bowles and Richardson readily available, most Americans in the nineteenth century could but remain indifferent to its allure, for they had neither the opportunity or the means to see it for themselves.[6] With the great distances involved, Western tourism at this time could only be categorized as an exotic luxury, a safari at home. Even in the early twentieth century, with the creation of cross country highways, the essential resources needed to make such a journey were prohibitive to most of the population.

The impetus for the United States Congress to pro-

tect western land, most of which the Federal Government already owned by the middle of the nineteenth century, was provided not only by the eloquent reports of journalists such as Bowles and Richardson, but by the compelling visual images of it painted by Albert Bierstadt and Thomas Moran. Founders of the Rocky Mountain School of painting, Bierstadt and Moran gave to an American audience, unsure of their cultural worth, the impression that the magnificence of their country's natural features far outweighed any such misgivings.[7] They did this not only with astonishing feats of painterly technique but with a little bit of exaggeration as well in the depiction of scale and abrupt landscape changes. The Yosemite Valley and the Sierra Redwoods, discovered in the early 1850s, was their chief subject. Not since the discovery of Niagara Falls had such an American landscape, worthy of international recognition, been hailed by the formation of a unique school of painting.

Coeval with the practices of mild painterly deception among the Rocky Mountain School, a number of writers were apt to describe the landscape of the West as superior to any landscape to be found in Europe and often made poetic references to the prehistoric origins of its land formations and forests.[8] In 1859, Horace Greeley of the *New York Tribune*, wrote of the Sierra Redwoods: "(They) were of very substantial size when David danced before the ark, when Solomon laid the foundations of the Temple, when Theseus ruled in Athens, when Aeneas fled from the burning wreck of vanquished Troy (and when) Sesostris led his victorious Egyptians into the heart of Asia."[9]

The lenses of the photographers documenting the natural features of the land that would ultimately be preserved forever as National Parks were less prone to exaggeration, but, indeed, their prints give credence to the level of frenzy that the appreciation of Western landscape had reached by the turn of the century.[10]

By the 1920s, the National Parks and their accompanying rail and road connections, were so well-established that their attractions were reported not only in newspapers and essays, but elevated to the level of being included in fiction. In F. Scott Fitzgerald's short story, *He Thinks He's Wonderful*, a road trip to a National Park is mentioned as a summer holiday: "... Basil, Listen! I have to tell you: Father was talking after breakfast and he told Uncle George that he'd never met such a nice, quiet, level-headed boy as you, and cousin Bill's got to tutor this month, so Father asked Uncle George if he thought your family would let you go to Glacier Park with us for two weeks so I'd have some company..."[11]

Examples of poetry and prose on the subject of the National Parks were not restricted to journalism and fiction. Even the authors of otherwise purely factual government reports could not resist waxing eloquence on the marvels to be found in the American West.[12]

National Parks

"He is numbed by the spectacle. At first he cannot comprehend it. There is no measure, nothing which the eye can grasp, the mind fathom. It may be hours before he can even slightly adjust himself to the titanic spectacle, before it ceases to be utter chaos; and not until then does he begin to exclaim in rapture. And he never wholly adjusts himself, for with dawning appreciation comes growing wonder. Comprehension lies always just beyond his reach."[13] (From a report on the Grand Canyon, *National Parks Portfolio*, Department of the Interior, 1916)

The motivation behind the creation of the great National Parks was based on an interest in conservation and the making of American wilderness accessible to the public. A report published in 1916 by the United States Department of the Interior reveals that the natural wonders of the country, which had previously been unknown as tourist sites among

Americans, had suddenly become a point of interest when Europe was made off limits to tourists because of the War.[14] This report also applauded the investment of tourist money into the United States rather than Europe. With the increased travel across the country, railroads as well as park lodges had made corresponding economic strides.

The Department of the Interior reminded its readers that the United States had much to offer in the way of fresh air and picturesque scenery: "There is no reason why this nation should not make its public health and scenic domain as available to all its citizens as Switzerland and Italy make (theirs)."[15] In this remark, there is a striking similarity in intention to the stated goals of Frederick Law Olmsted for park building as a means of improving the level of public health. By 1916, the advantages of park life for city dwellers had been made so evident that this line of reasoning, applied to a greater scale, i.e., the American wilderness, could be seen as a logical extension of the initial ideal: "Just as the cities are seeing the wisdom and necessity of open spaces for the children, so with a very large view the Nation has been saving from its domain the rarest places of grandeur and beauty for the enjoyment of the world."[16]

With the opening of so many new railroad routes the Department of the Interior could boast at this time that a large number of Americans had made a trip to the West to see for themselves the wilderness of the National Parks. A telling comment in the Department's *National Parks Portfolio* suggests that these excursions were preferable to traditional visits to the sites of natural grandeur in Europe: "It would appear from the experience of the past year that the real awakening as to the value of these parks has at last been realized, and that those who have hitherto found themselves enticed by the beauty of the Alps and the Rhine and the soft loveliness of the valleys of France may find equal if not more stimulating satisfaction in the mountains, rivers and valleys which this Government has set apart for them and all others."[17]

The largest of the National Parks is the Yellowstone. A forest covering thirty-three hundred square miles in the northwestern corner of Wyoming, it is marked by canyons, rivers, lakes, waterfalls, boiling springs and more geysers than all the rest of those in the world put together. This is the home of the famous geyser, "Old Faithful." The Great Falls of the Yellowstone are twice as high as Niagara Falls.[18]

Traversed by over two hundred miles of roads, the park contains five lodges built in the rustic manner characteristic of park architecture of the early twentieth century, as well as in a modernistic style and even a quasi-georgian mode. In addition, numerous clearings were provided for public camps so that visitors travelling by private touring cars could set up the tents that went along with their automobiles. Three of the four entrances to the park had railroad connections. These, in turn, led into a central belt road which connected many of the major sites of interest.[19]

The great canyon of the Yellowstone, seen from Inspiration Point, is described in the report of the Department of the Interior in vivid prose: "The whole is streaked and spotted and stratified in every shade from the deepest orange to the faintest lemon, from deep crimson through all the brick shades to the softest pink, from black through all the grays and pearls to glistening white. The greens are furnished by the dark pines above, the lighter shades of growth caught here and there in soft masses on the gentler slopes and the foaming green of the plunging river so far below. The blues, ever changing, are found in the dome of the sky overhead."[20]

In 1872, Yellowstone Park was made a preserve for wildlife and by 1916, it was reported that there were elk, bear, deer, antelope, bison, moose and bighorn mountain sheep protected by hunting restrictions. So sheltered were these animals that they became

comparatively tame and unafraid to wander among visitors.[21]

If Yellowstone's natural features were to be found in an immense forest, those of the Yosemite were to be discovered among the barren granite walls of a canyon formed by a glacial river in central California. Within this great canyon are at least five waterfalls of exceptional magnitude. The largest one, Yosemite Falls, drops 1,430 feet, a height nine times as great as that of Niagara Falls.[22] (This height is several hundred feet greater than that of the twin towers of the World Trade Center in New York.) This park also contains the gigantic Sierra Redwoods. The Yosemite Act of 1864, signed by President Abraham Lincoln restricted the Yosemite Valley to "public use, resort and recreation"[23] and thereby made it, officially, the first national park.

The Glacier National Park, on the Canadian border of northwestern Montana, is poised on the continental divide of the Rocky Mountains. As its name indicates, its topography is comprised of a particularly rugged range of mountains formed by glacial age sea deposits and capped with sixty glaciers. The report of the Department of the Interior refers to this park as the American Switzerland. The park is also the location of the Triple Divide, a source from which waters flow into the Pacific Ocean, the Hudson Bay and the Gulf of Mexico.[24]

The park is not immediately accessible from railroad lines but there are special buses that link the nearest railroad stations to the center of the park. Perhaps the most popular feature of the park are its two hundred and fifty lakes. The report of the Department of the Interior describes the park in the following way. "Imagine these mountains crumbled and broken on their east sides into precipices sometimes four thousand feet deep and flanked everywhere by lesser peaks and tumbled mountain masses of smaller size in whose hollows lie the most beautiful lakes you have ever dreamed of."[25]

While the report also lists a number of comfortable lodges and chalets for the visitor to stay in, it recommends more highly camping in the park as a way of improving one's physical and spiritual health: "If the enterprising traveler desires to know this wilderness wonderland in all its moods and phases, he must equip himself for the rough trail and the wayside camp. Thus he may devote weeks, months, summers to the benefitting of his health and the uplifting of his soul."[26]

The most extreme examples of natural phenomena in the panorama of American wilderness are Mount Rainier in the state of Washington and the Grand Canyon in Arizona. Over fourteen thousand feet high, the summit of Mount Rainier is the source of twenty-eight rivers of ice that slide down its sides. Indian legend describes a peak that had once been cone-shaped and two thousand feet higher, but blown off by a volcano.[27] The Grand Canyon, on the other hand is a spectacle of depth. Covering an area of one thousand square miles, it is filled with craggy minarets and pyramids carved out of its depths; the tiny silver line of the Colorado River lies one mile below the feet of the observer at the rim of the canyon.[28] Proclaimed a national monument in 1908 by Theodore Roosevelt, it was made a national park by Congress in 1919.[29]

The Lincoln Highway

While there were a number of railroad connections to entrance points of many of the National Parks, it was the building of roads across the land and into the wilderness that made independent voyages into natural preserves possible. Admittedly, such solo ventures were only possible with the use of the newly invented private automobile, a luxury beyond the means of most of the population at the time.

The first cross-country highway, named in honor of Abraham Lincoln, was built between 1916 and 1919 and extended 3,305 miles, from New York City to San Francisco.[30] It was promoted by the Packard Motor Car Company, which sold the official Lin-

104

View of Mirror Lake,
Yosemite, California, 1986.

Skyline Drive, Virginia,
1930s.

Mitchell Point Tunnel,
Columbia River Highway,
Oregon, 1933.

coln Highway touring car along with accompanying guidebooks containing maps and practical information for motorists planning to camp in parks along the way.[31]

This model of the Packard touring car was conceived of by its designers as a self-sufficient mobile home. It could even be converted into a tent with a canvas tarpaulin and support poles.

The highway followed a northerly route, passing through Chicago in the midwest and the Yellowstone National Park in the far west, before reaching California. By the early 1920s, there were overland touring highways established in California and the far west such as the "Pacific Highway," the "Ever-green National Highway" and the new "Santa Fe Trail."[32] At last, a systematized method of going into the wilderness on one's own and experiencing it directly had been established.

Both the touring highways that were proposed and actually built between 1910 and 1923 can be seen as having been instrumental in the promotion of the automobile as a means of seeing the country. The roads built as "parkways" immediately following this period, might be seen as similar in their initial intention of opening up the landscape to the automobile but, ultimately, must be addressed on the basis of their ubiquitous function as commuter routes to the cities that they surrounded.

[1]A. Runte, *National Parks*, University of Nebraska Press, Lincoln and London, 1979, p. 12.

[2]Ibid., p. 12.

[3]Ibid., p. 13.

[4]Ibid., p. 13.

[5]Ibid., pp. 14–15.

[6]Ibid., p. 14.

[7]Ibid., pp. 23–25.

[8]Ibid., pp. 19–21.

[9]Ibid., p. 22.

[10]Ibid., pp. 24–25.

[11]F. Scott Fitzgerald, "He Thinks He's Wonderful," in *The Basil and Josephine Stories*, 1928. A number of Fitzgerald's short stories give lyrical descriptions of summer cabins and lakes in the countryside immediately surrounding the twin cities of St. Paul and Minneapolis.

[12]In 1916, the United States Department of the Interior published a *National Parks Portfolio* (Scribner's, New York). Printed as a manual or guide book that listed railroad connections and provided comparative statistics on the various parks, it also gave way to a good deal of florid prose in the descriptions of the parks.

[13]U. S. Department of the Interior, "Colossus of Canyons," in *National Parks Portfolio*, Scribner's, New York, 1916.

[14]U. S. Department of the Interior, "Introduction," in *National Parks Portfolio*, Scribner's, New York, 1916.

[15]Ibid.

[16]Ibid.

[17]Ibid.

[18]U. S. Department of the Interior, "Threefold Personality," in *National Parks Portfolio*, Scribner's, New York, 1916 (description of Yellowstone National Park). The section describing the geysers is called "Threefold Personality" because it suggests that, "The Personality of the Yellowstone is threefold. The hotwater manifestations are worth minute examination, the canyon a contemplative visit, the park a summer."

[19]U. S. Department of the Interior, "Living in the Yellowstone," in *National Parks Portfolio*, Scribner's, New York, 1916 (description of Yellowstone National Park).

[20]U. S. Department of the Interior, "Many-Colored Canyon," in *National Parks Portfolio*, Scribner's, New York, 1916 (description of Yellowstone National Park).

[21]U. S. Department of the Interior, "Greatest Animal Refuge," in *National Parks Portfolio*, Scribner's, New York, 1916 (description of Yellowstone National Park).

[22]U. S. Department of the Interior, "The Valley Incomparable," in *National Parks Portfolio*, Scribner's, New York, 1916 (description of Yellowstone National Park).

[23]A. Runte, *National Parks*, op. cit., p. 29.

[24]U. S. Department of the Interior, "Making a National Park," in *National Parks Portfolio*, Scribner's, New York, 1916 (description of Yellowstone National Park).

[25]Ibid.

[26]U. S. Department of the Interior, "Comfort Among Glaciers," in *National Parks Portfolio*, Scribner's, New York, 1916 (description of Yellowstone National Park).

[27]U. S. Department of the Interior, "In an Arctic Wonderland," in *National Parks Portfolio*, Scribner's, New York, 1916 (description of Mount Rainier).

[28]U. S. Department of the Interior, "Colossus of Canyons," in *National Parks Portfolio*, Scribner's, New York, 1916 (description of the Grand Canyon).

[29]A. Runte, *National Parks*, op. cit., illustration caption between pages 16 and 17.

[30]Lincoln Highway Association, *Lincoln Highway Route Conditions and Directions*, Detroit, Michigan, 1915–20. "The purpose of this association is to immediately promote and procure the establishment of a continuous improved highway from the Atlantic to the Pacific, open to the lawful traffic of all descriptions, without toll charges and to be of concrete wherever practicable. The highway is to be known as "The Lincoln Highway" in memory of Abraham Lincoln. (This account of the Lincoln Highway is taken from C. Zapatka, "The American Parkways," in *Lotus International*, no. 56, Electa, Milan, 1988.)

[31]*The Complete Official Road Guide of the Lincoln Highway*, issued annually by the Packard Motor Car Company and the Lincoln Highway Association, Detroit, Michigan, 1915–1920.

[32]*Map of California*, Rand McNally, Chicago, 1923.

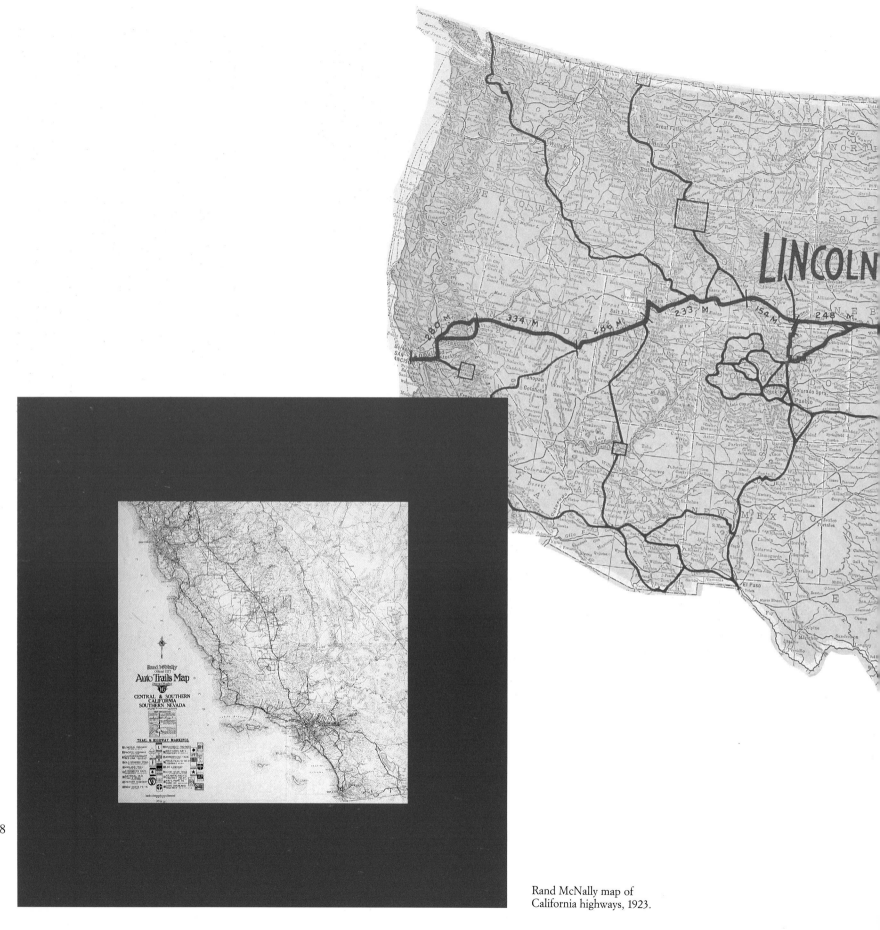

108

Rand McNally map of
California highways, 1923.

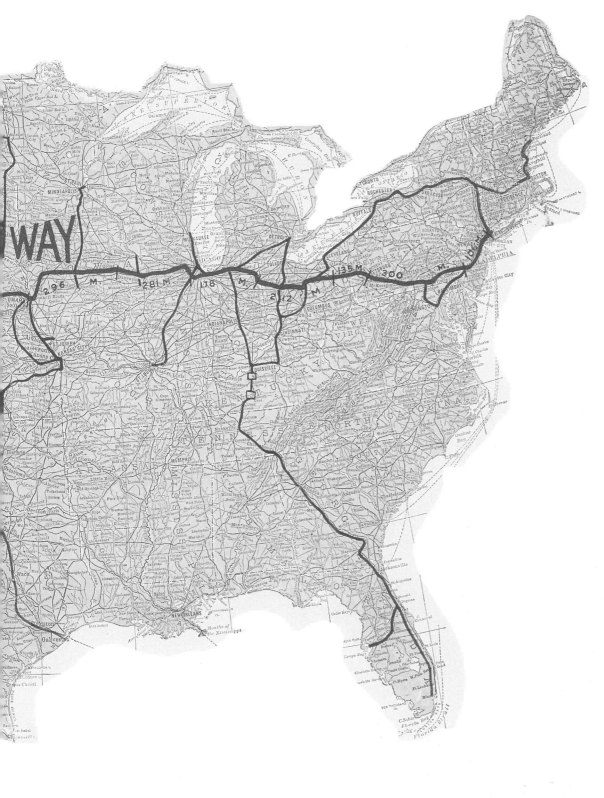

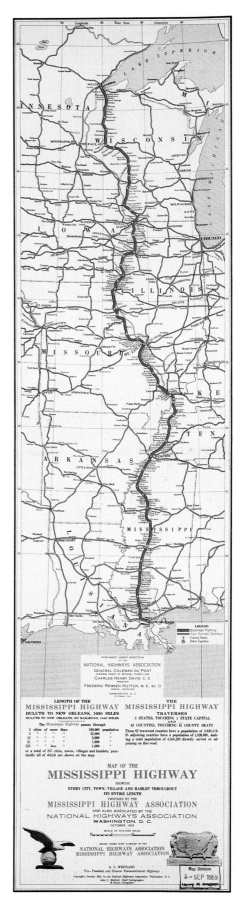

Promotional poster for the
Lincoln Highway, 1919.

Map of Mississippi Highway,
National Highways
Association, 1915.

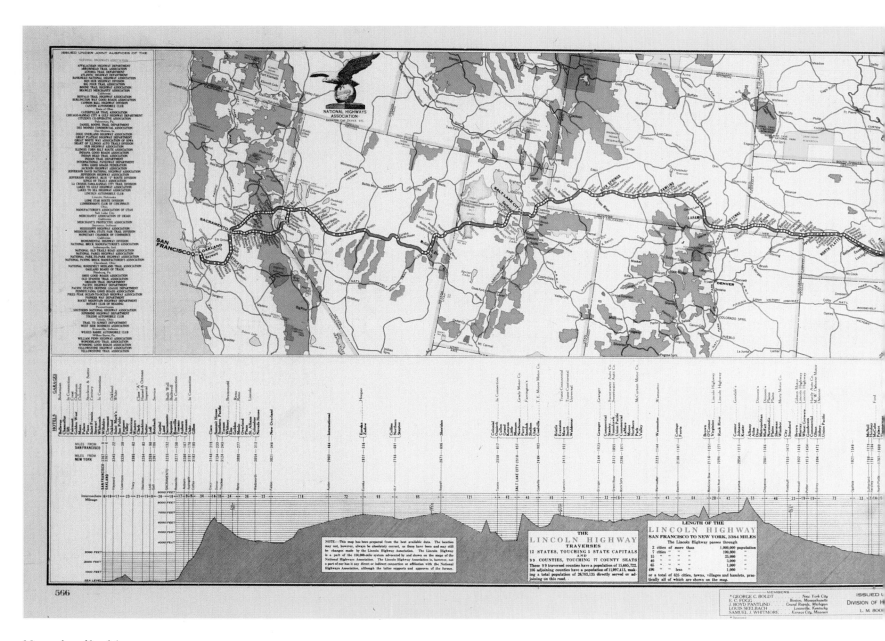

Map and profile of the
Lincoln Highway, 1923.

110

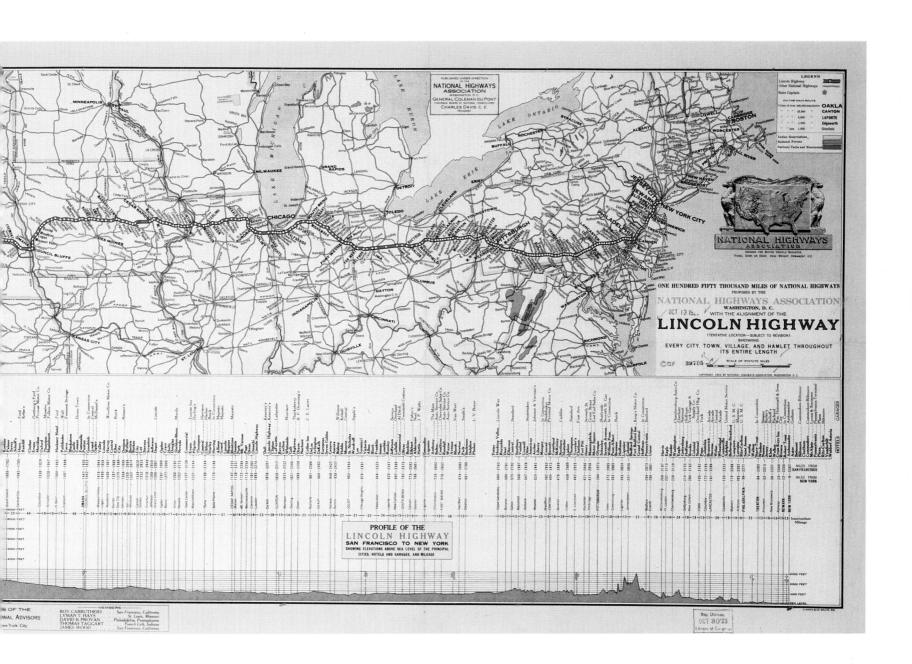

ONE HUNDRED FIFTY THOUSAND MILES OF NATIONAL HIGHWAYS
PROPOSED BY THE

NATIONAL HIGHWAYS ASSOCIATION
WASHINGTON, D. C.
WITH THE ALIGNMENT OF THE

LINCOLN HIGHWAY
(TENTATIVE LOCATION—SUBJECT TO REVISION)
SHOWING
EVERY CITY, TOWN, VILLAGE, AND HAMLET THROUGHOUT
ITS ENTIRE LENGTH

PROFILE OF THE
LINCOLN HIGHWAY
SAN FRANCISCO TO NEW YORK
SHOWING ELEVATIONS ABOVE SEA LEVEL OF THE PRINCIPAL
CITIES, HOTELS AND GARAGES, AND MILEAGE

The Lincoln Highway
Built between 1916 and 1919, the
Lincoln Highway stretched from
New York to San Francisco along a
northerly route for 3,305 miles
passing through Chicago and the
Yellowstone National Park. The
Packard Motor Car Company sold
an official Lincoln Highway Touring
Car complete with road maps,
guides and tarpaulins for camping.

Carbon County Court House, Rawlins, Wyoming

Ride 'Em Cowboy!
Cheyenne Frontier Days Held Annually the Last Full Week in July

Monument, Prairie Schooner, Museum and Old Headquarters Building

Fort Bridger, Wyoming

View from Sherman Hill, Wyoming's Summit of the Rockies

Castle Rocks on Lincoln Highway, between Cheyenne and Laramie, Wyo.

Church Buttes, Landmark on Lincoln Highway (U. S. 30)

Between Lyman and Granger

Telephone Cañon on Lincoln Highway

Between Cheyenne and Laramie, Wyo.

The Transportation Center of Cheyenne, Wyoming

Castlerock from Green River, Wyoming on Highway U. S. 30

Ames Monument, Sherman Hill, on Lincoln Highway between Cheyenne and Laramie

"In Wyoming"

"Where the Old West Still Lives"

The Arch, Rock Springs, Wyoming

HOME OF
ROCK SPRINGS COAL
WELCOME

A Solid Granite Canyon, Sherman Hill, Wyoming

Eagle Rock on Lincoln Highway, U. S. 30, East of Evanston, Wyoming

GREETINGS from
OLD WYOMING

"Yellowstone National Park," accordian postcard, 1937.

Yellowstone National Park

The largest of the National Parks, Yellowstone is a thirty three hundred square mile forest in the northwestern corner of Wyoming. Declared a wildlife preserve in 1872, it is also the site of the "Old Faithful" geyser and contains more geysers than all the rest of those in the world put together. Its "Great Falls" are twice as high as Niagara. Two hundred miles of roads and five park lodges provide access and lodging for visitors.

114

28003 © ELECTRIC PEAK, ELEVATION 11,155 FEET COPYRIGHT BY HAYNES INC.

10082 OBSIDIAN CLIFF AND BEAVER LAKE, YELLOWSTONE NATIONAL PARK PHOTO BY HAYNES INC.

10084 STEAMBOAT GEYSER, NORRIS GEYSER BASIN HAYNES INC., YELLOWSTONE PARK, WYO.

36450 NATIONAL PARK MOUNTAIN COPYRIGHT BY HAYNES INC., YELLOWSTONE PARK, WYO.

16049 © MORNING GLORY POOL COPYRIGHT BY HAYNES INC.

12546 © EMERALD POOL COPYRIGHT BY HAYNES INC.

10503 GEYSER HILL, UPPER GEYSER BASIN HAYNES INC., YELLOWSTONE PARK, WYO.

34222 © YELLOWSTONE LAKE AND COLTER PEAK COPYRIGHT BY HAYNES INC.

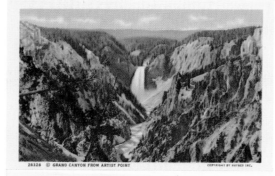

28328 © GRAND CANYON FROM ARTIST POINT COPYRIGHT BY HAYNES INC.

16343 © THE MADONNA OF THE WILDS COPYRIGHT BY HAYNES INC.

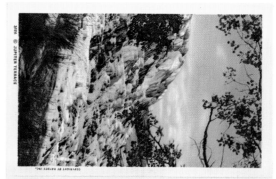

31111 © JUPITER TERRACE COPYRIGHT BY HAYNES INC.

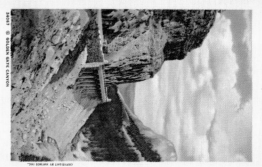

34067 © GOLDEN GATE CANYON COPYRIGHT BY HAYNES INC.

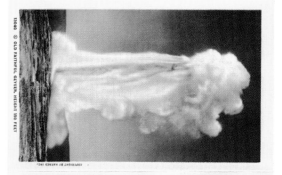

12040 © OLD FAITHFUL GEYSER, HEIGHT 150 FEET COPYRIGHT BY HAYNES INC.

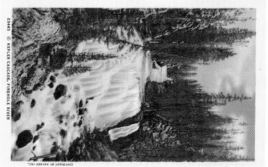

23443 © KEPLER CASCADE, FIREHOLE RIVER COPYRIGHT BY HAYNES INC.

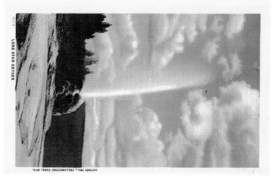

LONE STAR GEYSER HAYNES INC., YELLOWSTONE PARK, WYO.

"Scenic gems of Yosemite National Park," accordian postcard, 1937.

Yosemite National Park

An immense canyon in central California, the Yosemite Valley was preserved by the Yosemite Act of 1864 signed by Abraham Lincoln. Yosemite Falls drops 1,430 feet, a height nine times that of Niagara.

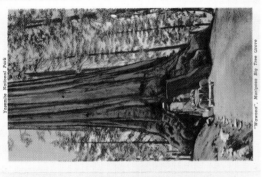

Yosemite National Park

"Wawona", Mariposa Big Tree Grove

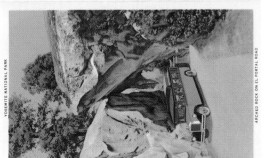

YOSEMITE NATIONAL PARK

ARCHED ROCK ON EL PORTAL ROAD

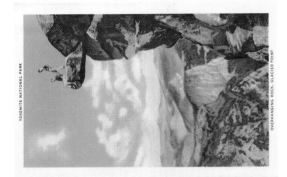

YOSEMITE NATIONAL PARK

OVERHANGING ROCK, GLACIER POINT

YOSEMITE NATIONAL PARK

NEVADA FALLS

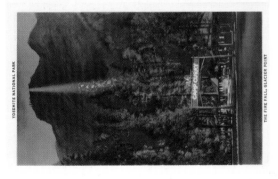

YOSEMITE NATIONAL PARK

"THE FIRE FALL, GLACIER POINT

YOSEMITE NATIONAL PARK

BRIDAL VEIL FALLS, YOSEMITE VALLEY

YOSEMITE NATIONAL PARK

YOSEMITE FALLS, YOSEMITE VALLEY

YOSEMITE NATIONAL PARK

EL CAPITAN, YOSEMITE VALLEY

YOSEMITE NATIONAL PARK

VERNAL FALLS

YOSEMITE NATIONAL PARK

HALF DOME FROM THE FLOOR OF THE VALLEY

YOSEMITE NATIONAL PARK

CATHEDRAL ROCKS FROM MERCED RIVER

YOSEMITE NATIONAL PARK

"I'M WILD ABOUT YOSEMITE"

YOSEMITE NATIONAL PARK

WASHINGTON COLUMN AND HALF DOME FROM MERCED RIVER

YOSEMITE NATIONAL PARK

HAPPY ISLES, YOSEMITE VALLEY

YOSEMITE NATIONAL PARK

"I CAN'T BEAR TO LEAVE YOSEMITE"

"Grand Canyon National Park, Arizona," accordian postcard, 1930s

Grand Canyon National Park
Proclaimed a national monument by Theodore Roosevelt in 1909, the Grand Canyon in northwestern Arizona was made a National Park by Congress in 1919. Covering an area of one thousand square miles, with the Colorado River one mile below grade, it is a dizzying spectacle of carved earth.

118

SUNSET FROM MOHAVE POINT

THE GRANITE GORGE FROM BRIGHT ANGEL TRAIL

SHEER WALL ON DESERT VIEW ROAD

NORTHWEST FROM POWELL MEMORIAL POINT

HOTEL EL TOVAR

KAIBAB SUSPENSION BRIDGE OVER COLORADO RIVER

GENERAL VIEW FROM MOHAVE POINT

FROM NEAR EL TOVAR HOTEL

MORAN POINT

THE COLORADO RIVER AT FOOT OF BRIGHT ANGEL TRAIL

LOOKING NORTH FROM THE WATCHTOWER AT DESERT VIEW

BRIGHT ANGEL LODGE ON THE CANYON'S RIM

THE HOPI HOUSE

ON KAIBAB TRAIL

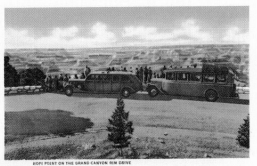

HOPI POINT ON THE GRAND CANYON RIM DRIVE

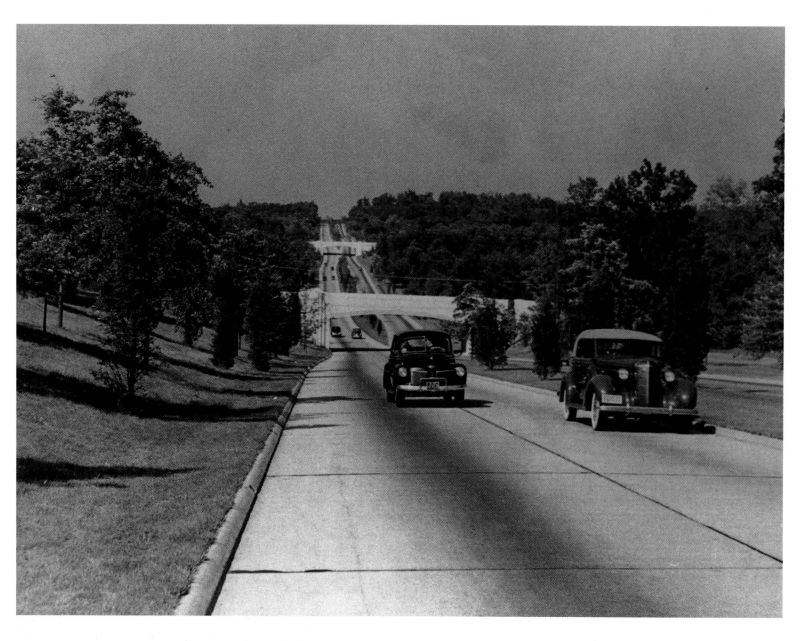

Merritt Parkway,
Connecticut, 1941.

Landscapes of the New Deal Era
Suburban and National Parkways, Greenbelt, Maryland; Jones Beach, New York

Franklin Delano Roosevelt and the Resettlement Administration; Robert Moses and the Triborough Authority

If touring highways and National Parks made possible the viewing of sensational landscapes, at least to one segment of the population, a quantity of projects realized under the aegis of federal and state legislation and funding offered an alternative "public landscape" to that vast majority of the population not in a position to purchase luxury items such as a Packard Touring car in the 1920s. The enjoyment of the "public landscape," however, did necessitate the purchase of some type of automobile. But by the 1930s, when most of this federally and state funded work was achieved, more affordable automobiles had been made available to the public. Now, at least the middle classes were in a position to avail themselves of the opportunities for diversion in nature made possible by the new projects. They could even consider the possibility of living in new suburban communities accessible only by automobile.

The grand scenic parkways built in the 1930s, descendants, ultimately, of Olmsted and Vaux's East-

ern "Park-Way" in Brooklyn, might be seen as the refined versions of earlier cross-country highways. They are broader and more compatible with the contours of the land. The Blue Ridge Parkway, a five hundred mile road through the piedmont plateau of Virginia and North Carolina, is designed to respond to the contours of the land it cuts across. This makes the act of driving itself pleasurable, as well as making a visually aesthetic man-made object in the landscape. Panoramic views of the valleys are afforded from various look-out points. The Lincoln Highway, by contrast, was laid down as a straight ribbon across the land, heedless of changes in topographical conditions from region to region. The end goal of traversal between coasts or, more locally, between National Parks, seems to have been more important in the case of the Lincoln Highway.

These "public landscapes," the state beaches, parkways and greenbelt towns initiated by leaders such as President Franklin Delano Roosevelt and Robert Moses, commissioner of the Triborough Authority, gave a greater portion of the population the opportunity to enjoy nature within close proximity of their homes or, in the case of the greenbelt projects, right in the midst of their homes.

Suburban Parkways

There is a watercolor rendering of an aerial view of the Bronx River Parkway which portrays an idyllically wooded residential area easily accessible to automobiles via graceful passages in the landscape in the form of shining new roads. Another rendering done in the same style shows a view of a futuristic automobile shooting along a sylvan parkway, unhindered by cross traffic which is conveniently carried overhead by rustic, yet streamlined, stone bridges. The Bronx River Parkway, completed in 1925, has a history that can be traced back to 1895,[1] when the commissioners of the Bronx River first made plans to clean the polluted river and transform its muddy banks into a park.[2]

121

Often thought of as the first "true" parkway,[3] the Bronx River Parkway extended fifteen and a half miles from the Bronx Botanical Garden to the Kensico Dam in Westchester County, and was heralded by detailed reports issued by the Bronx Parkway Commission from 1907 to 1925. The width of the land on either side of the road, varying from two hundred to twelve hundred feet, set a precedent for future parkway building, on both regional and national levels. Perhaps the most significant improvement in the parkway concept, as demonstrated with the Bronx River Parkway, was the idea of "limited access." The early urban parkways, such as the Eastern Parkway in Brooklyn and the Fenway in Boston, were constantly interrupted by cross traffic. With the new automobile parkways, traffic was simply raised overhead with bridges.[4] The success of the Bronx River Parkway led to a sudden and widespread surge in parkway building in Westchester County. Soon there were new parkways being discretely blended into the valleys of the Hutchinson River (1928) and the Saw Mill River (1930), as well as along the waterfronts of the Hudson River and the Long Island Sound.[5] Diversions along these parkways included recreational and amusement parks, as well as golf courses and camping grounds, which further enhanced the attraction of taking a ride in the country. All the necessary structures, such as bridges and service stations, were built of rough stone to blend in with the scenery. Yet it was the very same promotion of these parkways as recreational amenities for anyone who enjoyed the freedom of owning an automobile that also indirectly suggested the appeal of, not only getting out of the city on occasion, but of living outside of it altogether. For soon, the ease with which these parkways made automobile journeys into the remote regions of Westchester County a pleasant and expedient drive, led to the use of parkways as viable commuter routes. This might, in retrospect, be considered a factor in the institutionalization of suburbia. By 1931, the new road building in Westchester county had expanded to form a virtual "network of parkways"[6] including a thirty mile Bronx River Parkway Extension, which was described by the park commission as "thread(ing) a region of wild, picturesque beauty."[7] The obvious link between the Westchester County parkway network and the island of Manhattan, however, was not made until the Henry Hudson Parkway was opened in 1936.[8]

Robert Moses and the New York Parkways

While there had been plans for a "West Side Improvement in Riverside Park as far back as 1891,"[9] a comprehensive "West Side Plan" was not adopted until 1929. But then this plan was delayed by the Depression. The badly-needed improvements for the Upper West Side, however, were finally realized by 1936 under the powerful guidance of the park commissioner, Robert Moses.[10] The formerly exposed and noisy freight train route, passing just hundreds of feet in front of the grand houses lining Riverside Drive, was submerged under a bank of fill that extended Riverside Park out to the Hudson River; the Henry Hudson Parkway was built upon bulkhead and fill[11] along the edge of the river and continued northward through the Bronx in order to "make a connection with the Saw Mill River Parkway of the Westchester County Park System";[12] numerous recreational facilities were added along the route of the parkway, the 79th Street boat basin, accessed by a specially-designed traffic rotary, being the most prominent.

Despite the recreational features provided, the Henry Hudson Parkway became primarily a useful commuter route that connected New York City with Westchester County in a fairly straight line. It can perhaps best be understood within the realm of the changing notion of the parkway at this time, in which, indeed, expediency began to be emphasized just as much as pleasure.[13]

122

Henry Hudson Parkway, from 65th Street to the George Washington Bridge, New York, New York, aerial view, 1937.

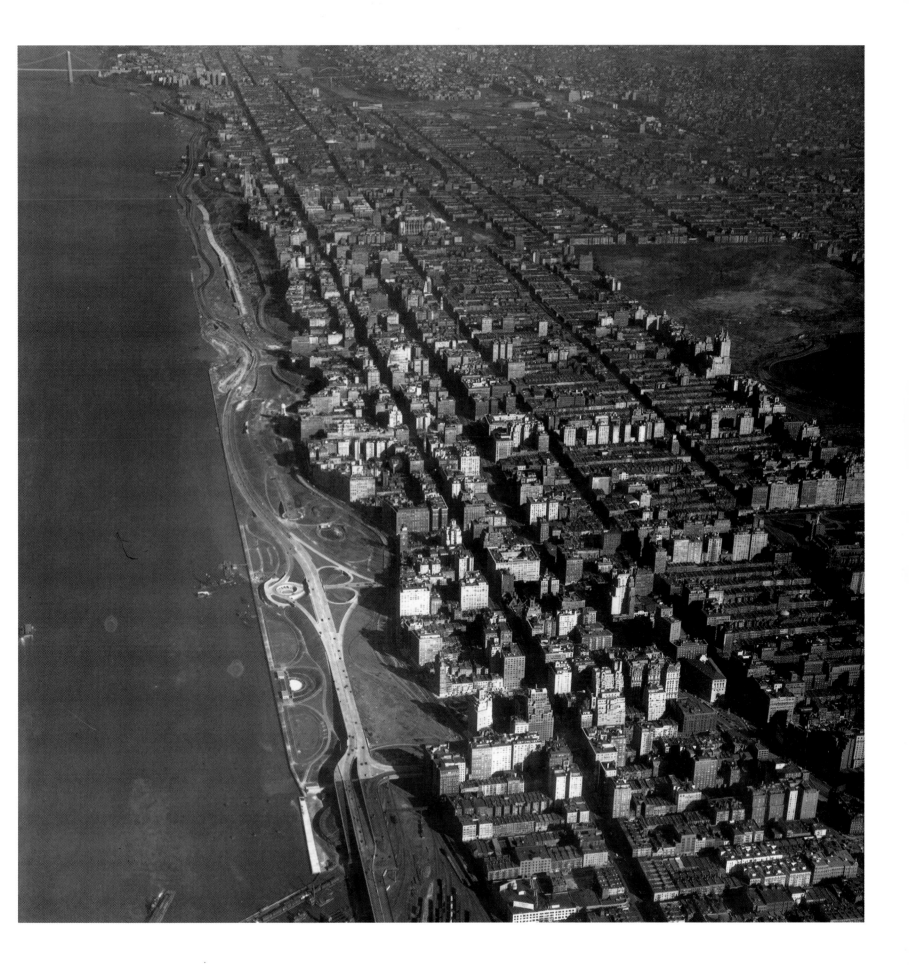

The implementation of the West Side Plan was only one of many large scale building projects undertaken by Robert Moses in a rigorous effort to suburbanize metropolitan New York. As city park commissioner, and then as head of the Triborough Authority, Moses exercised extraordinary power for several decades. Envisioning extensive parkways for Long Island that would rival the natural beauty of those in Westchester County, Moses opened up the formerly inaccessible Long Island (Long Island had been up to this point, strictly an area of extensive estates) with a series of state parks and parkways: Jones Beach State Park and Parkway, 1929; the Wantagh and Southern Parkways, 1929; the Northern State Parkway, 1931; the Grand Central, Interborough and Laurelton Parkways, 1936.

Calling for the well-being and recreation of the citizens of New York, Moses pursued his aim with a relentless intensity. Championing his right to build on municipally-owned land, Moses disregarded the protests of estate owners on the North Shore of Long Island, whose forests of imported trees would be exposed by the Northern State Parkway running between their property lines. He told one estate owner concerned about the possibility of dogs losing the scent in a fox hunt with the obstacle of a parkway, that underpasses would be provided for such an event.[14] From his landscape architects,[15] Moses required a standard of beauty and variety in all of the structures that defined the parameters of the new parks and parkways: "He wanted the parkways to be broader and more beautiful than any roads the world had ever seen, landscaped as private parks are landscaped so that they would be in themselves parks, 'ribbon parks,' so that even as people drove to parks, they would be driving through parks."[16]

In 1930, as chairman of the metropolitan conference on parks, Moses forwarded the most ambitious scheme for a metropolitan parkway system to date with his proposal for a "Circumferential Parkway" to be built around the city of New York. At the ceremony in 1938, marking eight years of progress on the project, Moses explained that the final plan "does not call for just an automobile roadway, but a narrow shoestring park running around the entire city and including all sorts of recreation facilities, opening territories which have been dead, relieving pressure on other parts of the city, connecting the city with the suburbs and the rest of the country, raising tax values, encouraging building and spreading the population."[17] The parkway, still not complete in 1938, already consisted of thirty-three miles of road running through eleven hundred acres of parkland and sixty-nine bridges for carrying cross-traffic in order to insure the proper degree of limited access on the parkway. Completed by 1944, the system offered over one hundred miles of parkways and express highways.[18]

While the transit goals of the circumferential parkway were grounded in the concept of running roads through nature, some of the later connecting segments of the system manifested themselves, not as the idyllic "ribbon parks" that Moses had envisioned, but as express routes cutting through densely settled and cohesive urban neighborhoods. An aerial photograph of the Gowanus Parkway, leaping over a sizable portion of Brooklyn on an elevated steel structure, headed towards lower Manhattan, shows one example of a "parkway" that offered no park-like features.

The vast network of parkways built in New York and on Long Island throughout the 1930s, under the influence of Robert Moses, in his position as chairman of the Long Island State Park Commission and commissioner of New York Parks, was followed by a period of parkway building, from the late 1930s through the 1950s, which introduced this new type of road to the states immediately surrounding the metropolitan sphere of New York.

A few examples of these scenic, limited-access routes, that served in both an intrastate and in-

terstate capacity, are: the Merritt Parkway built in Connecticut in 1938; the Garden State Parkway built in New Jersey in 1945; the Palisades Interstate Parkway, running through parts of New Jersey and New York, built in 1947; and the Taconic Parkway built in 1955 in Westchester County, New York, which incorporated the Bronx River Parkway Extension and the Eastern Parkway.[19]

Jones Beach State Park

The network of parks and parkways that Moses carved out of Long Island's privately-held land covered over 40,000 acres and were connected to one another as well as to the city of New York.[20] The keystone of this system was the Jones Beach State Park. Discovered by Moses as a barren sand spit on the southern shore of Long Island in 1921, it became by the 1930s the grandest and most popular of the state parks on Long Island.[21] Aside from the obvious benefits provided by such a park, the establishment of Jones Beach as a public recreation spot indicated a shift in the character of this coast of Long Island. Formerly lined with private estates, a whole segment of this coast was gradually given over to more and more public beaches such as Fire Island, Gilgo State Park and the Robert Moses State Park.

Before the construction of the buildings and parking lot that would establish the beach as a park, it was necessary, over the space of two years, to build up the beach with fill so this narrow spit of land would not be covered with water after every storm. All of this work required the employment of thousands of men over the space of many months using giant dredges and pumps mounted on barges. In addition, the sand itself, which was very fine, had to be anchored by hundreds of thousands of dune grass seedlings.[22]

When Jones Beach was officially opened in the summer of 1929, 325,000 people crossed the newly created Wantagh Causeway in the first month to park their cars in a monstrously large parking lot and avail themselves of the sand and surf of this already legendary beach.[23] The beach was demarcated by two bathhouses connected by a mile-long boardwalk. Nautical emblems were worked into all of the details of the boardwalk and mosaic tile surfaces of the paths leading to the bathhouses. Moses had chosen the seahorse as the symbol of the park so naturally the decoration of the entire complex was replete with this image. In addition, all of the employees of the park were dressed as mock sailors and naval officers.[24]

The buildings themselves were composed of broad and sweeping lines executed in Ohio sandstone and Barbizon brick. They exhibited a massive strength that belied their sand foundations. The water tower was ingeniously concealed in a two hundred foot stone tower, the beacon of the park.[25] Soon after its opening, architects and park planners from all over the world came to admire the beautifully integrated arrangement of ocean front park and park structures. The *Architectural Forum* applauded Moses's ability to reintroduce the fine details of craftsmanship so often absent in institutional buildings. Newspaper reports throughout the country praised this beach as the finest in existence.[26]

One discrepancy, however, in this picture of the ideal beach park was its inhospitality to the urban poor, living not so far from its shores. Moses's park was intended strictly for automobile owners. Groups chartering buses from New York City, for example, could not use the parkways leading to Jones Beach due to the height limitations of the overpasses crossing them.[27]

Parkways Outside of New York

While the systematic and rigorous program of parkway development for New York and its environs could perhaps be seen as the most prolific in the country, other cities such as Washington, D.C., produced parkways that offered beautiful approaches to the center of the city, as well as facilitating viable

commuter routes. Although less ambitious than those built in New York, the parkways built in Washington in the 1920s and 1930s could perhaps be seen as truer to the initial parkway concept of roads running through nature.

The Rock Creek Parkway, for example, first conceived of within the scope of the 1901 McMillan Plan for Washington,[28] but not realized until the 1920s, was formed by the judicious introduction of a road into an existing park. The road began at the Lincoln Memorial, ran briefly along the Potomac River, where it was called the Potomac Parkway, and then into and through Rock Creek Park, which divided the city roughly in half. Designed to provide access to the recreational facilities in the park, the parkway also served as a pleasant route for getting in and out of the city without having to negotiate the frequently congested diagonal avenues of the capital city.

The other major parkway built to serve metropolitan Washington at this time was the George Washington Memorial Parkway. The first phase of this project was the Mount Vernon Memorial Highway. Completed in 1932, the highway extended fifteen miles along the Potomac River, from the Arlington Memorial Bridge in Washington to Mount Vernon, Virginia. Designed by the United States Bureau of Public Roads, it provided scenic views of the capital city from across the river and ran along the central axis of the eighteenth century city of Alexandria, Virginia, halfway between Washington and Mount Vernon. This parkway, later absorbed into the more comprehensive George Washington Memorial Parkway, was, in fact, the first one attempted with federal funds, and designated as a "national" parkway maintained by the National Park Service.[29]

In a city like Los Angeles, however, where the widespread use of the automobile began to effectively determine the ideals and the very structure of the city, any hopes for a parkway system based on scenic drives that may have been proposed before 1920, were replaced with plans for an efficient freeway system. Designed to connect the many small towns that make up the composition of this metropolis, the highway system was ultimately destined to provide paths of speed and easy access before the provision of "ribbon parks."

The elaborately-conceived Arroyo-Seco Parkway plan of 1913, finally realized in 1940, is one such example.[30] Its originally-intended character, that of a beautiful passage through nature, which incidentally connected downtown Los Angeles with outlying Pasadena, was supplanted by the need to incorporate the parkway into a larger freeway system. Partially built with Federal funds, and modelled after the Merritt Parkway in Connecticut by its engineers, the Arroyo-Seco was renamed the Pasadena Freeway within ten years of its completion.[31]

Finally, it was only through the perseverance of the National Park Service, and accompanying federal legislation, that the original concept of the parkway, as a road running through a park, was preserved and defined with a set of regulations[32] differentiating a parkway from a highway. These efforts resulted in the building of the great national parkways of the 1930s, roads that ran through the national parks.

National Parkways

The National Park Service, as a division of the United States Department of the Interior, conducted a "Discussion of Federal Parkways" in 1936. Before a council meeting of the American Planning and Civic Association in Washington, D.C., the Service outlined the precedents and principles for federal parkway legislation.[33] The 1928 authorization of the Mount Vernon Memorial Highway and its subsequent incorporation into the George Washington Memorial Parkway in 1930 has been cited as the "first reference to federal parkway legislation."[34]

The National Industrial Recovery Act of 1933, which provided for "the construction, repair and

Coney Island, Long Island, 1939.

Stone Cottage in Rock Creek
Park, 1930s.

improvement of public highways and parkways,"[35] was acknowledged as an effort that furthered federal involvement in the building of parkways. The building of a "scenic parkway" to connect the Shenandoah and Great Smoky Mountains National Parks in Virginia and North Carolina, and that would become known as the "Blue Ridge Parkway," was one of the most impressive projects produced in accordance with this legislation. When completed, the Blue Ridge Parkway, which extended the old "Skyline Drive" in the Shenandoah, stretched across the peaks of this eastern mountain range for four hundred miles, and provided numerous rest stops along its route. The road was so well engineered that the difficulties of the existing mountain topography never prevented the possibility of smooth driving.

Another Federally-funded national road begun at this time was the Natchez Trace Parkway. Connecting Nashville, Tennessee, with Natchez, Mississippi, this road achieved the goal of legislation passed in 1934 calling for a survey of the old Indian trail known as "The Natchez Trace."[36] The name of the parkway kept the term, "trace," which in Old French refers to a line of footprints or animal tracks.[37]

The Mississippi River Parkway was an example of an attempt to create a scenic highway along the Mississippi that was not initiated by the federal government, but promoted by an interstate commission known as the Mississippi River Parkway Planning Commission, composed of the ten states bordering the river. By 1954, however, the plan was made so convincing by the commission that a federal-aid highway act, which named the Mississippi River Parkway, "The Great River Road," authorized aid for the building of the road through the Bureau of Public Roads.[38]

Running two thousand miles from the Gulf of Mexico to the Canadian border, it featured the possibility of visiting numerous historic sites along the way.

The commission referred to their scheme in the late 1950s as "the most interesting and beautiful parkway, not only of America, but of the world."[39] Today's three thousand mile long Great River Road is almost twice as long as the originally proposed Mississippi Highway of 1915, but winds through the river valley with the same intention of making the scenic views and historic sites of this region accessible to motorists.

The last proposal for a national parkway was the plan for a "Wonderful One National Parkway" (State Highway Number One) that was to span the pacific coast of California from Canada to Mexico by revitalizing and connecting the existing "Coast Highway" and "Skyline Parkway" with federal funds. This plan was also proposed in response to the National Park Service's 1959 recommendation that this region be maintained as a natural preserve.[40]

The idea of a "national parkway," spanning a broad tract of undeveloped landscape, vividly emphasizes the essential difference between a parkway and a highway. Perhaps it is within this context of the open landscape that the original inspiration of a "park way" as a road running through nature is best seen. While the urban park promenades of the late nineteenth century introduced the benefits of nature to certain city streets and the suburban expressways offered a sylvan alternative to existing routes outside of the city, the ever-present problem of cross- traffic somehow managed to erode the ideals of a continuous passage through nature within or near the city. Even the bridges that were introduced to carry cross-traffic overhead seemed to stress a need for expedient travel rather than a slow and pleasurable ride through nature or a composed linear landscape. The creation of national parkways allowed for a complete removal of the parkway from any reference to urban or suburban contexts. Here, the purity of the original idea could be realized in the

pleasure of driving through the landscape solely as a diversion.

Greenbelt, Maryland

The town of Greenbelt, Maryland (incorporated in 1937) was one of the manifestations of Franklin Roosevelt's "New Deal Program" for fighting the Great Depression. Produced through the efforts of the Resettlement Administration, Greenbelt was built "to employ the unemployed, to demonstrate the soundness of town planning and to provide low-rent housing."[41] When Roosevelt appointed Rexford Tugwell, who had previously taught economics at Columbia University, to direct the Resettlement Administration, he was able to realize one of his favorite ideas, the building of new towns on the model of the recent English Garden Cities. Tugwell shared the President's belief that the country should make use of its natural resources, and he was eager to find ways of resettling the countryside in order to alleviate the congestion of the cities.[42] The announcement made, however, by the Resettlement Administration in 1935 of its plans for three new government-owned towns was met by the public with great skepticism. It appeared to many that the administration might be interfering with the progress of private development. Tugwell was labeled a radical and the Resettlement Administration did not receive Congressional sanction for its plan. It was popularly believed that "putting Tugwell in charge of the Resettlement Administration was like putting 'Typhoid Mary' in charge of the Public Health Service."[43]

Despite strong public sentiment against the idea, three new towns were eventually built outside of cities that badly needed new housing. The towns were Green Hills, Ohio; Greendale, Wisconsin and Greenbelt, Maryland. A report in *The Baltimore Sun* on the progress of Greenbelt at least helped to salvage Tugwell's reputation: "The village, in spite of its associations with the idea of low incomes ...

will closely approach deluxe standards... If, as they anticipate, the demonstration of what can be done in the low-cost housing field, of what can be done in the way of town planning, have a nation-wide influence on private and public enterprise, skepticism will be laid, criticism will be hushed and Dr. Tugwell, the dreamer, will become Dr. Tugwell, the prophet."[44]

The building of Greenbelt began in 1936 when the Resettlement Administration bought land twelve miles outside of Washington, D.C. in Berwyn, Maryland.[45] Isolated from major arterial highways, the site, a slightly elevated crescent-shaped ridge, was insulated from the encroachment of private development by a broad band of forest—the "greenbelt."

The initial town plan, in the form of a grid, was rejected when the architects and planners decided that they could simply segment the crescent-shaped ridge into "super-blocks" (blocks five to six times the size of average city blocks) that followed the contour and size of the land.[46] With this system, only six miles of road needed to be constructed as opposed to some sixty that would be required for a grid pattern. The final plan had one main road following the inner curve of the crescent, with residential super-blocks on the outer side and a village green in the hollow of the crescent. Pedestrians were not obliged to cross the main road since there were a series of underpasses between the super-blocks and the town green. The super-blocks were, in turn, segmented by garden paths. The residential units (over 100 per super-block) were placed on the edges wherever possible so as to leave as much open parkland as possible. The village green encompassed a commercial center, recreational facilities, a civic building and a school/community center, all within easy walking distance of one another.

The architecture of Greenbelt was disarmingly simple. In 1941, O. Kline Fulmer, resident architect and assistant community manager of the town, com-

View of the shopping center, Greenbelt, Maryland, 1942.

mented that if the style of the buildings in Greenbelt had to be labeled, the word used would be, "functional" rather than "modernistic" or "continental." The architects devised ten residential plans based on discussions among themselves since the results of surveys sent out to potential residents were being returned too slowly.

The plans generally provided one large space rather than a multitude of tiny rooms and narrow corridors forced into the confines of small housing units. The large open rooms allowed breezes to travel through the small houses from front to back in the hot summer months. The service sides (including kitchen door, tool shed and refuse area) were accessed by a small court that separated the house from the street, while the living areas faced inwards toward community parkland. The facades were painted white over cinderblock or brick. The Farm Security Administration, which was responsible for running the town, provided inexpensive, sturdy furniture on credit.[47]

The commercial center of Greenbelt consists of a central square flanked by low-lying colonnaded buildings. The town Green, made up of grass plots and dotted with small trees, tables and benches, is dominated at one end by a monumental roughly-cut stone statue of a mother and child. The elementary school/community center displays a series of sandstone bas-reliefs at the base of its facade which represent the tenets of the preamble to the American Constitution: "Provide for the Common Defense, Promote the General Welfare, Insure Domestic Tranquility, Establish Justice, to Form a More Perfect Union." Carved in smooth, broad surfaces, the bas-reliefs depict bulky figures engaged in acts of good will and labor celebrating the New Deal ethic. This building was the hub of the town's cooperative society in 1937. (It still is to some extent, today.) The building was used at night for a great number of clubs and organizations, each assigned a classroom, while the auditorium was typically filled with the members of a meeting or the congregation of a church service.

If there was a problem with Greenbelt, it was the lack of an indigenous industry. While the spirit of cooperation was strong, the town could never be completely autonomous if it had to derive its economic sustainment from a larger city outside the bounds of its protective greenbelt, namely Washington, D.C. In 1947, this predicament was made clear in *The Magazine of Art*: "Located beyond reasonable commuting distance from its central city, the source of most employment, the community has never been permitted to develop that cornerstone of true garden cities—local industries within walking distance of homes. Such industries were originally planned, but selfish interests prevented their location in Greenbelt. The community remains a 'dormitory town.'"[48]

The Resettlement Administration did not, in fact, have enough money to initiate industry in any of its new towns, and in Greenbelt, the soil was no longer arable. In 1967, Albert Mayer, Director of the National Housing Conference, made an evaluation of Greenbelt in the *Journal of Housing*. The report was favorable but acknowledged the obvious drawback of the lack of an industry. He concluded, in light of the successful English Garden Cities, that industry, however light, is a necessary stimulant to a new town for achieving self-sufficiency.

If the lack of an industry made Greenbelt seem like a commuter town, the decision made by the Federal Government to build one thousand units of housing there for new employees of the Department of Defense in 1941 validated such an impression. Apart from increasing the mass daily commutation to Washington, the arrival of the defense workers congested the town's public facilities to a point where enthusiasm and activity gave way to frustration and apathy among the original settlers. The commercial cooperative was preserved but the community suffered a physical and spiritual decline.

General Plan of the New York Park System, included in Regional Plan of New York and its environs, 1928.

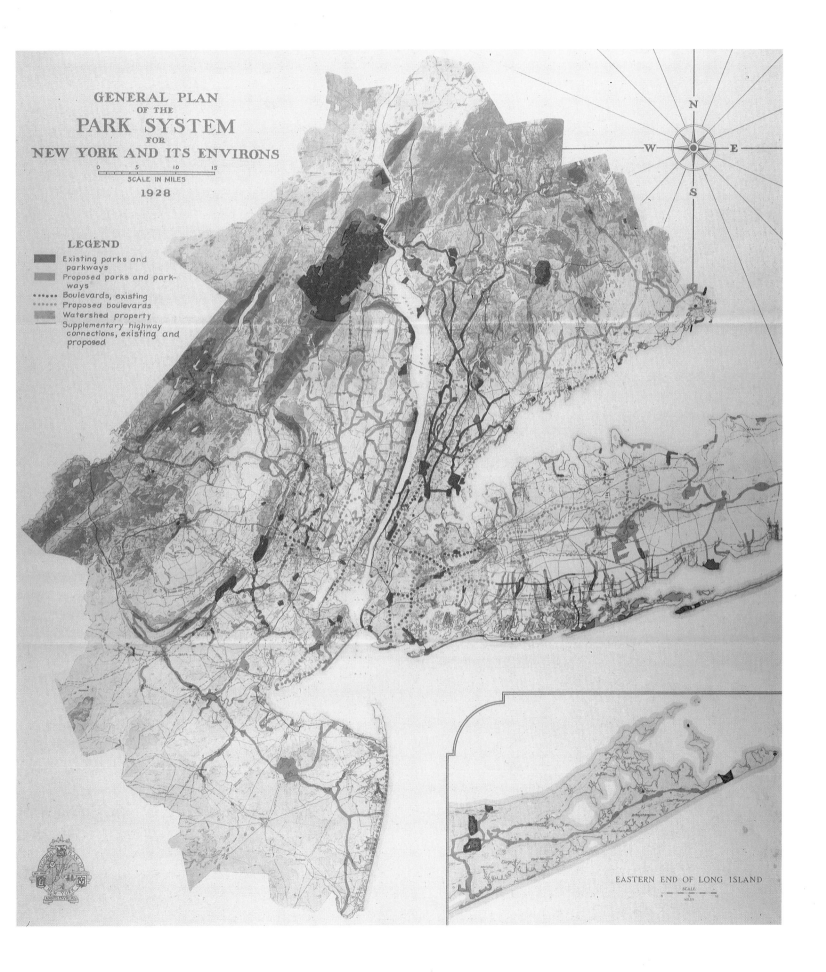

GENERAL PLAN
OF THE
PARK SYSTEM
FOR
NEW YORK AND ITS ENVIRONS

SCALE IN MILES
1928

LEGEND

Existing parks and parkways
Proposed parks and parkways
Boulevards, existing
Proposed boulevards
Watershed property
Supplementary highway connections, existing and proposed

EASTERN END OF LONG ISLAND
SCALE

133

In 1952, after some debate over the possibility of liquidating the town, the Veteran's Corporation bought the town of Greenbelt from the Federal government. With this transaction, Greenbelt was launched into the world of private development. The woods surrounding the town were slowly thinned out as private speculators began to acquire the land from the Veteran's Corporation. The completion of the Capital Beltway in 1964, a highway wrapping the boundaries of the city of Washington, D.C., made feasible the building of numerous subdivisions and shopping malls along its route. For Greenbelt, this meant the systematic erosion of its formerly protective "greenbelt" of trees.

If Greenbelt never had the chance to exist independently as a town, due to the lack of an industry, it is remarkable, nonetheless, that in spite of the bulldozer effect of private development and highway building over the past forty years, the town has managed to retain its core of super-blocks, village green and pedestrian paths. There have been some minor changes to the physical plant: the once white walls of the commercial center now have a red brick veneer; the neon "Greenbelt" theater sign has been replaced with plastic letters that spell, "Utopia Theater"; underpasses are covered with graffiti; some residential buildings have acquired solar panel roofs. Yet Greenbelt, as a community, can still recommend itself as a successful example of the work of Franklin Roosevelt's New Deal Administration, and more specifically, Rexford Tugwell's Resettlement Administration, for it is somehow still appropriate to call this place a town.

Coney Island, New York, postcard, 1920s.

[1]M. E. Weigold, *Pioneering in Parks and Parkways: Westchester County, New York, 1895–1945*, Public Works Historical Society, Chicago, 1980. (This passage on suburban parkways is taken from C. Zapatka, "The American Parkways," in *Lotus International*, no. 56, Electa, Milan, 1988.)

[2]"An Act which provides for appointment of commissioners to inquire into the advisability of preserving the waters of the Bronx River from pollution, and of creating a reservation of lands on either side of the river. "*Report of the Bronx Parkway Commission*, J. B. Lyon Co., State Printers, 1907.

[3]N. T. Newton, *Design on the Land, The Development of Landscape Architecture*, The Belknap Press of Harvard University, Cambridge, Mass., 1971, p. 600.

[4]Ibid., p. 597.

[5]M. E. Weigold, *Pioneering in Parks and Parkways: Westchester County, New York, 1895–1945*, Public Works Historical Society, Chicago, 1980, p. 12.

[6]Ibid., pp. 19–26.

[7]Ibid., p. 20.

[8]Taken from a pamphlet published by the Moore Press, New York, 1937, on the occasion of "The Opening of the West Side Improvement."

[9]Ibid., p. 2.

[10]For a complete biography of Robert Moses, see R. Caro, *The Power Broker*, Knopf, New York, 1974.

[11]The manpower required to build the Henry Hudson Parkway was provided by Frankin Roosevelt's Works Progress Administration.

[12]"The Opening of the West Side Improvement," the Moore Press, New York, 1937, p. 29.

[13]"The modern parkways are rather more frequently radial than circumferential, and provide primarily a quick and pleasant channel of traffic between the country or suburbs and the town," J. Nolen and H. Hubbard, *Parkways and Land Values*, Oxford and Harvard University Presses, London and Cambridge, 1937, *Harvard City Planning Series XI*, p. XII.

[14]R. Caro, *The Power Broker*, op. cit., p. 44.

[15]Landscape Architects employed by Robert Moses: Gilmore D. Clarke, landscape architect for Westchester County Park Commission; Delano and Aldrich; Charles Stoughton; Bowdin and Webster. Listed in R. A. M. Stern, *New York: 1930*, Rizzoli, New York, 1987, p. 694.

[16]R. Caro, *The Power Broker*, op. cit., p. 171.

[17]Taken from a pamphlet published by the Moore Press, New York and edited by H. Sweeny, Jr. on the occasion of the 1938 ceremony in honor of the completion of the first phase of the "Circumferential Parkway."

[18]C. Rogers, "Highways and Parkways," *The Studio*, vol. 127, no. 615, 1944, p. 206.

[19]Third Annual Report of the East Hudson Parkway Authority, Pleasantville, New York, 1963, p. 4.

[20]R. Caro, *The Power Broker*, op. cit., p. 10.

[21]Ibid., p. 8.

[22]Ibid., p. 232.

[23]Ibid., p. 308.

[24]Ibid., p. 309.

[25]Ibid., p. 309.

[26]Ibid., p. 309.

[27]Ibid., p. 318. "Now he (Moses) began to limit access by buses; he instructed Shapiro to build the bridges across his new parkways low—too low for buses to pass. Bus trips therefore had to be made on local roads, making the trips discouragingly long and arduous."

[28]"The Plan of 1901 reasserted the authority of the original plan of L'Enfant, extended to meet the needs of the nation after a century of growth in power, wealth and dignity, and also marked the path for future development." H. P. Caemmerer, *Washington, The National Capital*, op. cit., p. 95.

[29]Taken from a brochure published by the National Capital Park and Planning Commission, Washington, D.C., 1930.

[30]For a description of the Arroyo-Seco Parkway, see C. Zapatka, "The American Parkways," in *Lotus International*, no. 56, Electa, Milan, 1988.

[31]D. L. Clark, *Los Angeles, A City Apart*, Los Angeles City Historical Society and Windsor Publications, Woodland Hills, CA, 1981, p. 83.

[32]Taken from the minutes of a meeting on the "Discussion of Federal Parkways," National Park Service, United States Department of the Interior, Washington, D.C., 1936, pp. 2–5.

[33]Ibid., p. 1.

[34]Ibid., p. 1.

[35]Ibid., p. 1.

[36]Ibid., p. 1.

[37]Taken from a National Park Service (U. S. Department of the Interior) brochure on "The Natchez Trace Parkway," 1963.

[38]Pamphlet published by the Minnesota Highway Department on "The Mississippi River Parkway" or "The Great River Road," 1958, p. 3.

[39]Ibid., p. 4.

[40]Taken from a report to Congress made by the Boards of Supervisors of the counties of Monterey and San Luis Obispo, California, "Memorializing the Congress of the United States to Authorize a Study for a 'Wonderful One' National Parkway," 1962.

[41]L. G. Hunter, "Greenbelt, MD: A City on a Hill," in *Maryland Historical Magazine Number 63*, June 1968, p. 106. The Works Progress Administration provided the labor for the building of Greenbelt and the low-cost housing was intended primarily for government workers who could not afford to live in Washington. (This is adapted from C. Zapatka, "Greenbelt, Maryland," in *The Architecture of Western Gardens*, edited by M. Mosser and G. Teyssot, MIT Press, Cambridge, Mass. 1991.

[42]As an undergraduate at the University of Pennsylvania, Tugwell had written in a poem that he would, "Roll up his sleeves, bend the forces untameable, harness the powers irresistable and make America over." Ibid., p. 110.

[43]Ibid., p. 10.

[44]C. S. Hobbs, "Resettlement Administration Presents: Greenbelt," in *The Baltimore Sun*, August 26, 1936.

[45]This land was largely owned by individuals and families, some of the deeds going back to original grants from the King of England with never a change in title. O. K. Fulmer, *Greenbelt*, American Council on Public Affairs, Washington, D.C., 1941, p. 16.

[46]Ibid., p. 7.

[47]M. L. Williamson, *Greenbelt, History of a New Town, 1938–1987*, Virginia, 1987, p. 72.

[48]F. Gutheim, "Greenbelt Revisited," in *Magazine of Art*, January 1947, p. 3.

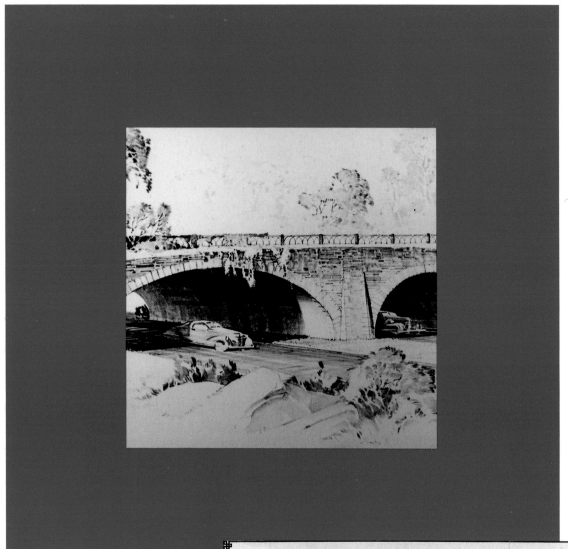

Drawing for the Bronx
River Parkway, 1920s.

Map of the Bronx River
Parkway Reservation, 1916.

Bronx River Parkway
Bronx, New York

A fifteen and a half mile long linear
park, the Bronx River Parkway can be
understood as the seminal American
parkway in its project to make
a drive in an automobile the
equivalent of a walk in a park.
Completed in 1925, this landscaped
pleasure drive was carved out of the
swamps and detritus that typically
characterized so many urban
riverfronts and set a precedent
for scores of parkways to follow.

136

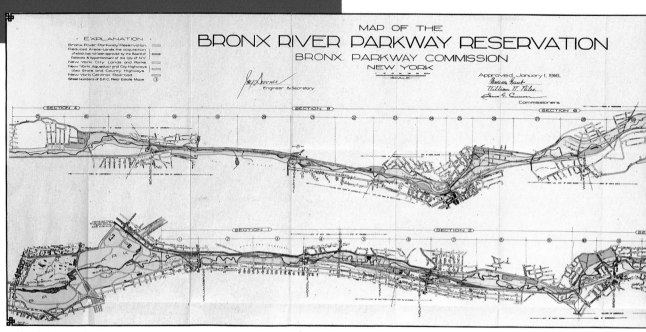

Bronx River Parkway
Reservation, 1920s, as a
connecting parkway between
the park system of New
York City, the Croton and
Catskill Watersheds and the
Harriman and Palisades
Interstate Parks.

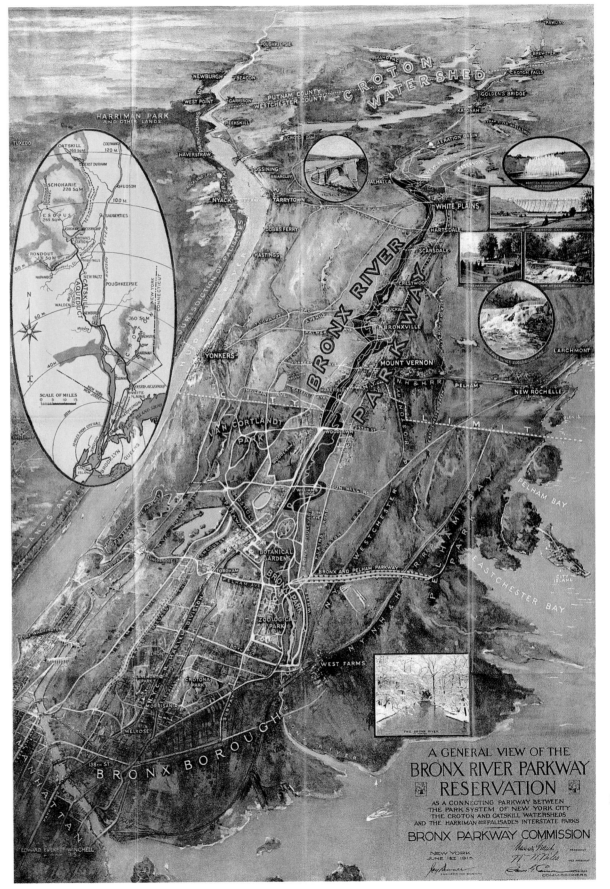

A GENERAL VIEW OF THE
BRONX RIVER PARKWAY
RESERVATION

AS A CONNECTING PARKWAY BETWEEN
THE PARK SYSTEM OF NEW YORK CITY
THE CROTON AND CATSKILL WATERSHEDS
AND THE HARRIMAN AND PALISADES INTERSTATE PARKS

BRONX PARKWAY COMMISSION

NEW YORK
JUNE 1ST 1915

137

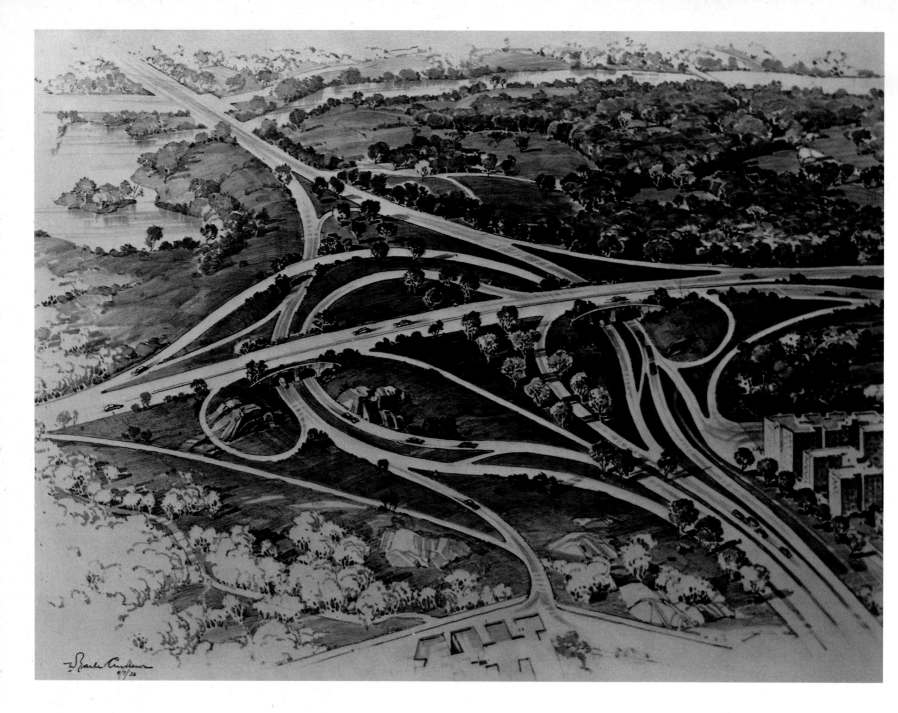

**Westchester Parkway System
Westchester County, New York**
An outgrowth of the Bronx River
Parkway, the Westchester Parkway
System both extended and expanded
on the features of the Bronx River
Parkway. Overpasses for diverting
cross traffic and right of way widths
were developed as characteristic
components of the automobile
parkway. This system led to the

suburbanization of the county and
set the example for future suburban
parkways.

Bronx and Pelham Parkways
Intersection, delineation by
Theodore Kautzky, 1936.

Westchester County Park
system, typical parkway
sections, in John Nolen,
"Parkways and Land Values,
Harvard City Planning
Studies, XI", 1937.

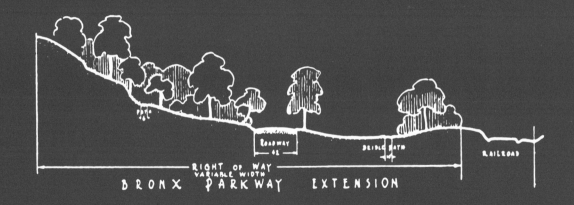

RIGHT OF WAY
VARIABLE WIDTH

BRONX PARKWAY EXTENSION

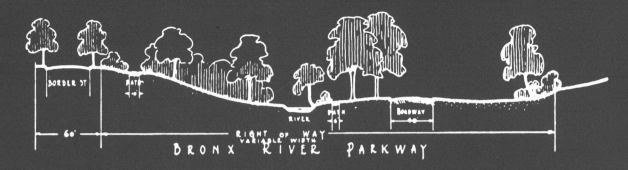

RIGHT OF WAY
VARIABLE WIDTH

BRONX RIVER PARKWAY

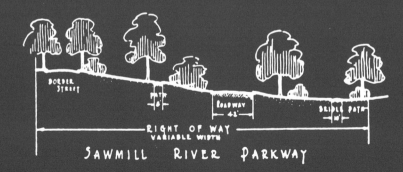

RIGHT OF WAY
VARIABLE WIDTH

SAWMILL RIVER PARKWAY

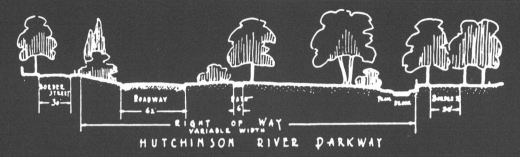

RIGHT OF WAY
VARIABLE WIDTH

HUTCHINSON RIVER PARKWAY

WESTCHESTER COUNTY PARK SYSTEM
TYPICAL PARKWAY SECTIONS

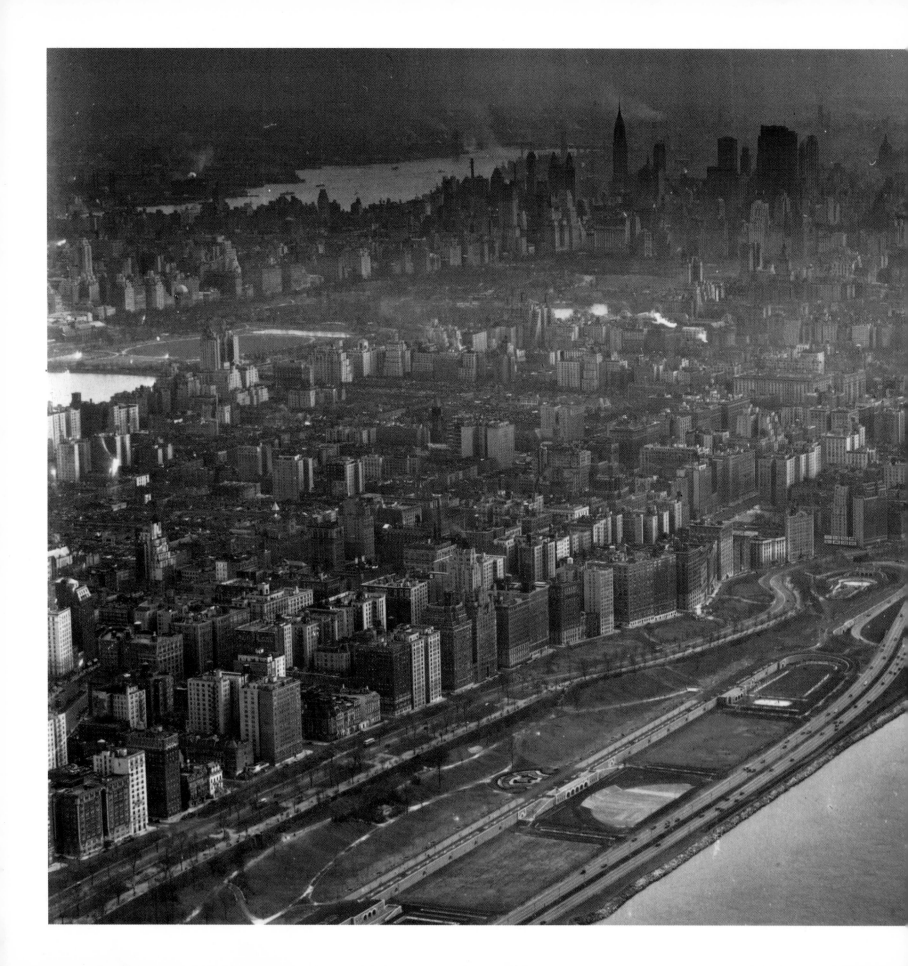

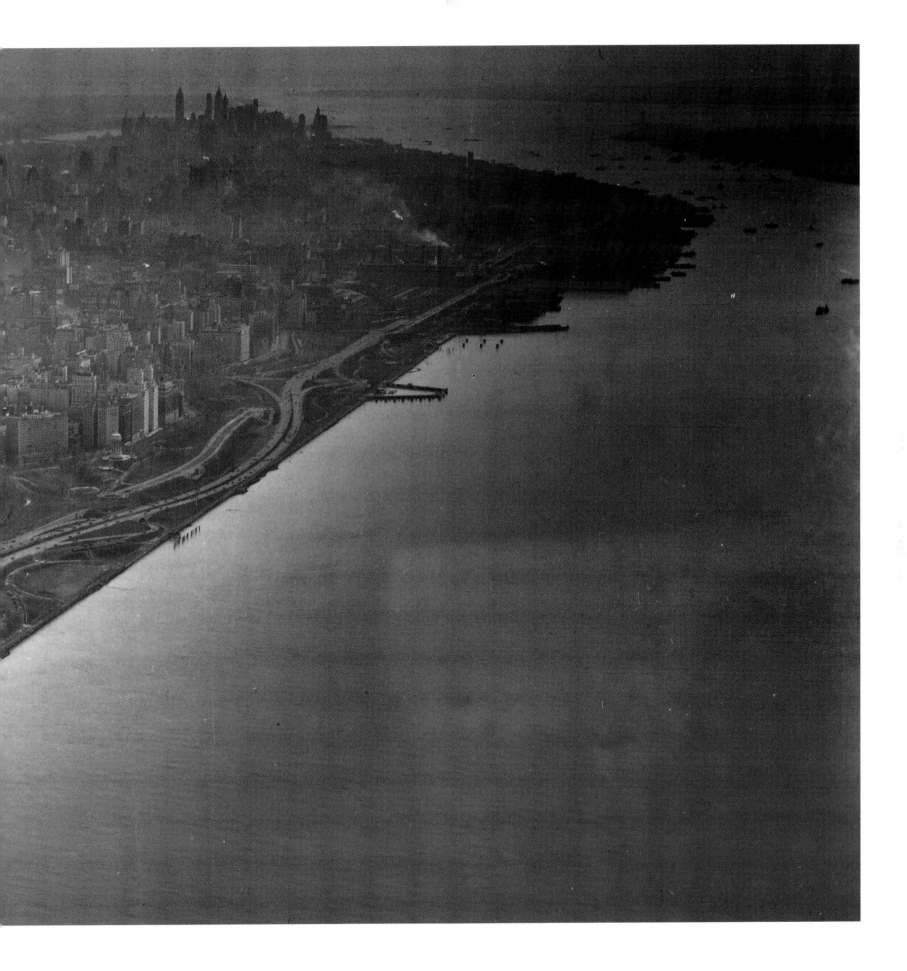

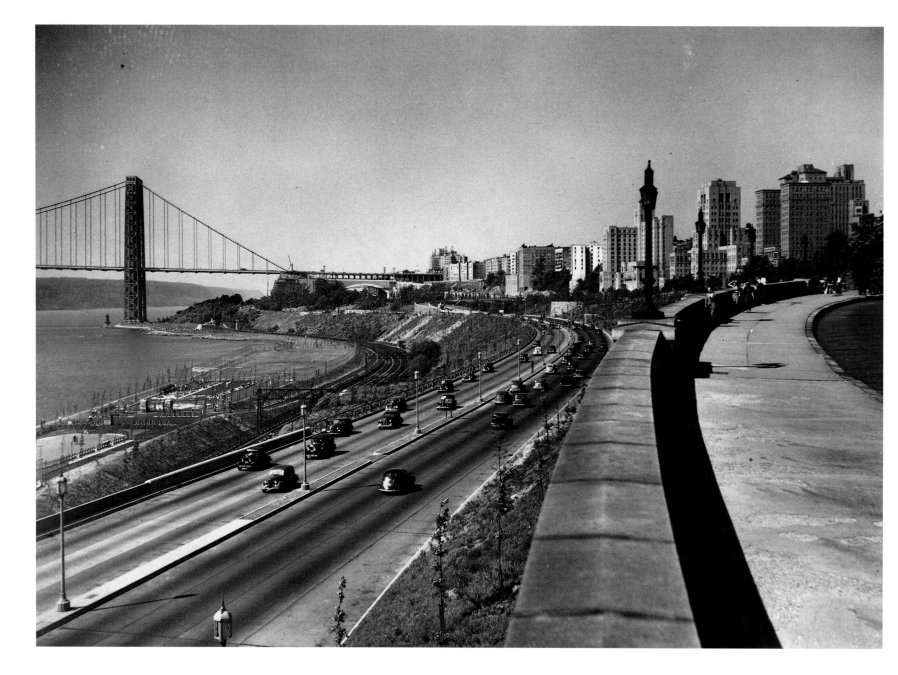

Henry Hudson Parkway
New York, New York

One of the most striking examples of the urban/suburban parkway, the Henry Hudson borrowed its landscape from Riverside Park while connecting the city with the Northern suburbs of Westchester County. Completed in 1937 under the direction of Robert Moses, the parkway and its adjacent green were built over landfill that covered an old freight railroad line.

Views of Henry Hudson Parkway, 1930s and 1953.

Preceding page: Panoramic view of Henry Hudson Parkway and Riverside Drive, 1940.

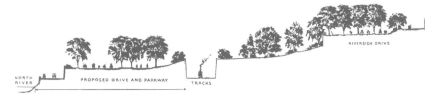

NORTH RIVER PROPOSED DRIVE AND PARKWAY TRACKS RIVERSIDE DRIVE

1891

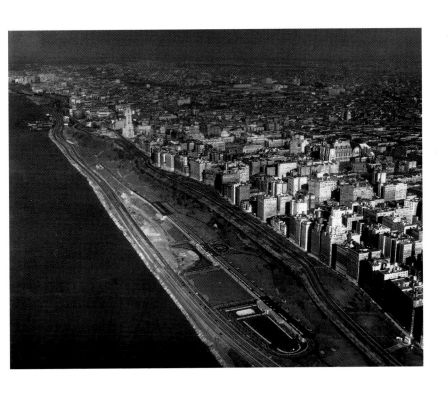

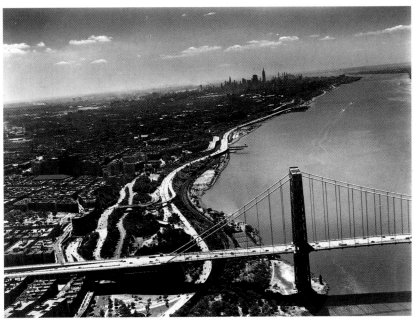

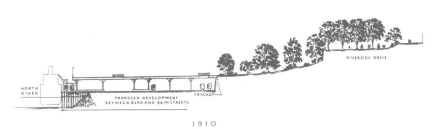

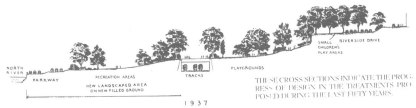

Cross sections through the
Henry Hudson Parkway,
1937.

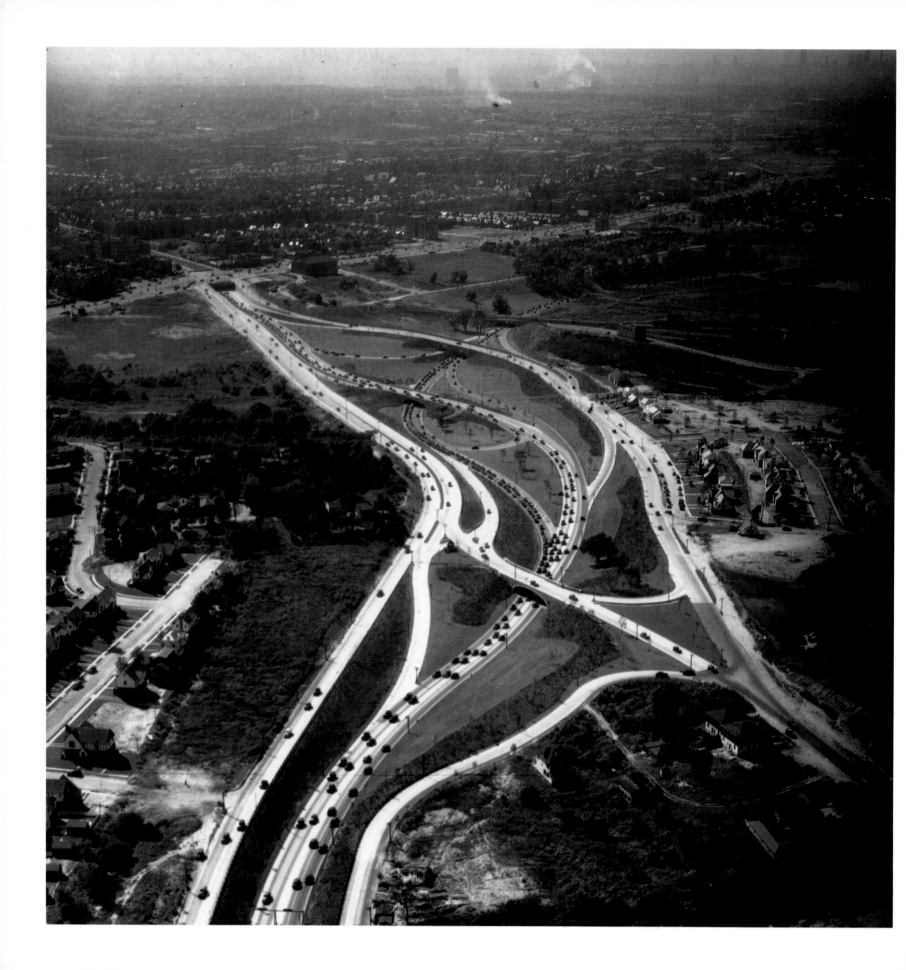

"The Pretzel" intersection of Grand Central Parkway Extension, Union Turnpike, Interboro Parkway and Queens Boulevard, aerial view, 1937.

Bronx River Parkway, 1953.

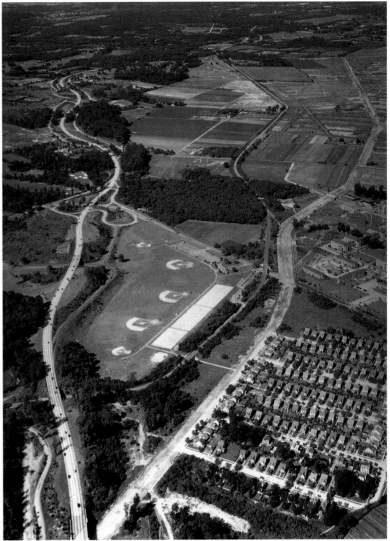

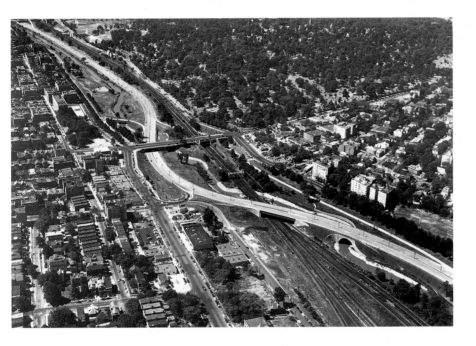

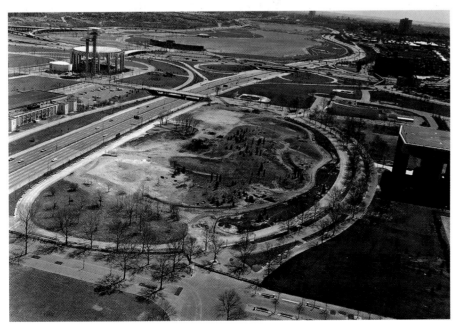

View of Alley Pond Park, City Line. Grand Central Parkway including motor parkway and Union Turnpike, aerial photograph, 1938.

Flushing Meadow North including remaining structures of 1964 World's Fair, Grand Central Parkway and Roosevelt Avenue, Queens, 1967.

Grand Central Parkway
Queens, New York

One of the most prominent of Moses's road projects, the Grand Central of 1936, leading to the Northern and Southern Parkways, became the link between New York City and Long Island's state parks. It also provided access to La Guardia Airport and had the distinction of acting as the front door to the New York World's Fair of 1964. It was also one of the first parkways to lose its identity as a landscaped drive as it slipped through densely settled neighborhoods in Queens.

145

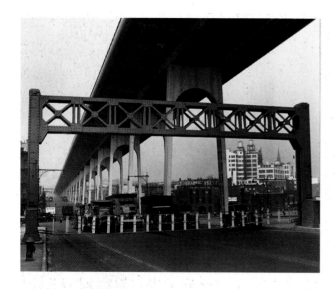

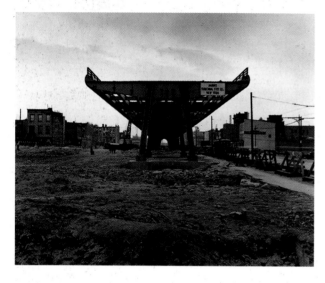

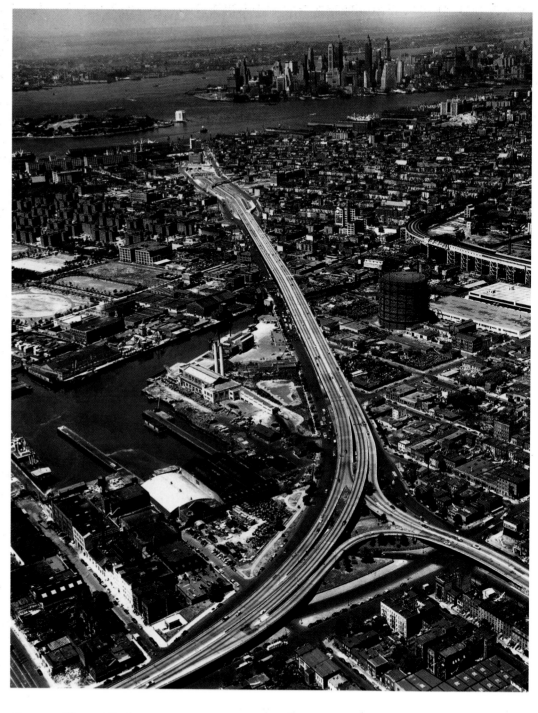

Gowanus Parkway, at Drawbridge Gate, Brooklyn, New York, 1942.

Gowanus Elevated Parkway from Brooklyn-Battery, tunnel entrance, 1953.

Gowanus Parkway, under construction at 3rd Avenue and 20th Street, Brooklyn, New York, 1941.

Gowanus Elevated Parkway
Brooklyn, New York
The first blatant example of the parkway abandoning the Olmstedian ideal of a landscaped pleasure drive in lieu of expedient transportation, the Gowanus of 1941 is simply a bridge over buildings. This new mark on the city opened the way for later urban highways such as Moses's notorious Bronx River Expressway of 1953 and the 1956 Central Artery in Boston.

Northern State Parkway, one of the Jones Beach accesses, 1934.

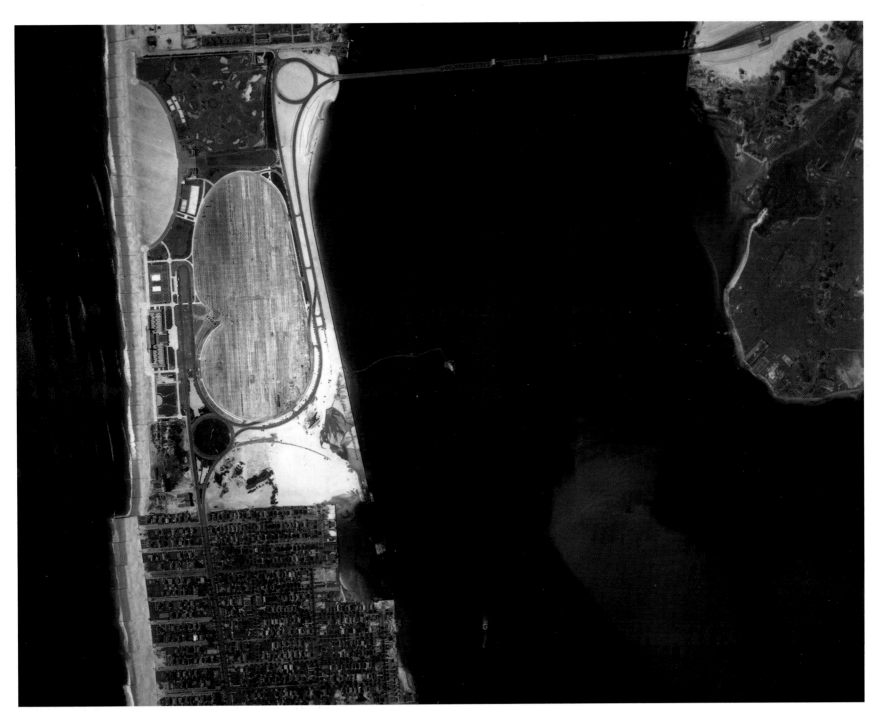

Jones Beach State Park
Long Island, New York

Dedicated in 1929 by Franklin Roosevelt, Jones Beach State Park was Robert Moses's first large-scale project to be realized during his tenure as Park Commissioner for the state of New York. With this scheme, Moses was determined to make the natural resources of Long Island readily available to the middle classes. Accessible by the Northern and Southern State Parkways which had overpasses too low for bus clearance, Jones Beach was only approachable by automobile.

Rockaway Beach, Queens, New York, aerial map, 1937.

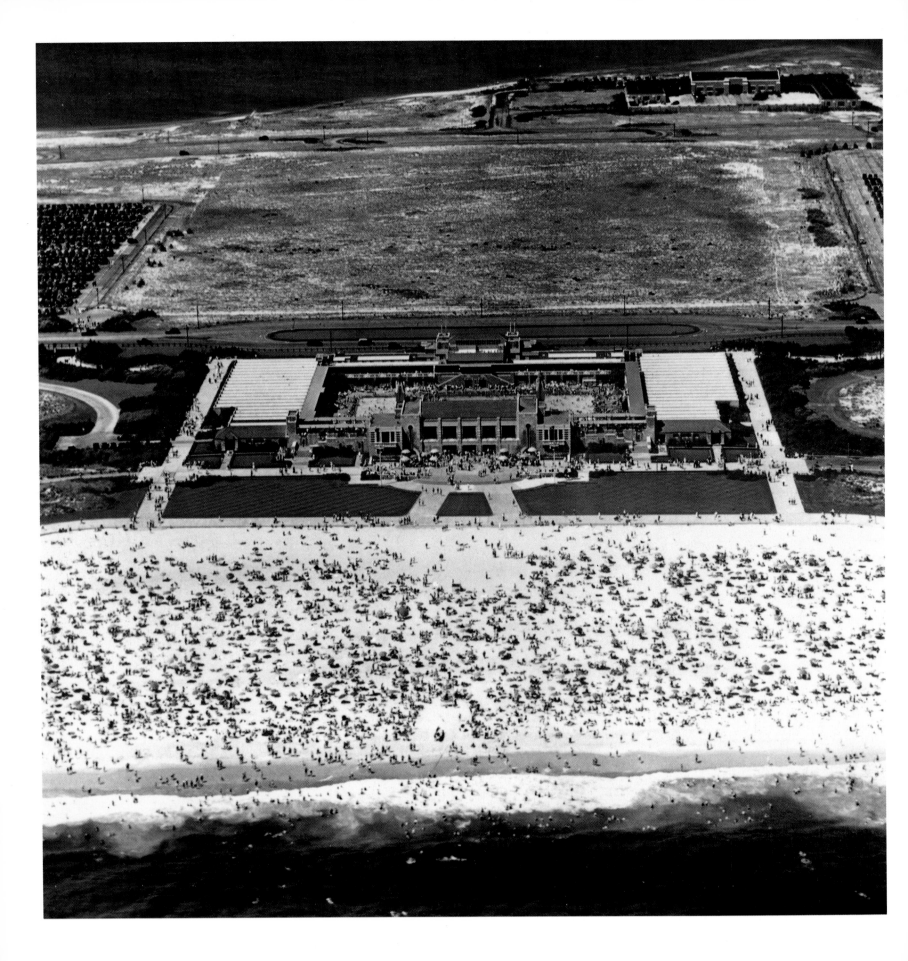

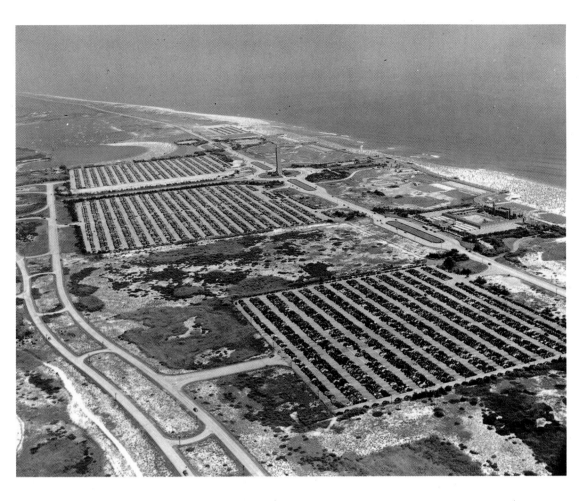

The strand and bathhouse,
Jones Beach State Park,
New York, aerial
photograph, 1936.

Parking for 16,000 cars,
1948.

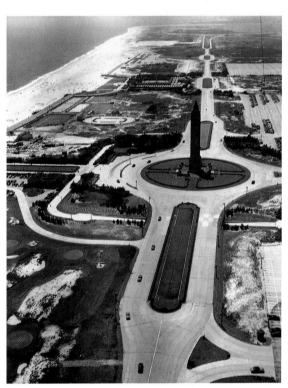

Water tower, Jones Beach
State Park, aerial
photograph, 1930s.

Central facility, Jones Beach
State Park, 1940.

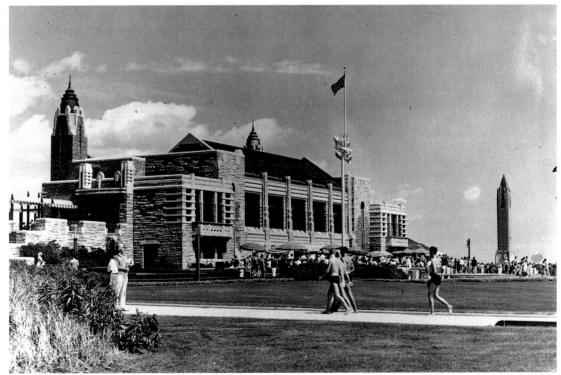

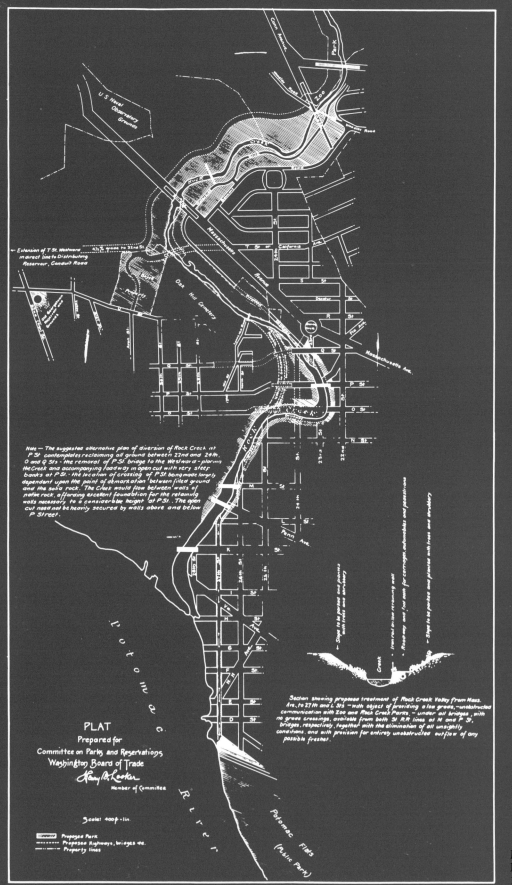

Map of Rock Creek Park and Parkway, Washington, D.C., 1924.

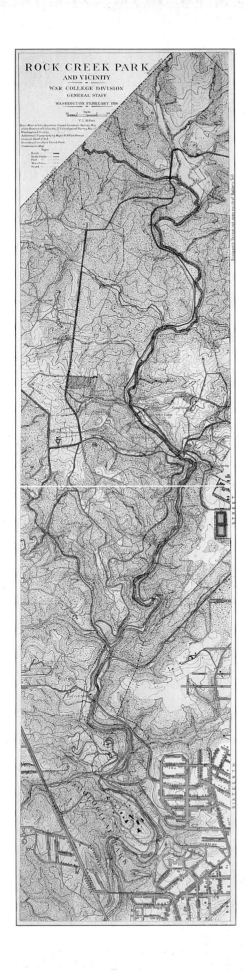

Flood conditions, Rock
Creek Parkway, 1920s.

Map of Rock Creek
Parkway, Washington, D.C.,
color lithograph prepared
by War College,
Washington, D.C., 1926.

**Rock Creek Parkway
Washington, D.C.**
Initially conceived of as part of the
McMillan Plan of 1901, the Rock
Creek parkway was built in the 1920s
as a sinuous road alongside of Rock
Creek well below the grade of the
city. It gave access not only to the
various open areas of the park but
to points within the city making it a
pleasant and efficacious alternative
to city driving.

151

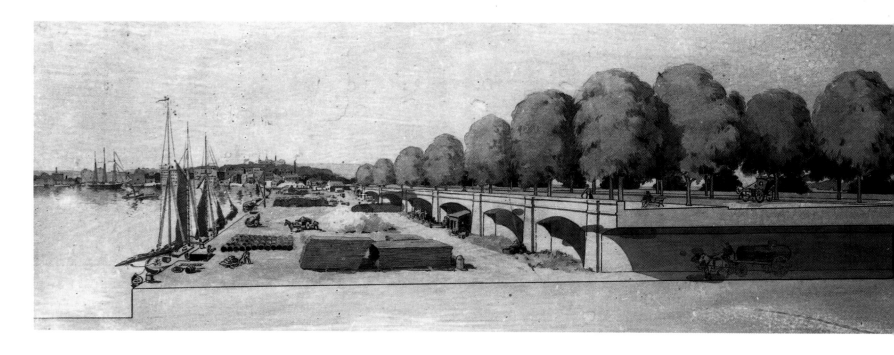

Log cabin style shelter, Rock
Creek Park, 1940s.

Elevated portion of Rock Creek and Potomac Parkway, Washington, D.C., 1940.

Profile of Rock Creek Parkway, Washington, D.C., 1930s.

Pierce Mill (early nineteenth-century structure), Rock Creek Park, 1940s.

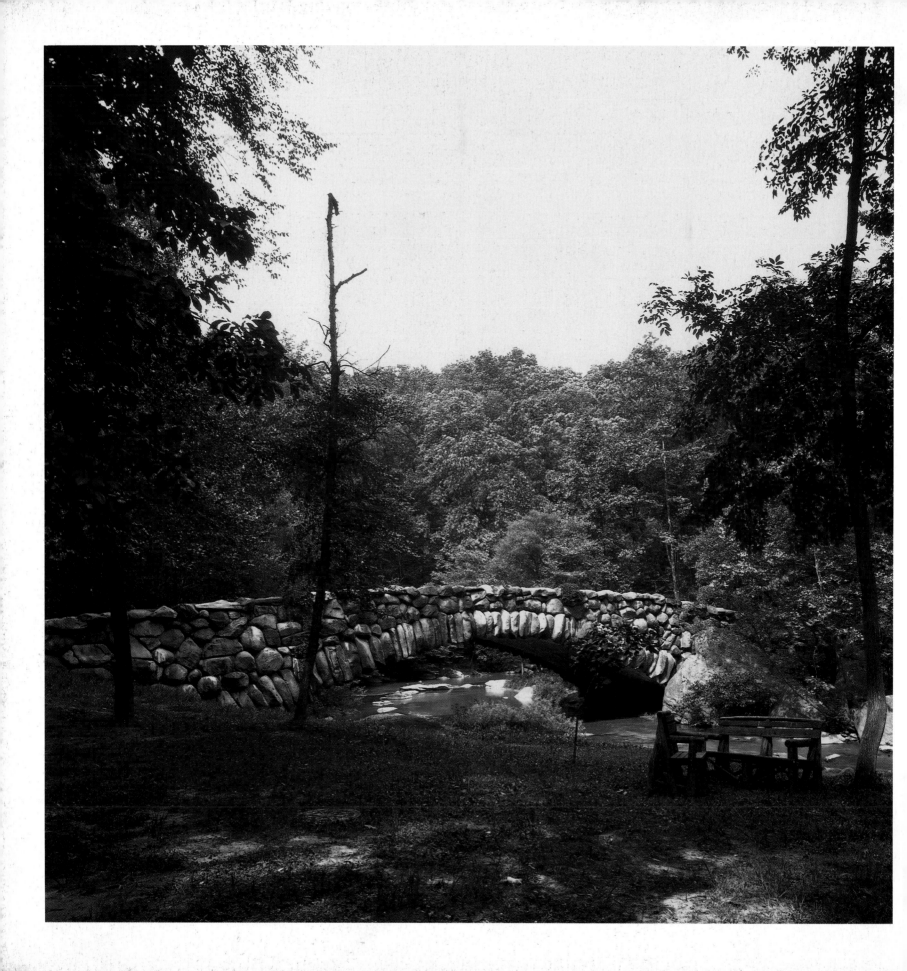

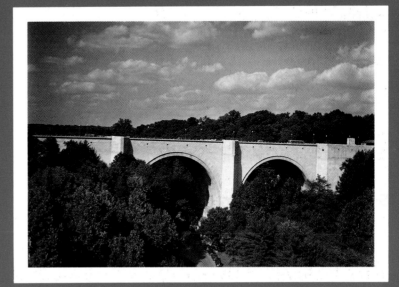

Stone footbridge in Rock
Creek Park, 1930s.

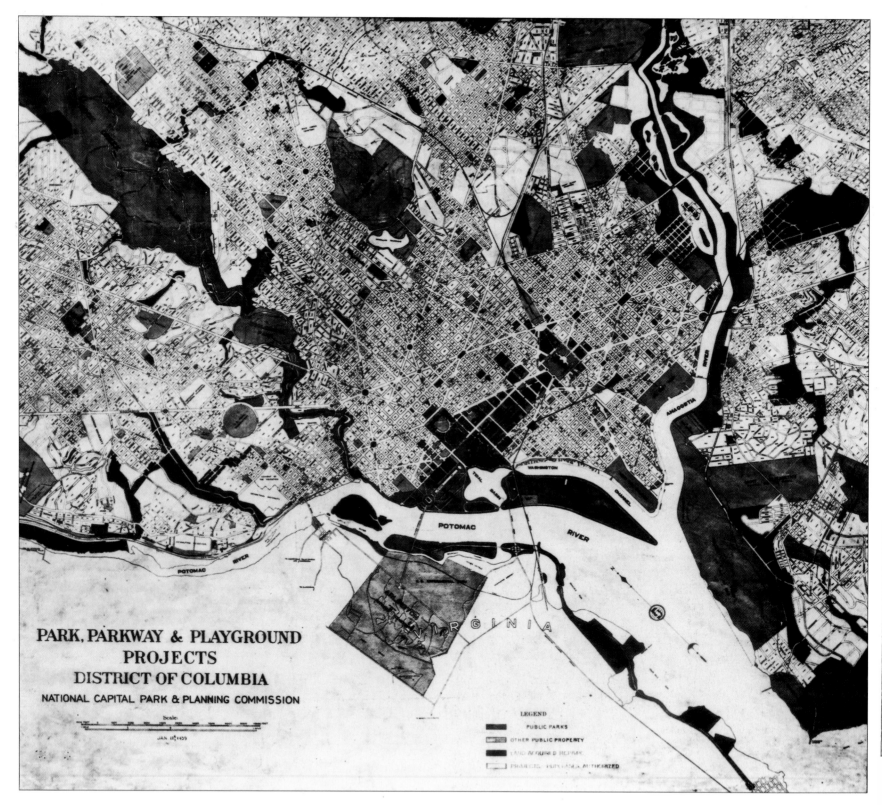

PARK, PARKWAY & PLAYGROUND
PROJECTS
DISTRICT OF COLUMBIA

NATIONAL CAPITAL PARK & PLANNING COMMISSION

Scale

JAN 18 1939

LEGEND

PUBLIC PARKS

OTHER PUBLIC PROPERTY

LAND ACQUIRED HEREBY

PROJECTS PROPOSED & AUTHORIZED

156

Park, parkway and
playground projects, District
of Columbia, National
Capital Park and Planning
Commission, 1939.

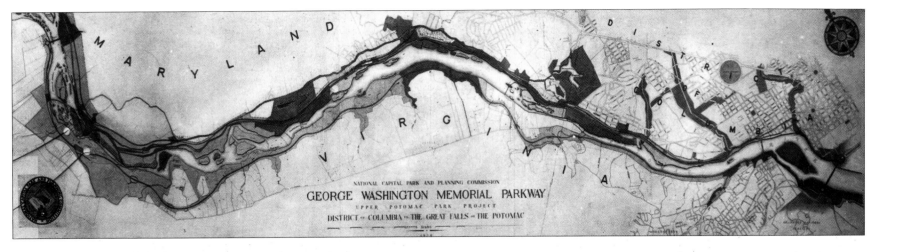

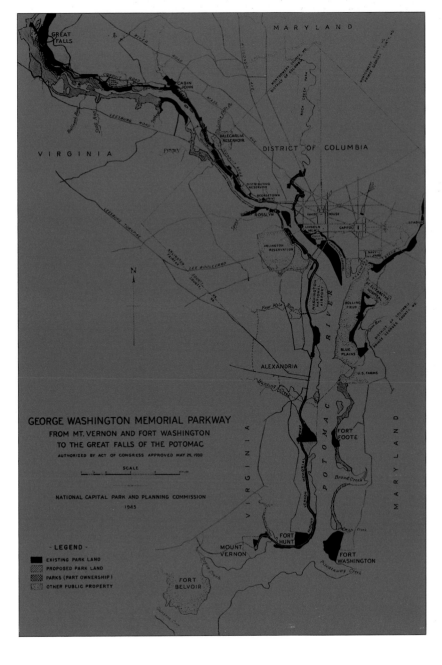

Park System
Washington, D.C.

A network of parks and parkways so extensive that it seems to engulf the city itself, the park system of Washington was formalized and strengthened by the creation of the National Capital Park and Planning Commission in the 1930s/40s. The Commission not only planned parkland within the city and on the city streets, but proposed extraurban projects such as the Fort Drive that would at once surround the city with a circumferential highway and commemorate the site of Civil War events.

Map of George Washington Memorial Parkway from Mount Vernon and Fort Washington to the Great Falls of the Potomac, 1938.

George Washington Memorial Parkway, 1945.

157

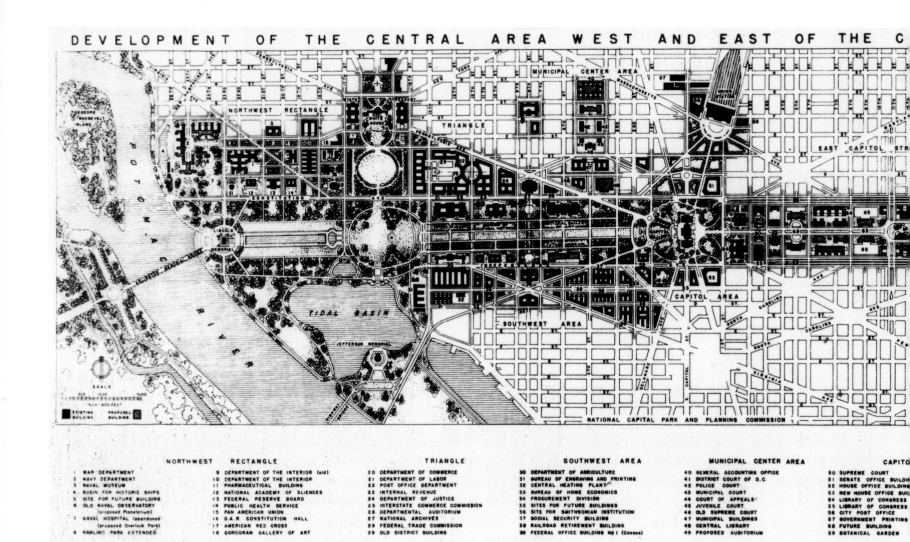

NORTHWEST RECTANGLE		TRIANGLE	SOUTHWEST AREA	MUNICIPAL CENTER AREA	CAPITO
1 WAR DEPARTMENT	9 DEPARTMENT OF THE INTERIOR (old)	20 DEPARTMENT OF COMMERCE	30 DEPARTMENT OF AGRICULTURE	40 GENERAL ACCOUNTING OFFICE	50 SUPREME COURT
2 NAVY DEPARTMENT	10 DEPARTMENT OF THE INTERIOR	21 DEPARTMENT OF LABOR	31 BUREAU OF ENGRAVING AND PRINTING	41 DISTRICT COURT OF D.C.	51 SENATE OFFICE BUILDIN
3 NAVAL MUSEUM	11 PHARMACEUTICAL BUILDING	22 POST OFFICE DEPARTMENT	32 CENTRAL HEATING PLANT	42 POLICE COURT	52 HOUSE OFFICE BUILDING
4 BASIN FOR HISTORIC SHIPS	12 NATIONAL ACADEMY OF SCIENCES	23 INTERNAL REVENUE	33 BUREAU OF HOME ECONOMICS	43 MUNICIPAL COURT	53 NEW HOUSE OFFICE BUIL
5 SITE FOR FUTURE BUILDING	13 FEDERAL RESERVE BOARD	24 DEPARTMENT OF JUSTICE	34 PROCUREMENT DIVISION	44 COURT OF APPEALS	54 LIBRARY OF CONGRESS
6 OLD NAVAL OBSERVATORY	14 PUBLIC HEALTH SERVICE	25 INTERSTATE COMMERCE COMMISSION	35 SITES FOR FUTURE BUILDINGS	45 JUVENILE COURT	55 LIBRARY OF CONGRESS
(proposed Planetarium)	15 PAN AMERICAN UNION	26 DEPARTMENTAL AUDITORIUM	36 SITE FOR SMITHSONIAN INSTITUTION	46 OLD SUPREME COURT	56 CITY POST OFFICE
7 NAVAL HOSPITAL (abandoned)	16 D.A.R. CONSTITUTION HALL	27 NATIONAL ARCHIVES	37 SOCIAL SECURITY BUILDING	47 MUNICIPAL BUILDINGS	57 GOVERNMENT PRINTING
(proposed Overlook Park)	17 AMERICAN RED CROSS	28 FEDERAL TRADE COMMISSION	38 RAILROAD RETIREMENT BUILDING	48 CENTRAL LIBRARY	58 FUTURE BUILDING
8 RAWLINS PARK EXTENDED	18 CORCORAN GALLERY OF ART	29 OLD DISTRICT BUILDING	39 FEDERAL OFFICE BUILDING No 1 (Census)	49 PROPOSED AUDITORIUM	59 BOTANICAL GARDEN

Development of the central area east and west of the Capitol, Washington, D.C., rendering, 1941.

Map and views of a proposed "Fort Drive" encircling Washington, D.C. and commemorating Civil War sites, National Capital Park and Planning Commission, 1943.

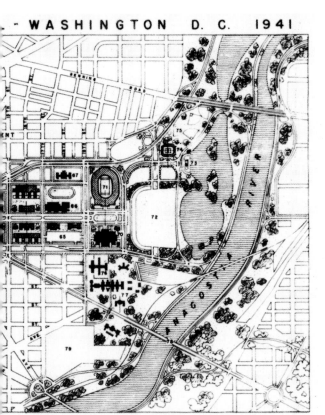

WASHINGTON D.C. 1941

EAST CAPITOL STREET DEVELOPMENT

60 FOLGER LIBRARY	70 ARMORY
61 HOLMES MEMORIAL GARDEN	71 STADIUM
62 ARMY MEDICAL MUSEUM	72 SPORTS FIELD
63 PROPOSED SEMI-PUBLIC BUILDINGS	73 NATATORIUM
64 PROPOSED FEDERAL OFFICE BUILDINGS	74 TENNIS ARENA
65 PARKING AREAS	75 RECREATION AREA
66 EASTERN HIGH SCHOOL	76 DISTRICT JAIL
67 ELIOT JUNIOR HIGH SCHOOL	77 GALLINGER HOSPITAL
68 CONSTITUTION AVENUE EXTENDED	78 PROPOSED MASSACHUSETTS AVE BRIDGE
69 INDEPENDENCE AVENUE EXTENDED	79 CONGRESSIONAL CEMETERY

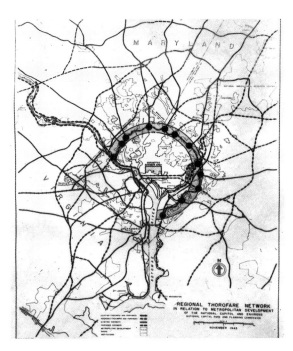

Proposed developments of
East Capitol Street, National
Capital Park and Planning
Commission, 1941.

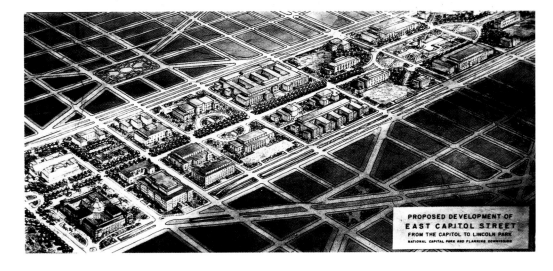

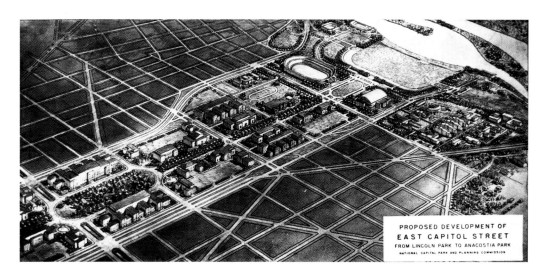

159

RICHLAND BALSAM PIGEON RIVER FALLS MOUNT MITCHELL LINVILLE FALLS

MOUNT PISGAH CRAGGY GARDENS CRABTREE MEADOWS TOMPKINS KNOB THE BLUFFS CUMBERLAND KNOB

NEWPORT

GATLINBURG

BRYSONCITY

2Z

2Y

GOOD GAP

2X

BALSAM GAP

2W

RAINBOW GAP

2V

SYLVA

CLYDE CANTON

WAYNESVILLE

ASHEVILLE

CANDLER

BREVARD

OLD FORT

MARION

LENOIR

WILKESBORO

INDEPENDENCE

GREAT SMOKY MOUNTAINS
NATIONAL PARK

N. CAROLINA BLUE RI

2V 2U 2T 2S 2R 2Q 2P 2N 2M 2L 2K 2J 2H 2G 2F 2E 2D 2C 2B 2A 1V

PIGEON RIVER FALLS | FLAT GROVE | BEAVERDAM GAP | FRENCH BROAD RIVER | AZALEA | HULL GAP | BALSAM GAP | BIG LAUREL GAP | GOOCH GAP | McKINNEY GAP | LINVILLE FALLS | BEACON HEIGHTS | GRANDFATHER MOUNTAIN | BLOWING ROCK | DEEP GAP | BOONE GAP | N. CO STATE ROUTE 16 | AIR BELLOWS GAP | US ROUTE 21 | STATE LINE

BLU 1051 A 1 OF 2

160

Master development plan,
Blue Ridge Parkway and
Parks, Virginia and North
Carolina, topographical
rendering, 1936.

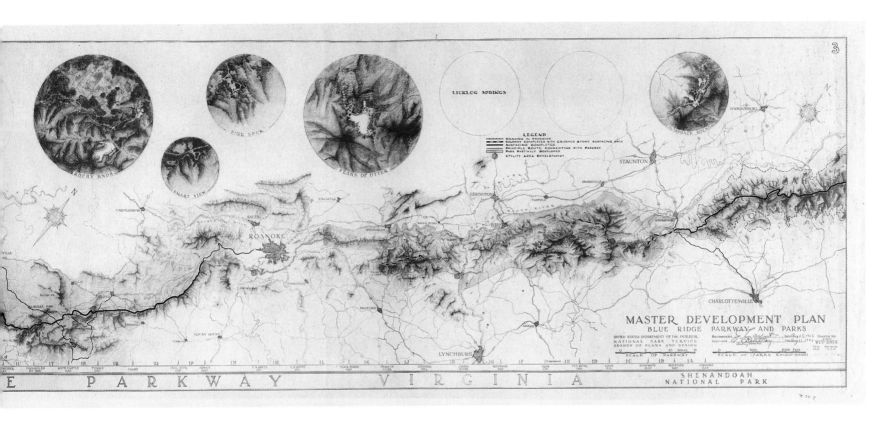

Blue Ridge Parkway
Virginia/North Carolina
A four hundred mile scenic drive
built in order to connect the
Shenandoah National Park of
Virginia and the Great Smoky
Mountains National Park of North
Carolina, the Blue Ridge Parkway is
one of the grandest of the Works
Progress Administration projects. It
is also one of the best examples of
the parkway ideal in which the
contours of natural topography are
both deferred to and highlighted by
the route and gestures of the road.

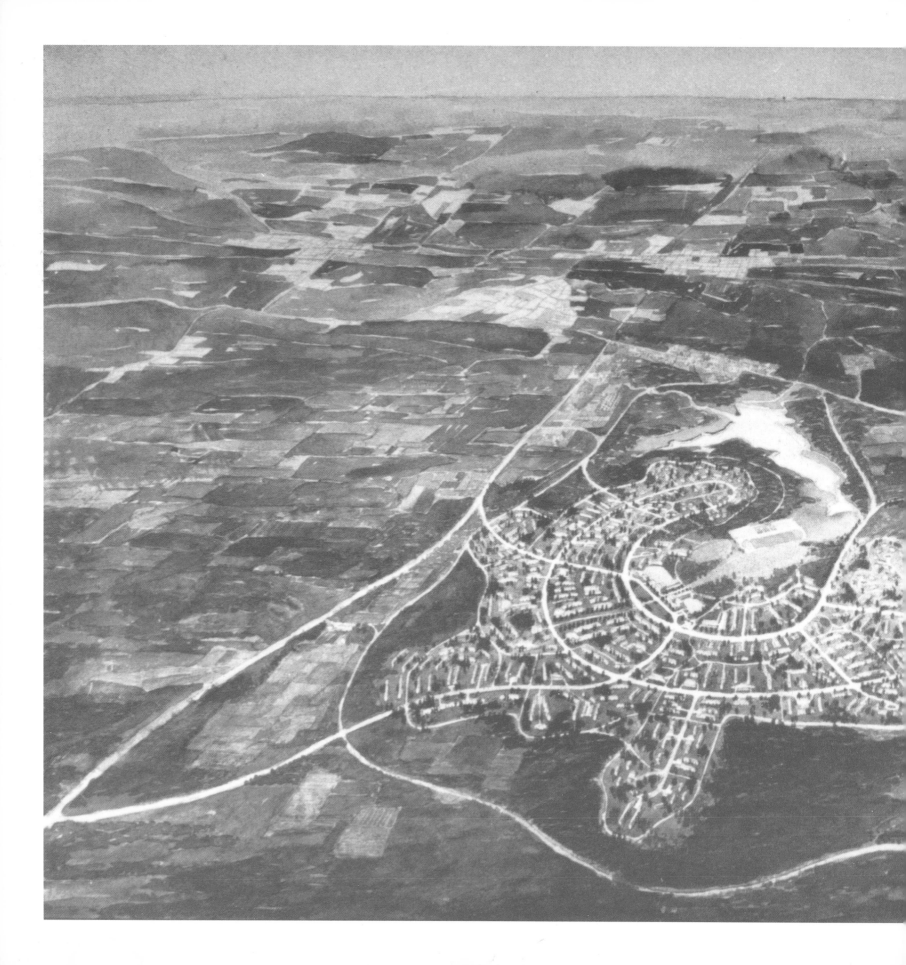

A Federal Housing Project by the Resettlement Administration, Greenbelt, Maryland, 1936.

Page from an exhibition book on the housing shortage in Washington, D.C., Resettlement Administration, 1936.

Projects for the commercial center and Typical underpass, Greenbelt, Maryland, 1936.

Greenbelt, Maryland

Constructed by Franklin Roosevelt's Resettlement Administration, Greenbelt was designed in 1936 as a town that would provide low cost housing as well as the civic and commercial functions necessary for a sustainable community in a park-like setting outside of Washington, D.C. The traditional American grid plan was replaced here by a crescent-shaped form nestled in to the low hillside of the site. Streets were de-emphasized while pedestrian paths were provided in abundance.

163

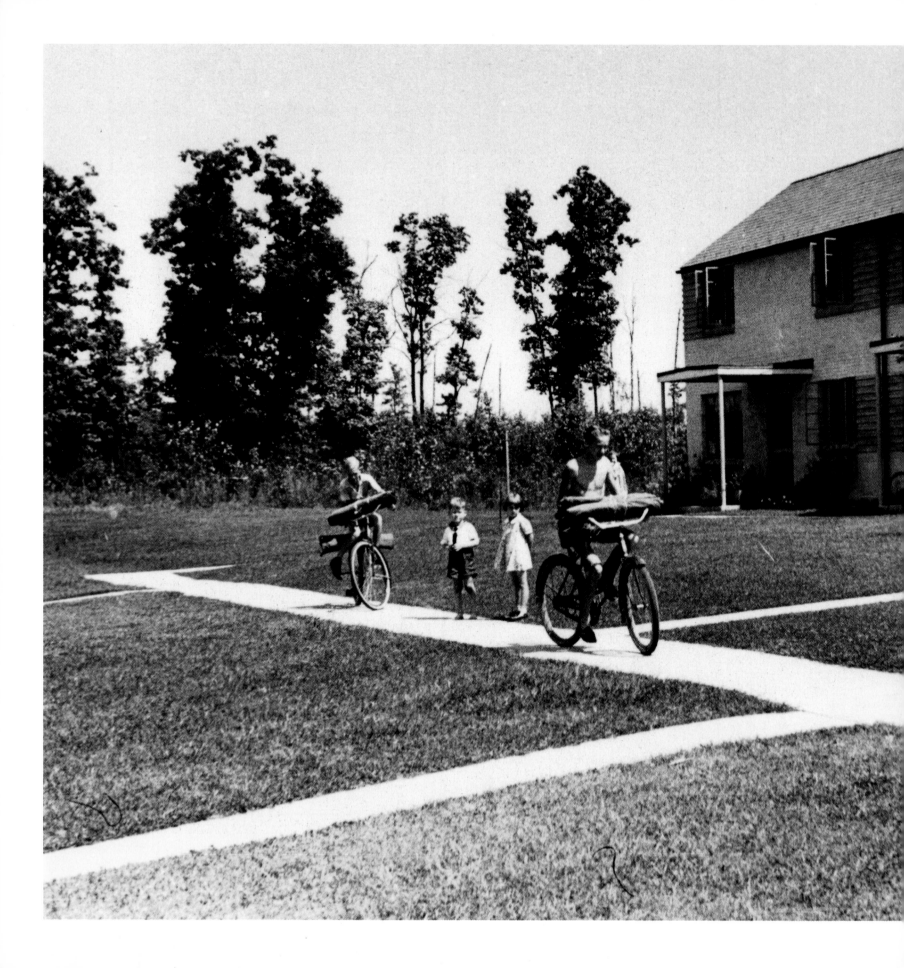

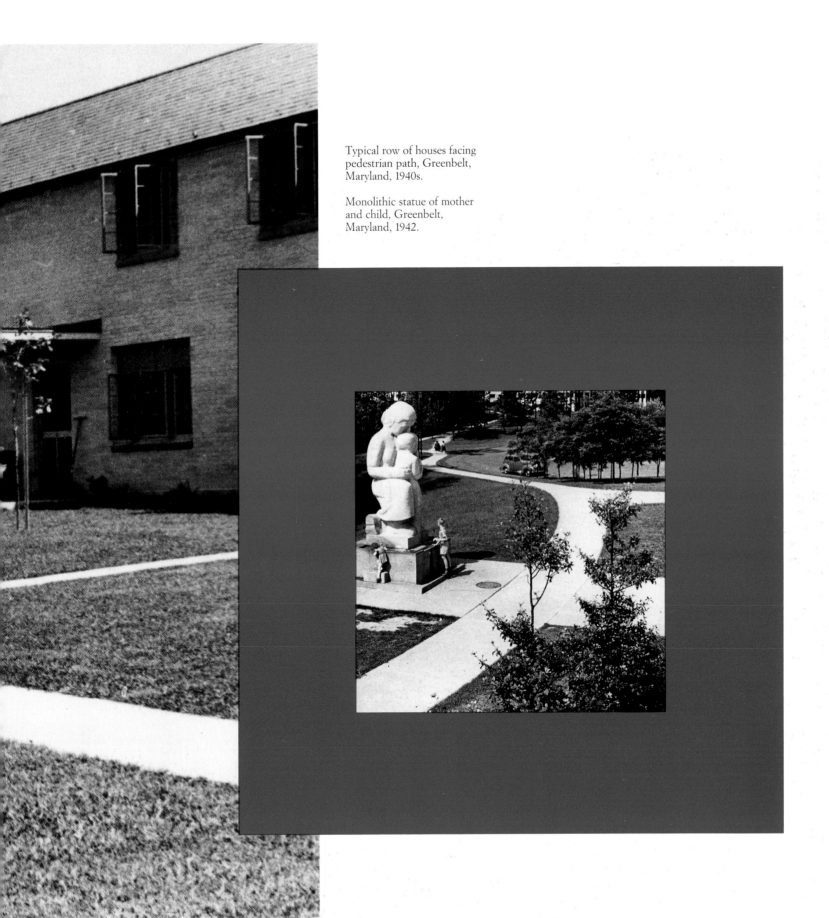

Typical row of houses facing
pedestrian path, Greenbelt,
Maryland, 1940s.

Monolithic statue of mother
and child, Greenbelt,
Maryland, 1942.

Contemporary Landscape Architects and a Sculptor

Daniel Urban Kiley, Peter Walker, Ron Wigginton, Hargreaves and Associates, Mary Miss

Some projects of a few landscape architects and artists in the late twentieth century might be viewed as efforts to make visible again the sublime in the American landscape. Projects by Mary Miss, for one, show an understanding of the mysterious force and magnitude of the land that can be gleaned from simply viewing the landscape within a certain framework, or seeing it altered in an unusual way. She does not simply decorate the surface of the land with objects, as some contemporary landscape artists are apt to do, but, instead, upturns, distorts and re-forms the land. The landscape architects and the sculptor considered in this chapter have a connection with the legacy of the mid-nineteenth century artists who were attempting to recognize the phenomenal in the American landscape and then attempting to portray it.

Contemporary landscape architects, George Hargreaves and Peter Walker have shown, with various projects, an appreciation of the resources of the American landscape. Peter Walker's Concord Per-

forming Arts Center in Concord, California is a giant grass crater in a huge landscape. George Hargreaves's suburban development, Lakewood Hills in Windsor, California includes a canal that offers a continuous reminder of the original agrarian character of the land in this place. His project for Candlestick Point Cultural Park in San Francisco considers the land along the water as an object in itself. This park is a response to its location in its effort to harness the elements of nature present—wind, water and air—in a way that is evocative of the place. Daniel Kiley's projects for private gardens refer to the topographical conditions of various regional landscapes. Rather than attempting, for instance, to impose traditional European gardening principles on land not necessarily suitable for such, he manages to manipulate what is given into something appropriate for the situation and, incidentally, profoundly architectural. Kiley's work is on a level with the ideals of Olmsted, Vaux and Eliot.

Daniel Urban Kiley

"I think of design in the landscape as being like a walk in nature. It's all there really, instead of copying the end result of a natural process, which the landscape architecture profession has done, especially ever since the mid or very early eighteenth century. From then on, landscape architects were always copying something. But the walk in nature is exciting and original, a fresh experience where you are going through a deep wood, maybe a grove of beech trees, then you come into an open meadow and you walk up the hill and then you come into the sugar maples, or 'sugarbush,' as they call it in Vermont, and you walk through that. You squeeze in between the trunks, and it's always moving and changing spatially. It's dynamic. This is the thing that intrigued and excited me right from the beginning. What I've been trying to do in my work is create a man-made scene having those attributes or characteristics."[1]

Mary Miss, "Blind Set" (steel, concrete, crushed rock, 140 feet across × 8 feet deep), Artpark, Lewiston, New York, 1976.

Daniel Urban Kiley of East Farm, Vermont is perhaps the most American of landscape designers in his approach to design in that he is intrigued not by an artificial decorative landscape, but in the purest of existing landscapes, of which there are a multitude in the United States. It is this acknowledgement of the richness of the American landscape that not only ties him to the roots of the early American landscape painters but to pioneering planners and conservationists such as Frederick Law Olmsted. His description of a walk through nature is so evocative of what is actually in the American land that it gives instant credence to his position as the "dean of Landscape Architecture in the United States."[2] Kiley is not interested in fashion. He is interested instead in "aptness," (a term he credits Olmsted with) in the determination of, not only what is designed, but where and why it is appropriate.[3]

Kiley has admitted that his first impulses to work with the land were derived from his experiences of working on a golf course. Indeed, golf courses in America are perhaps the most serene and extensive of contained landscapes. There is also a built-in assurance that they are unlikely to be impeded upon by development. While not intended as parks, they do, however, make beautiful pastoral scenes. Olmsted's Country Park in Prospect Park and the preserve of Franklin Park exhibited some of the qualities of a golf course in their peaceful, uninterrupted panoramas.

Aside from Olmsted, Kiley has mentioned the work of the French renaissance gardener, Andre Le Notre, as a source of inspiration. Given Le Notre's clean and expansive designs for parks such as those at Versailles and Vaux-le-Vicomte and Olmsted's interest in making pastoral preserves, Dan Kiley's work can be seen as a synthesis of the two, brought to a smaller scale. In many of his projects, geometric and spare (but organically rich) vistas give way to small preserves of lawn or woods, suggesting two types of landscape within a single garden.

Kiley's description of landscape design conceived of as a walk through nature seems curiously incongruous with his repeated recommendations for geometric patterns in garden design strategy. His use of geometry, however, has made environments in which it is possible to feel as if one is taking a walk through nature. He argues that since the beginning of time man has attempted to order the landscape, whether it is for agricultural purposes (which is quite evident from the air flying over farmlands, for example), or for the division of land. Kiley's plans for small suburban gardens have shown a successful use of this principle.

Kiley's earliest and possibly best-known works, done in collaboration with Eero Saarinen, for the Jefferson National Expansion Memorial in St. Louis, Missouri and Dulles International Airport in Chantilly, Virginia, attest to his concern with making the viewer experience nature while approaching a destination. Whether with a giant arch on a riverfront or an airport on a flat plain, Kiley achieved a landscape that could be understood sequentially with the simple but judicious use of geometric forms. In each, though, small deviancies within the geometry alleviate a potentially stiff composition. It is the view from a distance and the isolated views along a route that create an experience of travelling through nature.

At Dulles, the landscape plan is based on a module which includes native Virginia hedgerows and blocks of towering trees such as oaks and red cedars. Quaking Aspen trees were planted in the median strip. Within the pattern formed by the module, Kiley eliminated plantings at selected intervals in order to prevent the growth of too rigid a pattern on the land. In St. Louis, Kiley's plan called for geometrically-spaced rows of trees leading up to and surrounding Saarinen's Arch. These, in turn, formed the basis of the park.

Kiley's plans for private gardens are simple and effective.[4] To make a compatible landscape for a

house by Eero Saarinen in Columbus, Indiana, the Irwin Miller residence, Kiley extended the block-like geometry of the house out into the surrounding land. This land, which would otherwise be quite flat and uninteresting, is rendered architectural with the planting of groves and allees of trees. Kiley surrounded the house with a ten foot wide terrace, which, in turn, emphasizes the centralized plan of the whole. (Kiley compares this arrangement to that of the Villa Rotunda where a centralized house/temple has four faces but all of them stand above the land.) Running in front of one of these terraces is an allee of honey-locust trees which lead to a reclining Henry Moore sculpture, which is an obviously over-scaled figure for the perspective available. The greensward between the rows of trees here has the lowcut spareness of a golf course.

Beyond the geometry of the terraces and allees, a large group of trees, interlaced by a meandering path, forms a "Romantic" park. The entrance drive to the house is lined with low arborvitae hedges and horse-chestnut trees. On the street side of the drive, there are closely-planted red maple trees. In response to the owner's desire to maintain privacy without "keeping the community out," Kiley planted a hedge with alternating openings and closings in its density so that one cannot see in, but at the same time, one is not faced with a sheer wall of foliage from the street.

Another garden in Columbus started as an undistinguished suburban backyard. Kiley, acknowledging its size limitation, avoided any notion of trying to introduce a scene of nature and instead planned it as an outdoor set of rooms based on the same geometry of the house. He justly maintains that a sense of greater space can be achieved by treating a mimimum amount of land with an orderly composition and even putting a roof over it. Covered and uncovered terraces, two garden pavilions, an allee of honey-locust trees and uniform plantings make of the Hamilton backyard a set of outdoor rooms.

Dominating this diminutive landscape is a bosquet of littleleaf linden trees with ground cover. It is surrounded by a seven-foot-high wall, one side of which is lined with a long narrow pool filled with small fountains, which Kiley calls the Spanish Fountain.

Kiley's design for the Oakland Art Museum is a set of landscaped terraces set over the highways and interchanges of the city, a kind of hanging gardens of Babylon.[5] It completely denies the city's fabric and introduces an independent superstructure, an artificial landscape in fact, but one which is an addition to the otherwise mundane environment of its context. The underground plan of the museum had been proposed in fact in deference to the nearby city Hall and auditorium.

In the atrium of the celebrated Ford Foundation in New York, Kiley originally wanted to plant Eucalyptus trees that would grow to be one hundred and thirty feet.[6] Realizing, however, that they would not do well in such an enclosed environment, he planted masses of southern magnolias without even conditioning them. They are still doing well today, interspersed among various ramps, stairs benches and a pool.

With the giant corporate office complexes, the dilemma of every landscape architect, Kiley follows Frederick Law Olmsted's advice on aptness, i.e., do whatever is appropriate for the site. With the double sixty story towers of I. M. Pei and Henry Cobb for the Dallas Bank, Kiley was immediately convinced that what it needed around it was six acres of water. He had recently read a passage from Genesis about the opening of four waterfalls and therefore proposed four hundred as suitable for Dallas. The Squibb headquarters in Lawrenceville, New Jersey defers to the farmland of New Jersey it is built upon. Having accepted the necessity of a large cooling pond on the site of such a building complex, Kiley made a long and circuitous drive in front of it, treating it as a natural body of water.

170

Dan Kiley, Henry Moore
Sculpture Garden, Nelson-
Atkinson Museum, Kansas
City, Missouri, 1987–89.

Some small urban projects such as the one for an allee of trees and foliage tied in to a vertical truss system for the exterior of Indiana Bell (designed in conjunction with Paul Kennon) make a distinct reference to early park promenades of Olmsted and Vaux, such as the Eastern Parkway in Brooklyn.

Peter Walker

The Concord Performing Arts Center in Concord, California, designed jointly by Frank Gehry and Peter Walker exhibits very succinctly the enormity and richness of the western landscape of America. It is a giant green crater with a mountain range in the background. This ability to make evident, in an unself-conscious manner, the potential force and drama of nature should be recognized as the mark of successful landscape design in America. There is not a limited range of landscape so there is no need to disguise it. Its natural grandeur should be celebrated. It is a mistake, in the American context, to attempt to make pretty sculptural devices decorate the land. It is only through making evident its characteristics can it be done justice.

Walker's project for Marina linear park in San Diego appears as a late twentieth century urban parkway. With its rows of trees and segregated paths for pedestrians and vehicles, it will not only bring a park to San Diego, but make an urban boulevard along its waterfront.

Ron Wigginton/Land Studio

Ron Wigginton's recent project, *City Forest* is a forest brought indoors, not as a botanical garden, but as a metaphysical indoor landscape. It can perhaps be seen as the final gesture, in a long series, starting with the landscape painters of the nineteenth century, of trying to represent, conserve, utilize and, ultimately, contain nature. If this is the most inappropriate and cynical possible gesture for the American landscape, it can also be seen as a potent sign of the stage of progress or anti-progress we are at, in making use of the resources of our landscape.

The setting is an abandoned warehouse in downtown San Diego. Suddenly, the mythical empty plot of land in the middle of the city is no longer a viable option. The only open urban space left is indoors. Just as planners and designers of the early twentieth century made use of the remnants of polluted land within the city, Wigginton's gesture appears to be in the same spirit of salvaging through planting. As artificial and contrived as *City Forest* may appear, especially by comparison to the very noble and ecologically responsible efforts of earlier landscape designers, this stage-set does make clear to a lay audience what elements go in to producing a landscape design, for it is a microcosm of a landscape. *City Forest* can even be experienced as a three-dimensional painting. The designers of this environment have referred to perspectival techniques of the Sung dynasty in representing landscapes. This forest is uncomfortably contained in a closed-in space, forcing the viewer to realize that it is not an outdoor space, which might, in turn, reinforce the power of the actual image of the outdoors.

The *Wheat Walk* project of the Land Studio is another startling design. It is quite simply a wooden platform strung out over a wheat field. It provides a way of observing the field without descending into it. Such a construction has an archetypical quality to it. An image of an elevated walkway in the woods, also in California, from the beginning of the twentieth century is remarkably similar. It is not a project concerned with entering or carving into the land, or field (in this case), but rather skimming above the surface of it in order to examine it as a specimen of nature.

This, too, is in direct contrast to some of the other noteworthy projects of the late twentieth century that try to engage more directly the actual topography of the land rather than just viewing it. Just as with *City Forest*, *Wheat Walk* is intended for an urban audience, perhaps not accustomed to actually

touching the organic aspects of nature. The use of platforms is in fact exactly what Wigginton's work relies on—the stopping point, and then resting point, from which the mind can absorb these landscapes, whether completely fabricated, as with *City Forest*, or completely natural, as with *Wheat Walk*.

Hargreaves Associates

George Hargreaves and Associates have expressed an interest in using natural elements aside from earth, such as light, air and wind. Hargreaves has even referred to a desire to harness fog in his work. The project that the firm is currently working on with the artist Doug Hollis for Candlestick Point Cultural Park, for example, makes use of wind and water as an integral part of the design.

A reference Hargreaves uses in describing his work is "open composition." By this, Hargreaves means that he wants to employ elements of the land that exist in a site, not in a strictly contextual manner, but in a way that addresses their peculiarities. He stresses that it is essential to first walk on and around a site in order to understand its character and its position within a region.

Like Kiley's insistence on aptness in approaching the landscape, Hargreaves wants to employ the elements that exist within a site as a way of making reference to what was already there.

The firm's well-known first project, Lakewood Hills, 1979, in Windsor Hills, California is marked by the liberal use of water and trees in the plan of a suburban development in a formerly agricultural area.[7] Within the standard development style "loop road" that the house lots are strung out on, Hargreaves Associates placed two lakes. Admittedly close to the backyards of individual houses, the borders of the lakes are rimmed in concrete which give them a quasi-urban character. They are somewhat evocative, in fact, of the concrete-bordered ponds in New York's Central Park, from which children launch toy sailboats.

Connecting the two lakes, on a north-south axis, is a canal punctuated by circular pools. Inner walls of stacked wooden beams and rough-hewn rock embankments preserve the canal's distinct form and prevent its edges from getting merged into the surrounding earth. Rings of cypress trees are planted around the round forms of the canal, which will eventually mature into dense screens of foliage. Rows of poplar trees are planted perpendicularly to the canal as an effort to create a tree-lined greensward with a view eastwards towards the mountains. The visual and auditory benefits of using so much water in the plan of a residential development is unusual in twentieth century suburbia. The possibilities of wandering about the land and the bodies of water in this "neighborhood" might be compared to the character of mid-nineteenth-century communities such as Llewellyn Park in New Jersey that were built around a central natural feature. In the case of Lakewood Hills, Hargreaves Associates has attempted to make the entire community not only focus on the two small lakes and canal, but blend in to the character of the Sonoma Valley that it is built in, the foothills of which lie in the visible distance. Distinct architectural lines are drawn within the plan by evenly planted rows of trees, whether they border the streets and punctuate individual driveways, as seen on Lakewood Drive, or separate houses from recreational facilities such as tennis courts. Rigorously lining the streets with trees is a simple but effective way of avoiding the suburban blight of too much open space between houses and streets. It is a reference to early suburban developments and, ultimately, the tree-lined boulevards of the nineteenth century city. There are even traditional street lamps lining these streets. In addition to the loop road bordered with subdivisions, there is a series of mini-neighborhoods formed of houses around courts planted with small orchards. This, too, is an attempt, at a micro scale, to increase density in a suburban development.

Ron Wigginton, City Forest, San Diego, California, Land Studio, 1985.

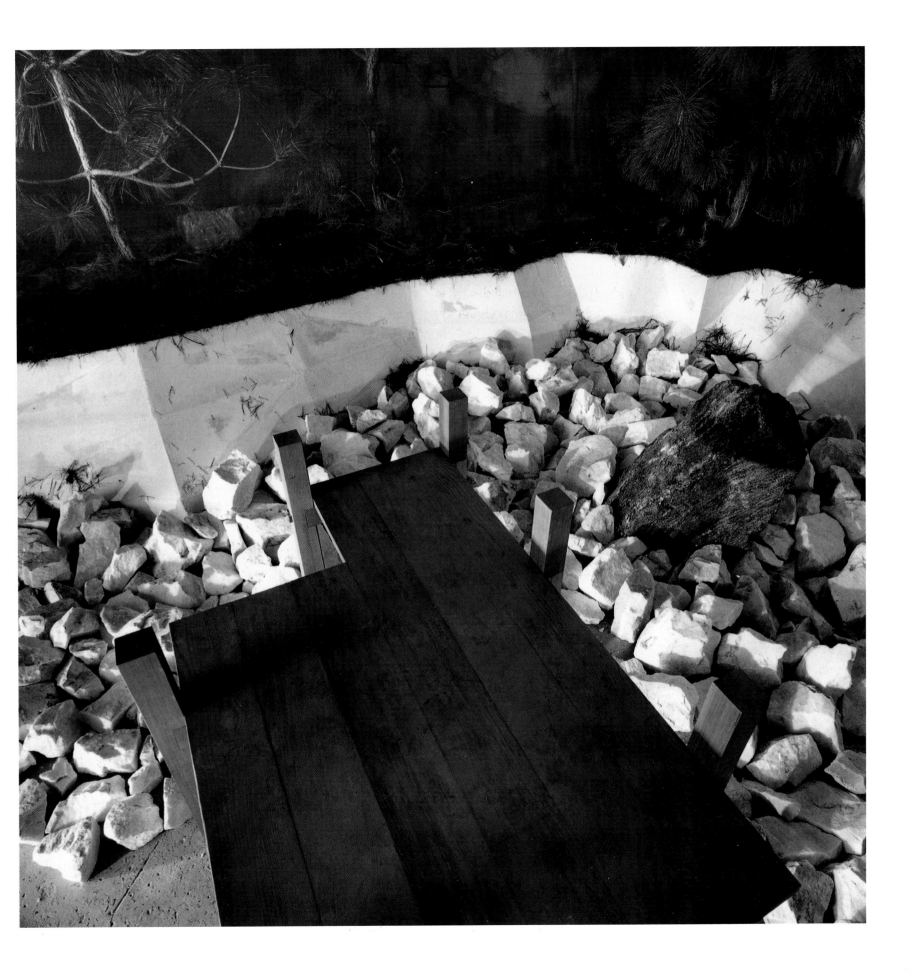

Lakewood's success as a mildly anachronistic suburb is something that will need to be proven over time, for it relies on variables such as the maturation of trees and the willingness of potential inhabitants to live in such close proximity to one another, sharing the benefits of common parkland, rather than owning individual plots of land. It is an effort, however, strikingly close in some of its intentions to Olmsted's plans for residential parks in the nineteenth century. It is also a bit recollective of greenbelt towns, where centrally placed community parks replaced individual yards.

Hargreaves Associates' Fiddler's Green Amphitheater in Englewood, Colorado is perhaps the purest expression of his desire to make evident the existing quality of a landscape. Set at the foot of a mountain range, it is a great green bowl, impeccably clear of any man-made obstructions.

A recent project Hargreaves Associates has been working on is the Candlestick Point Cultural Park in San Francisco.[8] Collaborating with the architect Mark Mack and the artist, Doug Hollis, Hargreaves has used this opportunity to examine closely the more ephemeral elements of the landscape such as wind and fog, as well as its possible drawbacks—highways and industrial plants. The site is an eighteen acre portion of landfill hemmed in between the Bay and California's Route 101. Nearby Candlestick Stadium and a number of naval superstructures complete the picture. The team, rather than attempting to obscure the noise levels present, decided to exploit them as an asset. In response to the wind, they focused it as a "wind tunnel" in order to call attention to and exaggerate its force.

Working, quite literally, in a sandbox, the team approached the problem of manipulating the landfill with a series of three dimensional studies in sand. They were also very conscientious about visiting the site frequently and noticing their own reactions to its features. For example, they noticed that they always walked towards the water and frequently stood with their backs to the wind. Based on these information gathering visits, the team decided upon five elements as appropriate for the site: a wind gate, an inclined plane leading to the water, tidal channels, a series of dunes and the building location.

The wind gate is a one hundred and thirty foot long door set in to a high screening mound that contains windpipes that play according to the level of the winds. It is an entry to the park that draws visitors in with sound. So as one enters the park the wind is at one's back. The gate leads the visitor directly onto the inclined grass plane pointed towards the water, its direction made even more evident by its forced perspective shape. A theater is at the end of the plane before the water. The theater building is composed of rough building elements such as concrete block and galvanized metal roofing, both being materials that one would expect to find on an industrial waterfront. Its conception as a warehouse is appropriate for the site not only because of its image but because of its light weight for the landfill. The park furniture is made out of rubble found on the site in forms similar to Mark Mack's furniture designs.

Tidal channels carve the shape of the plane into a long jutting form similar to the industrial piers of San Francisco. Out of the landfill have also been carved four planting terraces, whose plants are fed by the water of varying tides. At the ends of the channels are overlooks jutting out into the Bay. These have been particularly appealing elements to Hargreaves who imagines the possibility of standing on them in the middle of the fog.

Mary Miss

"I think the idea of putting a nice little garden in the middle of a city doesn't make a lot of sense. I like to do things that somehow come out of the place in which they are built; to introduce a peaceful bit of Eden in the midst of 42nd Street seems like an inappropriate response to the situation."[9]

The sculptor, Mary Miss produces work that is fundamentally concerned with the character of the American landscape. She has stated that she is interested in providing an emotional experience for the viewer. A clear parallel can be drawn between this approach and that of the Hudson River School painters. The emotional response that the romantic painters of the nineteenth century evoked from their audience was based on the viewing of nature through a canvas.

In the case of Mary Miss's work, however, that canvas has assumed another form, that of the real or virtual screen between the viewer and the landscape, the product of constructions that call attention not to themselves, but to what they frame or make evident in the land that they occupy. Yet Miss is not strictly concerned with the views provided by an open landscape. She has also expressed an interest in using and making desirable sites that have typically been left abandoned such as old bridges or other physical remnants of an earlier era.

Her intention has been to integrate sculpture with the landscape, regardless of the site, with the use of transparent structures, whether they are actual screens or implied filters such as wooden cages. References to fences are based on her own memories of corrals demarcating land in the American west where she grew up. Above all, she has been trying to get away from the monolithic structures that sculptors of the 1960s were indulging in that stood as objects in the land rather than as part of the land.

An object such as a platform constructed of timber, or a screen of posts and chain link, is the medium through which an observer is offered an opportunity to focus attention on a view of nature in a specific place. The physical presence of the individual works are perhaps less important than their ability to locate, for the viewer, a certain place in time and memory. They become the physical constructs upon which the viewer's memory can anchor itself, a point from which it can then wander off in apprecia-

tion of the site. Within the myriad range of possible American landscapes, Miss has worked with relatively anonymous sites. Her stated desire to provide sites with emotional content to be experienced directly by the viewer relies on a framing of a view or the marking of a spot. She uses natural materials that might have been drawn from the site. In wooded areas, timber construction is used. On open plains, an upheaval or excavation of the earth begins to suggest content in an otherwise blank surface.

With her projects for excavating and then giving structure to segments of the earth, Miss presents situations in which the terrain has not been added to, but rather altered in such a way as to call attention to the raw elements already existing in a certain place. She has stated that she is not interested in making imaginary landscapes, but in questioning the boundaries of space that are normally taken for granted and calling attention to the very physical aspects of the space. In the project called *Perimeters, Pavilions, Decoys*, for example, a sixteen foot square well set in an open field strangely expands to forty square feet under the earth. It makes the viewer unsure of the limits of the earth in this spot and thereby begins to make evident the intangible in the very form of the land.

Miss has attempted to involve the viewer in her work, on both physical and emotional levels, by making it something that needs to be walked around, in, through or on top of in order to be understood. She has spoken of making the viewer a participant in the work in which vistas are revealed in a gradual, almost choreographic way. Aside from *Perimeters, Pavilions, Decoys*, the projects, *Veiled Landscape, Field Rotation* and *Staged Gates* are all examples of this program to make the work accessible to the viewer.

Miss has referred to an interest in the architecture of fortifications and gardens. She is intrigued by their ability to provide physical and spiritual protection

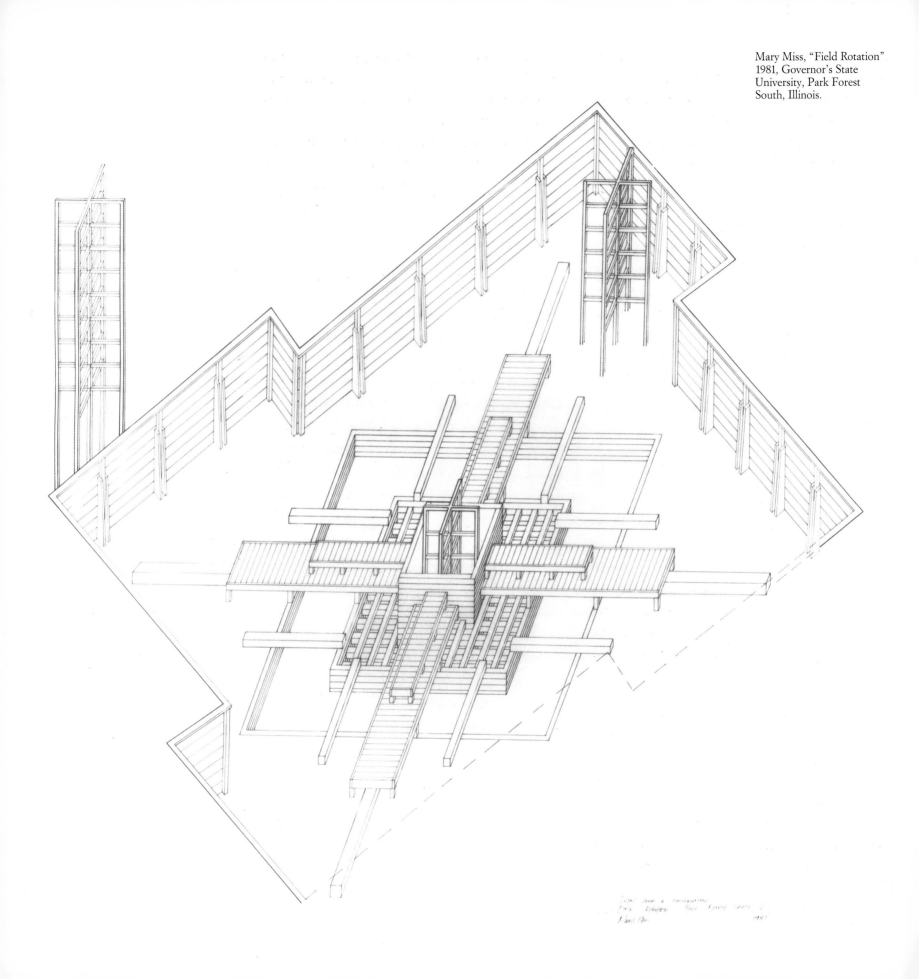

Mary Miss, "Field Rotation"
1981, Governor's State
University, Park Forest
South, Illinois.

on an open plain, for example. But the descriptions of gardens in novels by Jane Austen have been particularly influential for her. When one imagines the gardens described in *Mansfield Park*, some of which had in fact been worked on by Humphrey Repton, it becomes a plausible reference for the kind of sequential and participatory landscapes that Miss has produced in recent years.

The Battery Park City project that Miss has collaborated on recently has been well publicized. Her work here has been to help make usable a park at the edge of a landfill on the lower West Side of Manhattan. Dominated at one end by the towers of the World Trade Center and exposed to the wastelands of West Street just north of the complex, the site is shockingly different from the rural locations that Miss has typically worked in. Its setting, however, is relevant to some of the ideas stated by Miss earlier about her inclination to work with the conditions of a given site, whatever they may be. Here, the slippery walls of the new towers, in contrast to the roughness of the surrounding industrial detritus, must have presented a potent challenge to such an ideal.

The two thousand acre site of South Cove that Miss worked on with Landscape Architect, Susan Child and architect, Stanton Eckstut, is quite simply composed of plants, boulders, wooden planks and painted steel railings. Set in the residential area of Battery Park City, the project refers to both the elements of a natural cove and those of an industrial waterfront. Heavily planted with shrubbery and pine trees and marked by a set of boulders, the inner part of the cove seems hardly to be in Manhattan, while the wooden construction at the water's edge is suggestive of the piers of the West Side docks.

The form of the new pier is a three quarter circle with a humped bridge crossing it in the middle. It is approached through a portal that also serves as a viewing platform. The end of the circular pier reveals its supporting posts while the concrete spans that hold up the landfill itself are exposed at the other end. The sinuous lines of this pier are in strong contrast to the sharp profiles of the towers that cover most of the landfill.

Finally, the straight promenade that leads to the pier is evocative of a simple boardwalk along a beach and picks up the line of the esplanade leading towards the end of the island of Manhattan, south of Battery Park City.

[1] J. Robertson, "Renowned Landscape Architect Dan Kiley reviews his life and times in a University of Virginia symposium," in *Inland Architect*, March/April 1983, p. 15.

[2] J. Robertson, "Introduction," *The Work of Dan Kiley*, A Dialogue on Design Theory, Proceedings of the First Annual Symposium on Landscape Architecture, The University of Virginia, 1982.

[3] Dan Kiley Lecture, *The Work of Dan Kiley, A Dialogue on Design Theory*, Proceedings of the First Annual Symposium on Landscape Architecture, The University of Virginia, 1982, p. 7.

[4] These descriptions are based on Dan Kiley's Lecture, *The Work of Dan Kiley*, University of Virginia, 1982.

[5] Ibid.

[6] Ibid.

[7] S. R. Frey, "Lakewood Hills, A Future for Memory Lane," in *Landscape Architecture*, March/April 1984, pp. 47–51.

[8] S. R. Frey, "Candlestick Point Park," in *Landscape Architecture*, May/June 1987, pp. 53–59.

[9] From an interview with Paola Antonelli in *Domus*, no. 732, November 1991. The information for the description of Miss's work is based on this interview and one with Deborah Nevins in *Landscape*, The Princeton Journal, Vol. 2, 1985, pp. 96–104.

Dan Kiley with Eero
Saarinen, St. Louis Arch
Park, St. Louis, Missouri,
view of model and plan,
1947.

Dan Kiley
St. Louis Arch Park, 1947
St. Louis, Missouri
A park of lawns and allees of trees
leading to the famous arch of Eero
Saarinen, the setting of the Jefferson
National Expansion Memorial
exemplifies the principles of
landscape design that Kiley
maintains. It offers a pleasant walk
through nature towards a specific
destination while providing visual
178 diversions along the way.

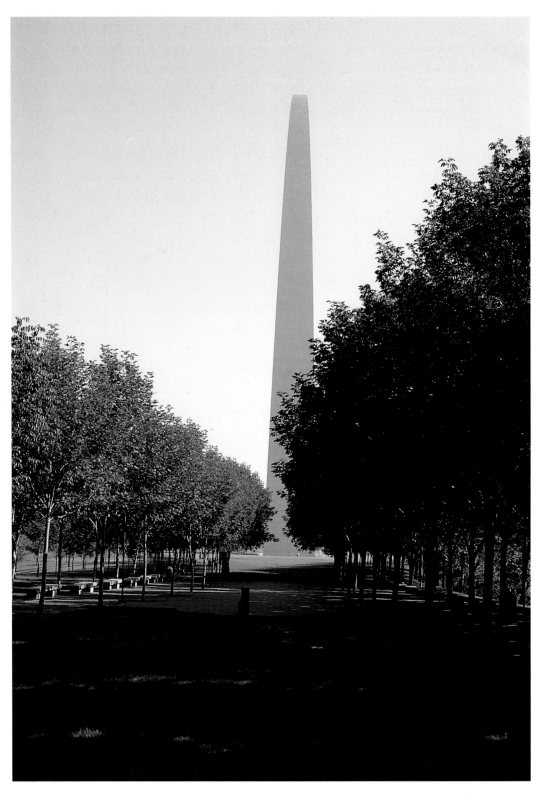

View of the park and sketch
details, 1947.

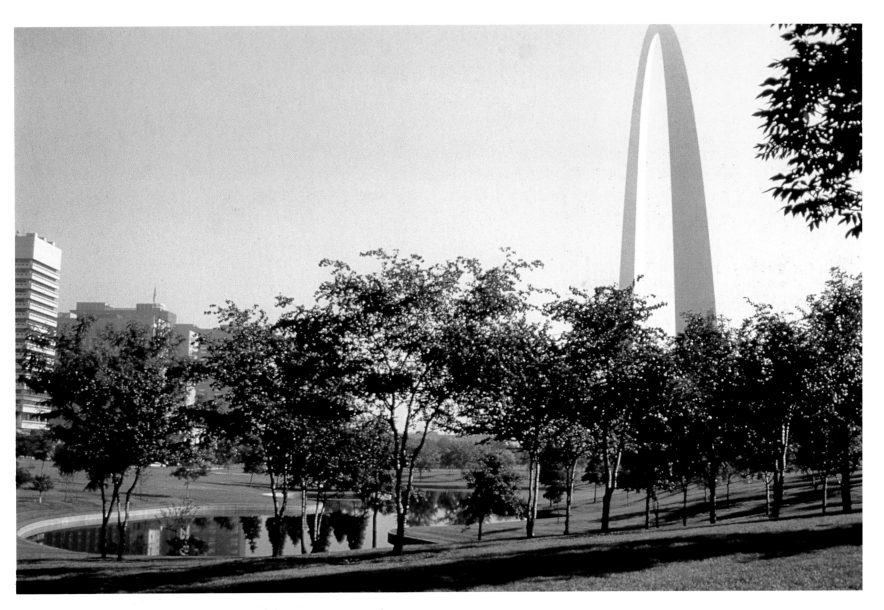

Dan Kiley with Eero
Saarinen, Dulles Airport
grounds, Chantilley,
Virginia, 1958.

Dan Kiley
Dulles International Airport, 1958
Chantilley, Virginia
The allee of trees lining the
approach road to Saarinen's terminal
building at Dulles reinforces the
sweeping lines associated with this
canonic work of architecture that so
poignantly represents the thrill of
flight. True to the site, Kiley used
native Virginia hedgerows and
blocks of oak and cedar trees.

181

Dan Kiley
Irwin Miller Residence, 1955
Columbus, Indiana

An example of Kiley's astute understanding of differing but compatible types of landscape environments, this private garden offers both the ordered geometry associated with classical gardening and the looseness that characterizes the picturesque. With a series of allees in conjunction with a romantic grove, Kiley evokes the quality of a walk in nature which he prizes so highly. The block-like geometry of the Saarinen designed house was stretched out into the land to provide the plan for the garden.

Dan Kiley, Irwin Miller residence, Columbus, Indiana, 1955.

Dan Kiley, Hamilton residence, Columbus, Indiana, 1963.

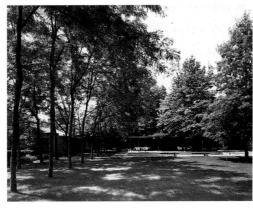

**Dan Kiley
Hamilton Residence, 1963
Columbus, Indiana**
This garden is based on the geometry of the house it serves but is so small that Kiley decided to consider it as a set of outdoor rooms rather than a scene in nature. The orderly composition makes an otherwise ordinary backyard seem like a more expansive environment. Covered and uncovered terraces as well as walls and a fountain contribute to the continued nature of the garden.

183

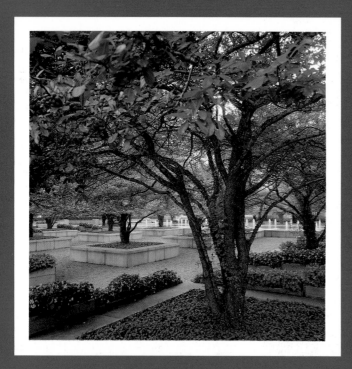
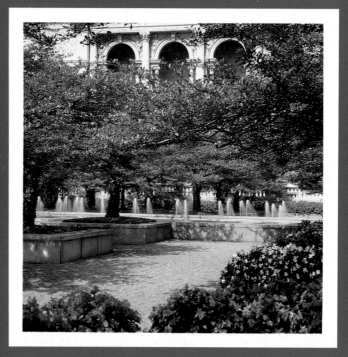

Dan Kiley
Art Institute of Chicago, 1962
Chicago, Illinois
Planted over a parking garage and
composed of hard surfaces and
geometrically-organized trees planted
in parterres, this urban garden refers
to the major thoroughfare it faces,
Michigan Avenue and the limestone
walls of the museum it serves.
Five rows of honey locusts help to
block traffic noise. A pool is at the
center of the park.

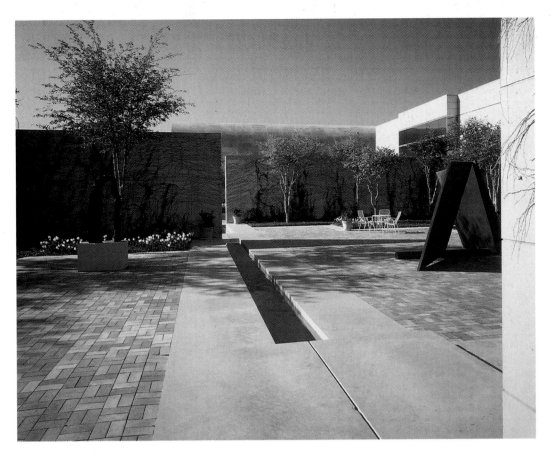

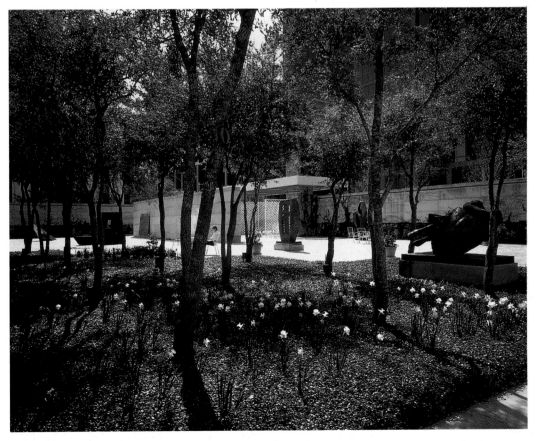

Dan Kiley
Dallas Art Museum, 1985
Dallas, Texas
A disarmingly minimal plaza and greensward offer a forecourt to the museum designed by Edward Larrabee Barnes. A series of room-like courts act as a sculpture garden.

185

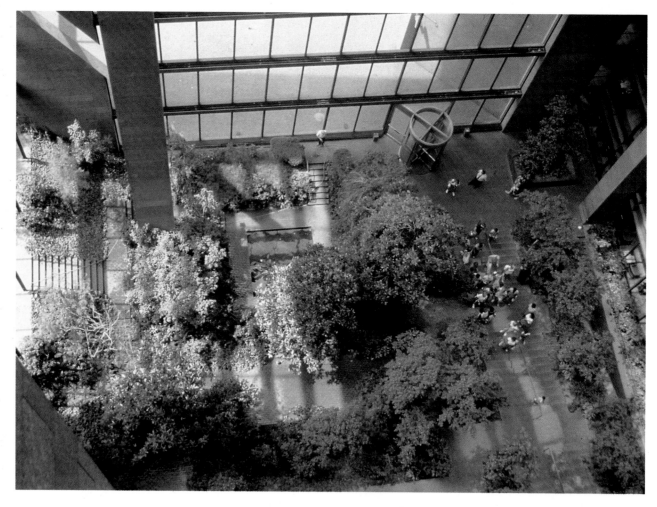

Dan Kiley
Ford Foundation, 1964
New York, New York
This internal city garden is composed of masses of southern magnolia interspersed among ramps, stairs, benches and a pool. It offers a quadrant of nature within the density of a major corporate headquarters in New York designed by Kevin Roche and John Dinkeloo.

Dan Kiley with Kevin Roche and John Dinkeloo, atrium of Ford Foundation Building, New York, 1964.

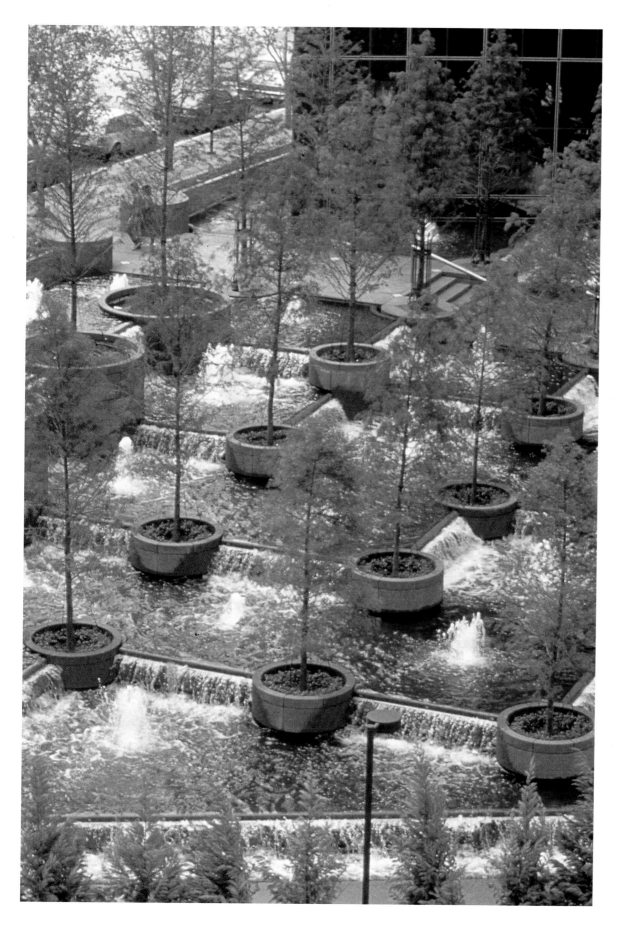

Dan Kiley
Fountain Place, 1987
Dallas, Texas
In front of the Dallas City bank,
a double sixty-story tower designed
by I. M. Pei and Henry Cobb, Kiley
called for the creation of a six acre
water park comprised of four
hundred fountains that feed a series
of low waterfalls. Potted trees set
into the water establish the grid
points of the design. The project is
based on a reading of Genesis that
described the opening of four
waterfalls. It is the most ambitious
water garden since the Renaissance.

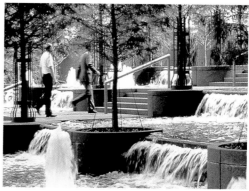

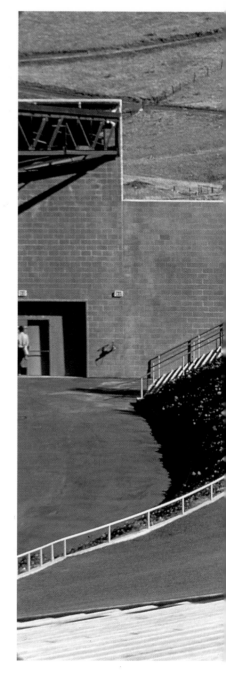

Peter Walker with Frank
Gehry, Concord Performing
Arts Center, Concord,
California, 1975.

Peter Walker
Concord Performing Arts Center, 1975
Concord, California
A joint venture with Frank Gehry,
this is one of the finest examples of a
contemporary landscape design that
allows the character of the land to
assert itself. Nothing but a giant
green crater, the amphitheater is
testimony to the richness of the
California earth from which it is
carved.

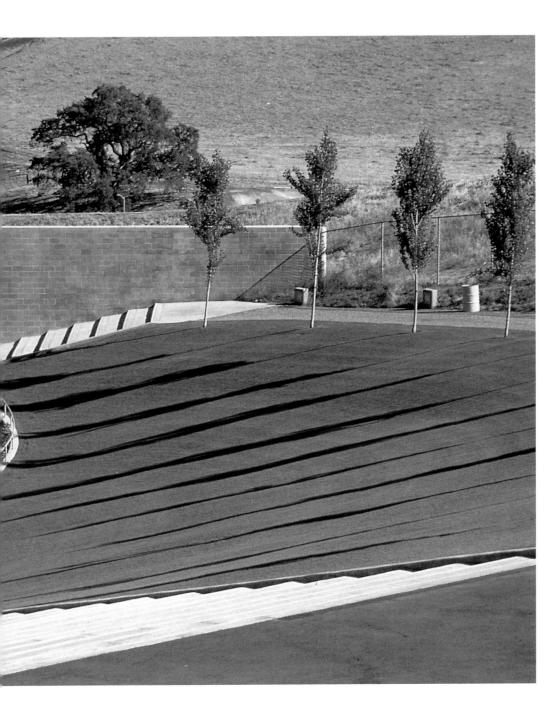

Peter Walker, Marina Linear
Park, San Diego, California,
model and views, 1989.

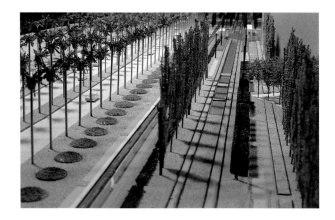

Peter Walker
Marina Linear Park, 1989
San Diego, California
The repetition of trees and multiple
lanes for traffic mark this linear park
as a contemporary urban parkway
reminiscent of Olmsted's seminal
190 Eastern Parkway in Brooklyn but
incorporating the various levels of
speed integral to modern life. It
extends the city grid into the park
and recalls the lost urban character.

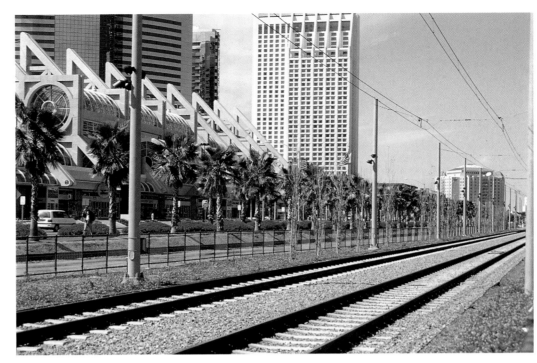

Ron Wigginton, Land
Studio, City Forest, San
Diego, California, view
of the entrance, plan
and section, 1985.

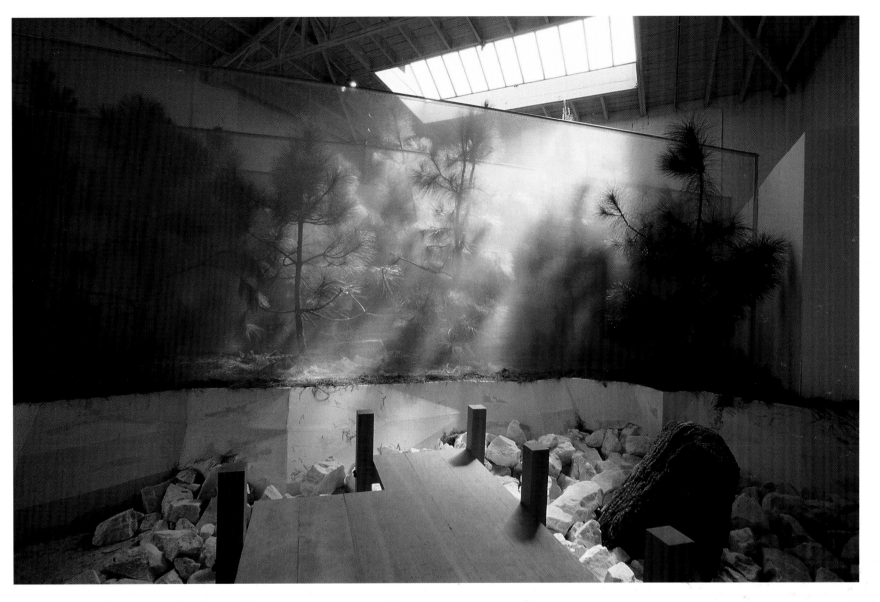

Ron Wigginton, Land
Studio, City Forest, interior
views, 1985.

Ron Wigginton/ Land Studio
City Forest, 1985
San Diego, California
If the pioneers of landscape design
made use of the leftover outdoor
spaces in the city to introduce
parkland, then Ron Wigginton's use
of an empty warehouse in San Diego
is the logical extension of reviving
abandoned space in the city but this
time, indoors. Conceived of as a
three-dimensional painting, it also
has ties to the Hudson River School
in its attempts to contain and portray
nature, but this time, internally.

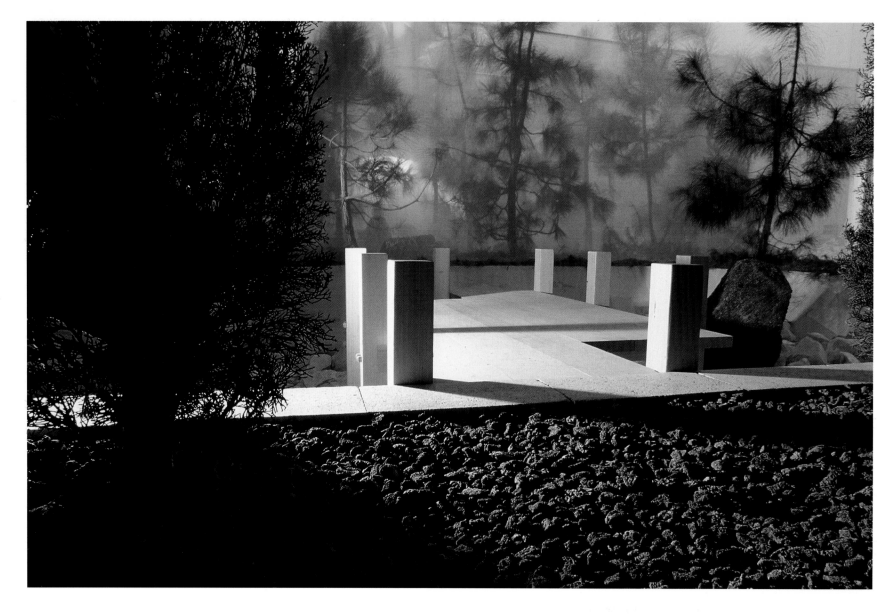

Ron Wigginton, Land
Studio, City Forest, interior
view and unloading of trees,
1985.

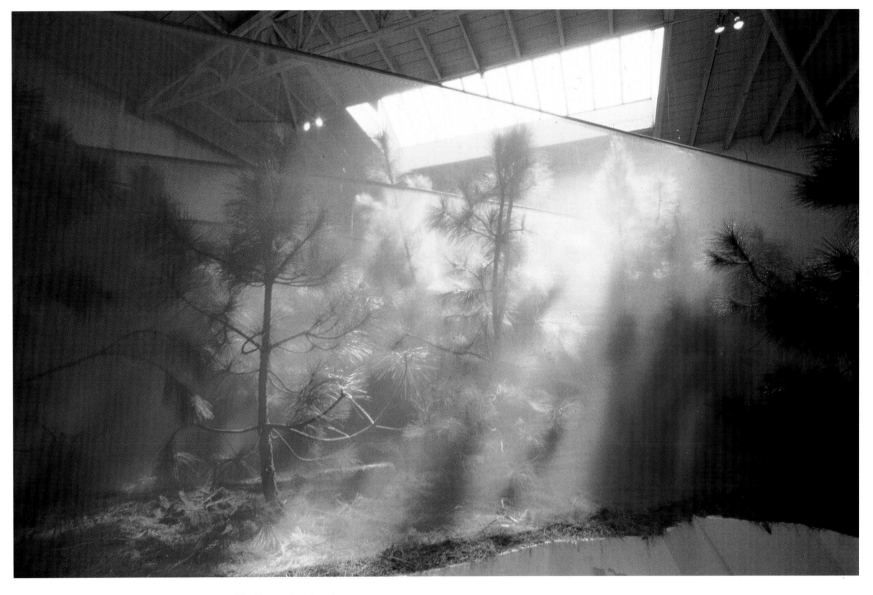

City Forest, interior view,
1985.

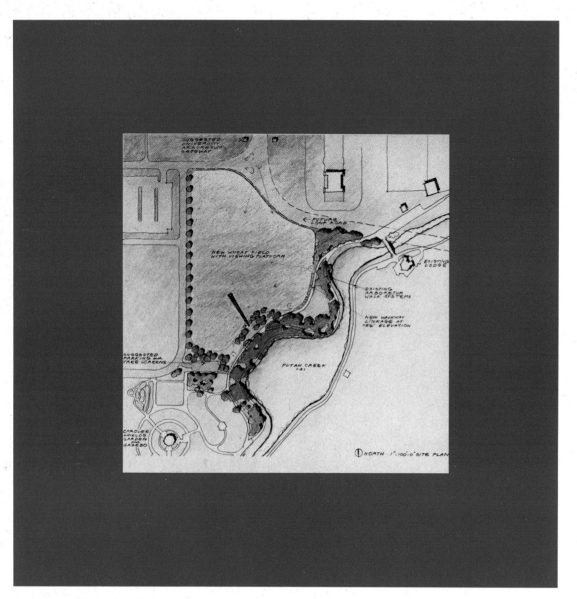

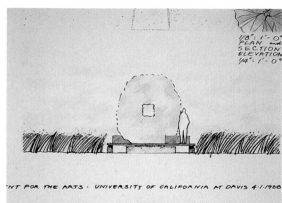

Ron Wigginton/Land Studio
Wheat Walk, 1988
University of California at Davis
An elevated wooden boardwalk, the
Wheat Walk project is simply for
196 viewing nature from a safe distance.

Ron Wigginton, Land
Studio, Wheat Walk, general
plan and perspective
drawings, 1988.

Board Walk, Presidio,
San Francisco, California,
circa 1912.

Ron Wigginton sitting
on boulder, 1980s.

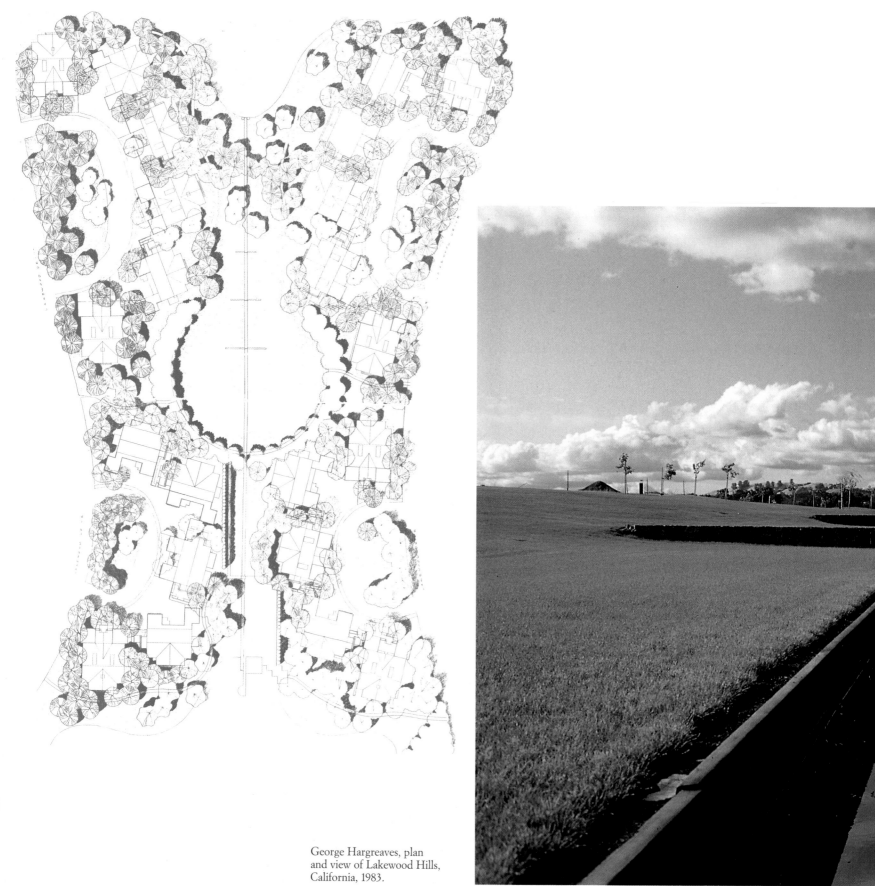

George Hargreaves, plan
and view of Lakewood Hills,
California, 1983.

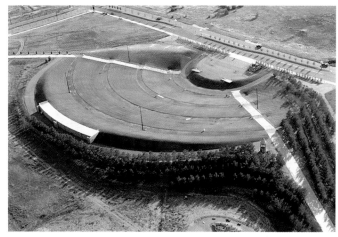

George Hargreaves,
Fiddler's Green, Colorado,
aerial photograph.

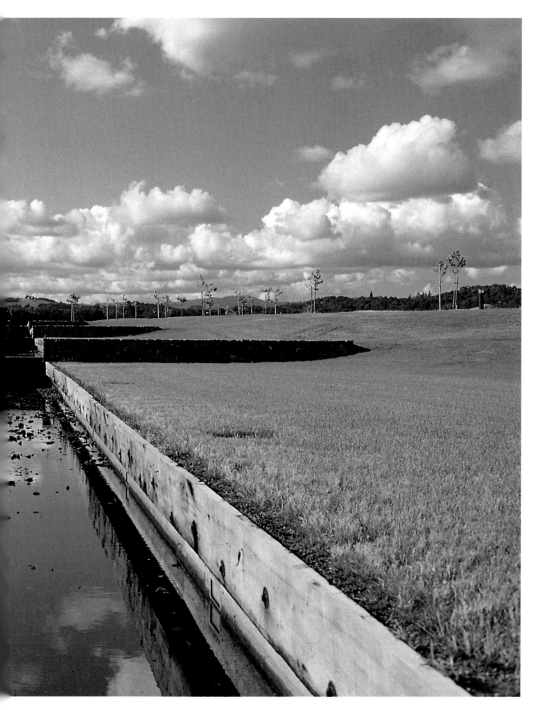

George Hargreaves
Lakewood Hills, 1979
Windsor, California
A suburban development in
Windsor, California, this project is
marked principally by the generous
use of trees and water. The
conventional subdivision plan is
given reinforcing lines with trees and
is bordered with two small lakes
connected by a canal. The hard
edges of the concrete describing the
outlines of the water and the close
repetition of trees lining the streets
lend the feeling of an urban park to
the neighborhood.

199

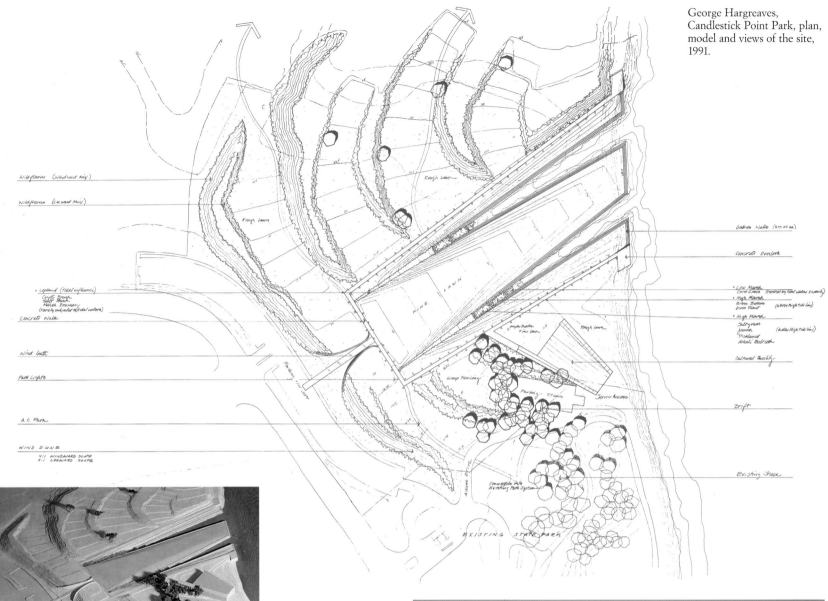

George Hargreaves,
Candlestick Point Park, plan,
model and views of the site,
1991.

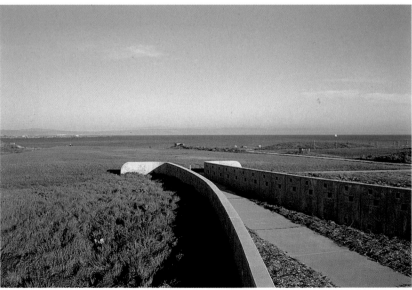

George Hargreaves
Candlestick Point Park, 1991
San Francisco, California

This waterfront park, produced in collaboration with Mark Mack and Doug Hollis, is an eighteen acre portion of landfill between the Bay and Route 101. The noise of the water, a nearby stadium, naval superstructures and industrial plants were exploited rather than quelled. A wind gate, a wind tunnel, an inclined plane leading to the water, dunes and tidal channels are among the elements of which the park is composed. The wind, air and fog are instrumental in the making of the park's environment.

200

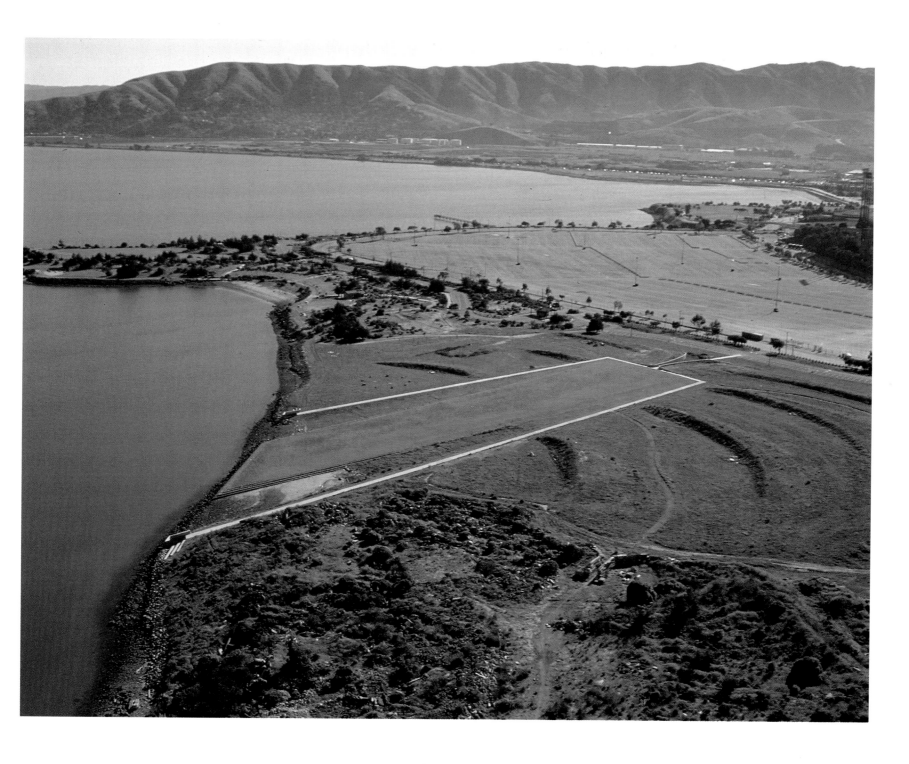

Mary Miss
Field Rotation, 1981
Governor's State University
Park Forest South, Illinois
Giving a context to an otherwise flat and blank field, Miss literally twisted the land into a point of tension. A centralized embedded platform offers a set of interlocking wooden terraces from which to view the surrounding landscape. The timber posts leading into the center suggest a presence of something that is never revealed while recalling the familiar boundary lines of western ranches.

Mary Miss, "Field Rotation" (wood, steel, gravel, earth, 60 feet × 60 feet × 7 feet deep on five acre site).

202

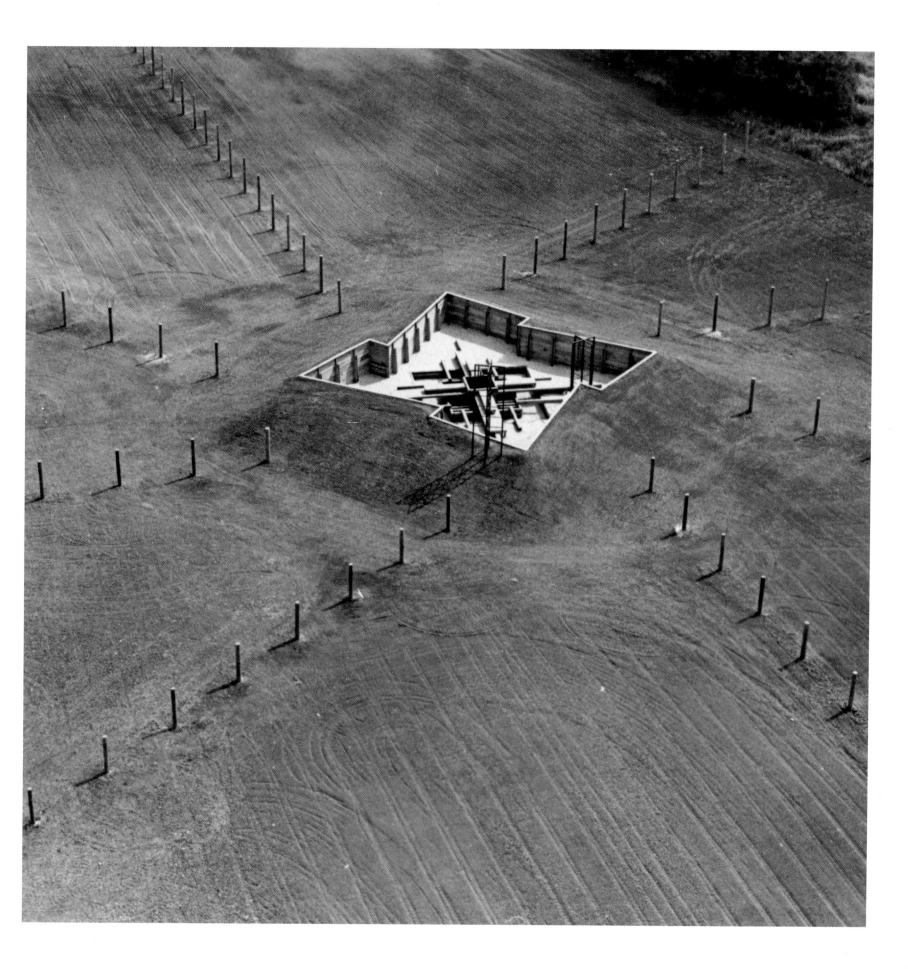

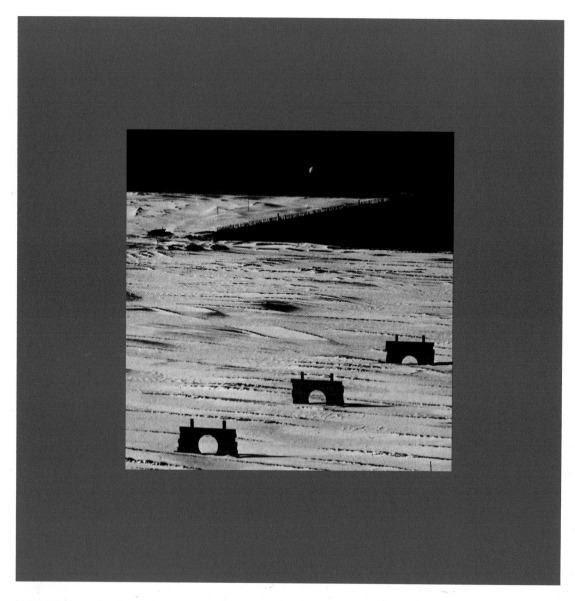

Mary Miss, "Veiled
Landscape" (wood, steel,
wire mesh, overall length,
400 feet), detail of the
viewing platform
(15 feet × 6 feet × 12 feet
high).

"Veiled Landscape," detail
of the curtain of posts (30 feet
high × 60 feet wide).

"Veiled Landscape," detail
of the wood lattice wall
(20 feet × 6 feet × 60 feet
wide).

Mary Miss
Untitled, 1973
Battery Park
New York, New York
A series of punctured billboards
composed of wooden planks, these
structures on the edge of Manhattan
were evocative of the uncertain
nature of this leftover terrain.
The viewer is obliged to line them
up visually.

Mary Miss, "Untitled"
(12 feet × 6 feet wood
sections at 50 feet intervals).

Mary Miss
Veiled Landscape, 1979
Lake Placid, New York
A three-dimensional canvas
of nature, this project not only frames
a distant view but captures within
the squares of its grid formation,
segments of that view abstracted into
a texture of foliage and sky.

Mary Miss
Staged Gates, 1979
Dayton, Ohio
Recollective of fortress walls, these barriers of wooden planks set into a wooded ravine present a dream-like sequence of opening and closures.

Mary Miss, "Staged Gates" (wood, 50 feet × 12 feet high × 120 feet deep).

Mary Miss, "Perimeters,
Pavilions, Decoys," pit
opening: 16 feet square,
40 feet square underground.

"Perimeters, Pavilions,
Decoys," 18-foot-high tower.

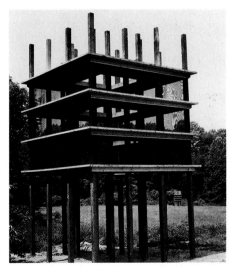

Mary Miss
Perimeters, Pavilions, Decoys,
1977–80
Nassau County Museum
Roslyn, New York
Working with basic principles of
inversion, Miss constructed a tower
and a pit on this site. The eighteen
foot high tower appears as the
skelston of a building with its
platforms and posts. The unmarked
pit widens up below grade and
suggests a sunken courtyard house
with an ambulatory.

207

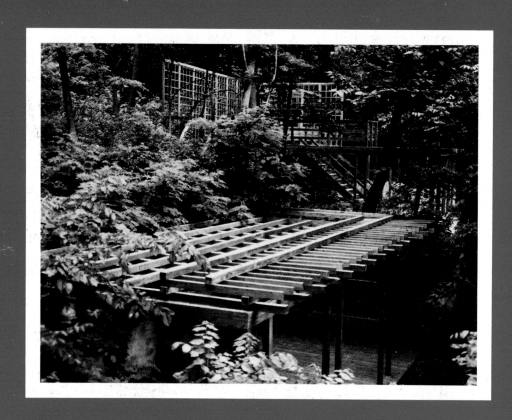

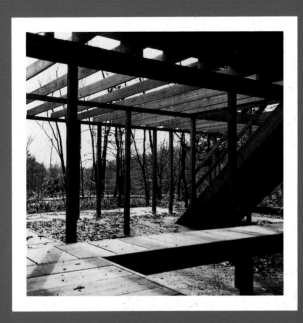

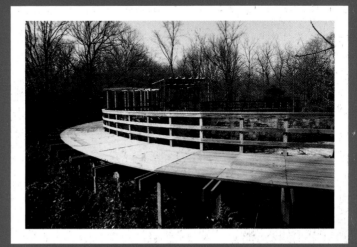

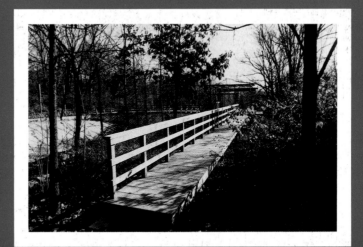

Mary Miss
Pool Complex: Orchard Valley, 1985
Laumeier Sculpture Park
St. Louis, Missouri
A curving boardwalk and railings
surrounding an abandoned pool in
the shape of a pond. The new is
layered over the old, wood over
concrete.

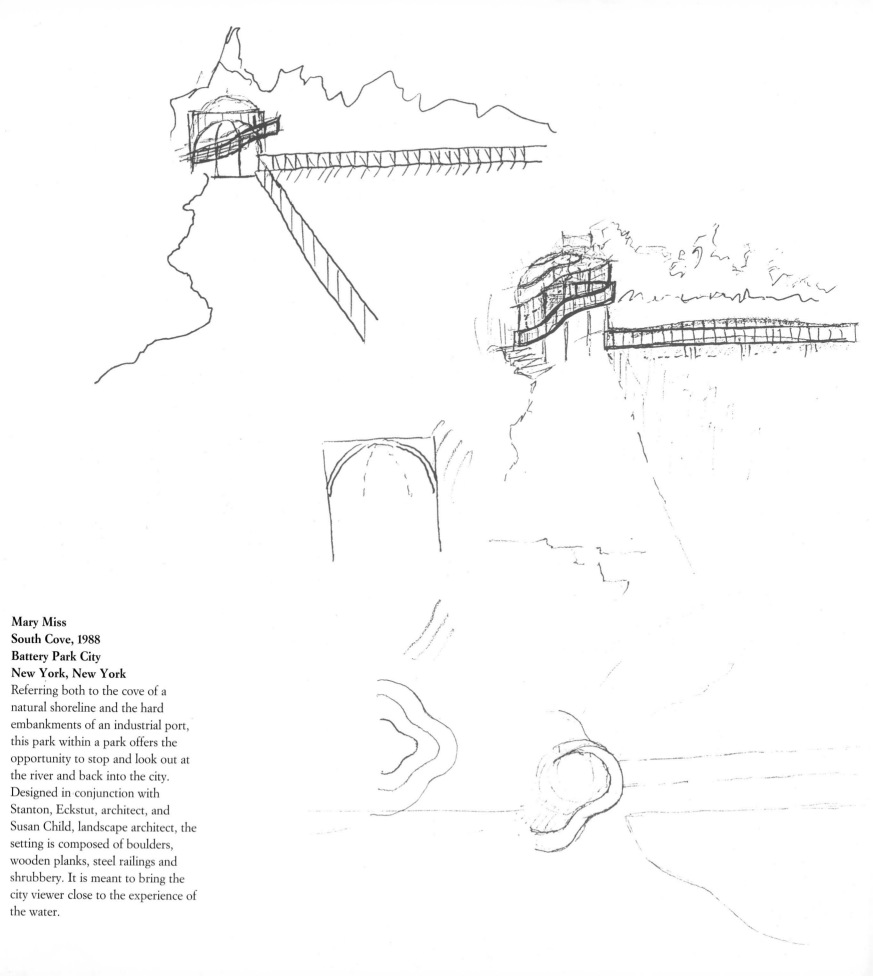

Mary Miss
South Cove, 1988
Battery Park City
New York, New York
Referring both to the cove of a natural shoreline and the hard embankments of an industrial port, this park within a park offers the opportunity to stop and look out at the river and back into the city. Designed in conjunction with Stanton, Eckstut, architect, and Susan Child, landscape architect, the setting is composed of boulders, wooden planks, steel railings and shrubbery. It is meant to bring the city viewer close to the experience of the water.

210

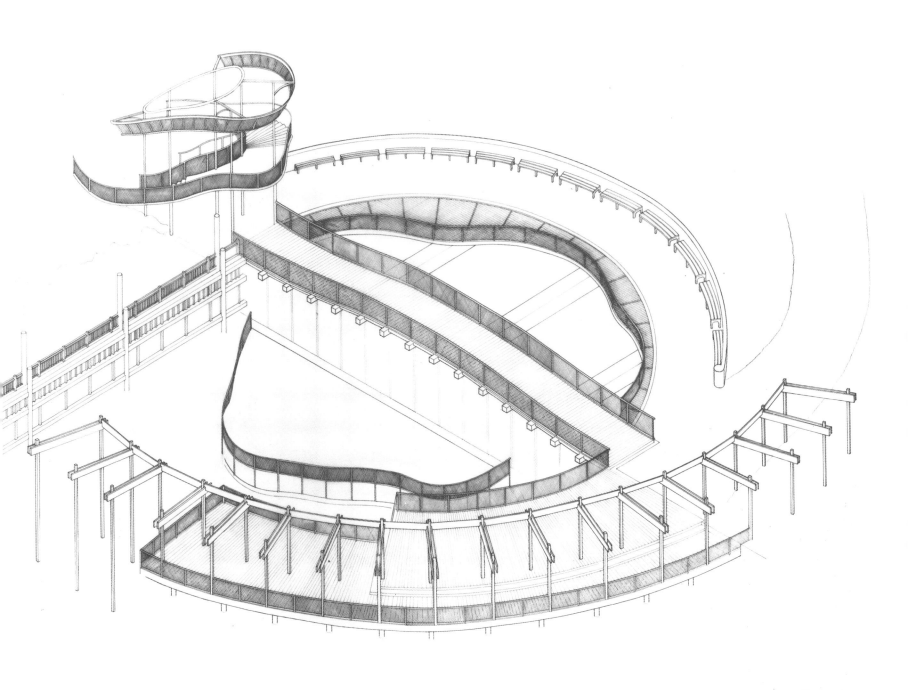

Mary Miss with Stanton,
Eckstut, architect, and Susan
Child, South Cove (2 1/2
acre site), Battery Park City,
New York, New York, 1988.

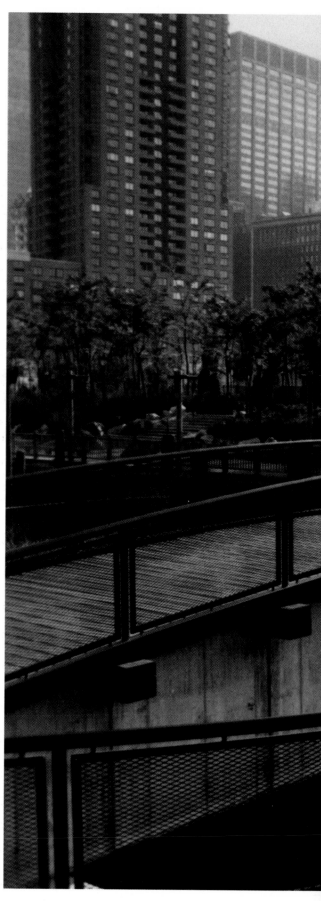

Mary Miss with Stanton, Eckstut, architect, and Susan Child, South Cove (2 1/2 acre site), Battery Park City, New York, New York, 1988.

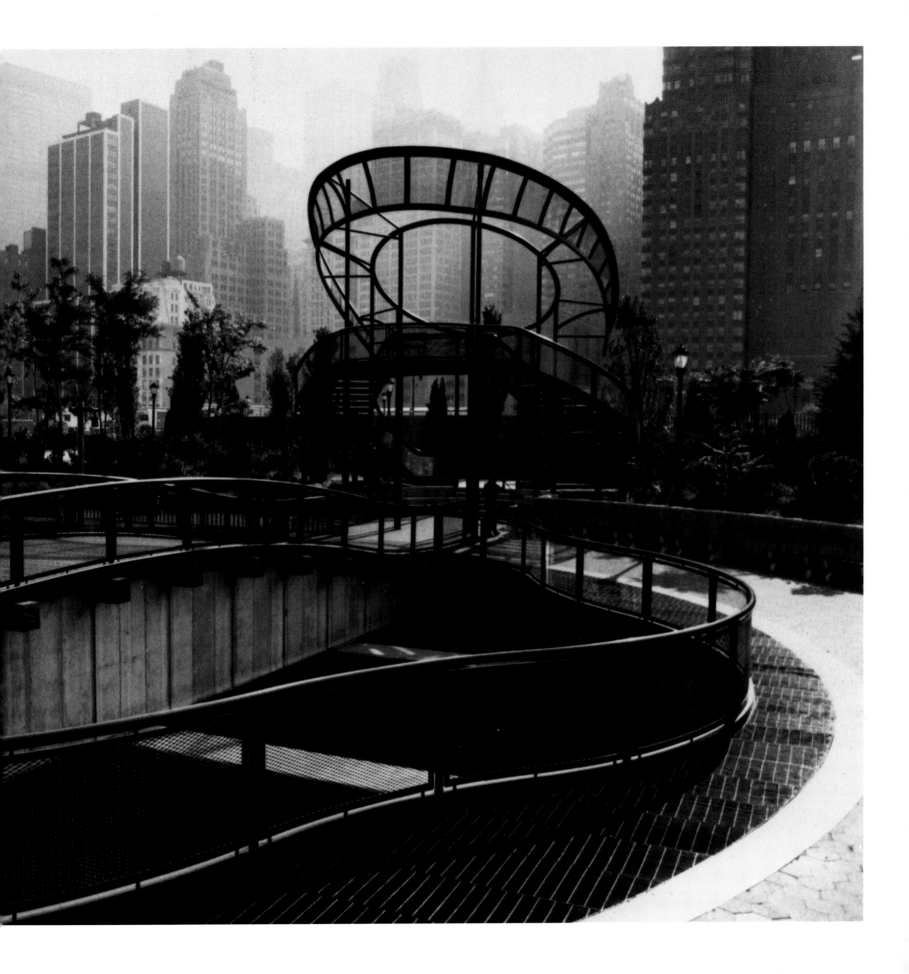

Image Credits

Chapter One

The New York Historical Society, N.Y.C., pp. 12, 15, 16, 18 (lower), 19 (lower right), 20, 21 (upper), 24/25.

The Corcoran Gallery of Art, Washington, D.C., pp. 14, 19 (upper right).

Library of Congress, Washington, D.C., p. 18 (upper), p. 19 (left).

Dumbarton Oaks, Washington, D.C., Trustees for Harvard University, p. 21 (lower).

Collection of Christian Zapatka, pp. 22, 23.

Chapter Two

Library of Congress, Washington, D.C., pp. 26–27, 28, 39, 49 (upper left, upper right, lower right), 52, 53 (upper), 55 (upper, lower), 63, 66, 68.

New York Historical Society, N.Y.C., pp. 29, 44–45 (lower), 47, 49 (lower left).

Dumbarton Oaks, Washington, D.C., Trustees for Harvard University, pp. 30, 31, 50, 51 (lower), 53 (lower left, lower right), 54 (upper).

Frances Loeb Library, Harvard University Graduate School of Design, Cambridge, Massachusetts, pp. 34, 58 (lower), 62.

Martin Luther King Library, Washington, D.C., p. 42.

New York City Parks Photo Archives, pp. 44–45, 46–47, 51 (upper), 56 (lower), 57.

Library of the American Academy in Rome, pp. 69–71.

Collection of Christian Zapatka, pp. 48, 67.

National Park Service, Frederick Law Olmsted National Historic Site, Brookline, Massachusetts, pp. 54–55 (middle), 56 (upper), 58 (upper), 59 (upper), 60, 61, 64 (lower), 64–65.

National Archives, Washington, D.C., pp. 72–77.

Chapter Three

Dumbarton Oaks, Washington, D.C., Trustees for Harvard University, p. 78.

Frances Loeb Library, Harvard University Graduate School of Design, Cambridge, Massachusetts, p. 81, 89 (lower).

Library of Congress, Washington, D.C., pp. 84, 91, 93 (right).

Library of the Lawrenceville School, Lawrenceville, New Jersey, pp. 87, 96–99.

National Park Service, Frederick Law Olmsted National Historic Site, Brookline, Massachusetts, pp. 89 (upper), 90, 92/93.

Wellesley Historical Society, Wellesley, Massachusetts, pp. 94, 95.

Chapter Four

Library of Congress,
Washington, D.C., pp. 100,
108–111.
Patrick Berry, photographer,
p. 105.
Courtesy of Cameron
Trowbridge, p. 106 (upper).
Collection of Christian Zapatka,
pp. 106 (lower), 112–119.

Chapter Five

Library of Congress,
Washington, D.C., pp. 120, 131,
151 (left), 162–165.
New York City Parks Photo
Archives, pp. 123, 126, 136
(upper), 138, 140–141, 142–149.
National Archives, Washington,
D.C., pp. 128, 150, 151 (right),
152, 153 (right), 154, 156–161.
Collection of Christian Zapatka,
p. 134.
Library of the American
Academy in Rome, pp. 136
(lower), 137.
Martin Luther King Library,
Washington, D.C., pp. 153 (left),
155 (left, lower right).
Washington Historical Society,
Washington, D.C., p. 155
(upper right).

Chapter Six

Mary Miss, pp. 166, 176, 202–
211.
Dan Kiley, pp. 170, 178–187.
Ron Wigginton, Land Studio,
pp. 173, 192–197.
Peter Walker, pp. 188–191.
Collection of Christian Zapatka,
p. 197 (upper).
Hargreaves Associates,
pp. 198–201.